The Genius of RENOIR

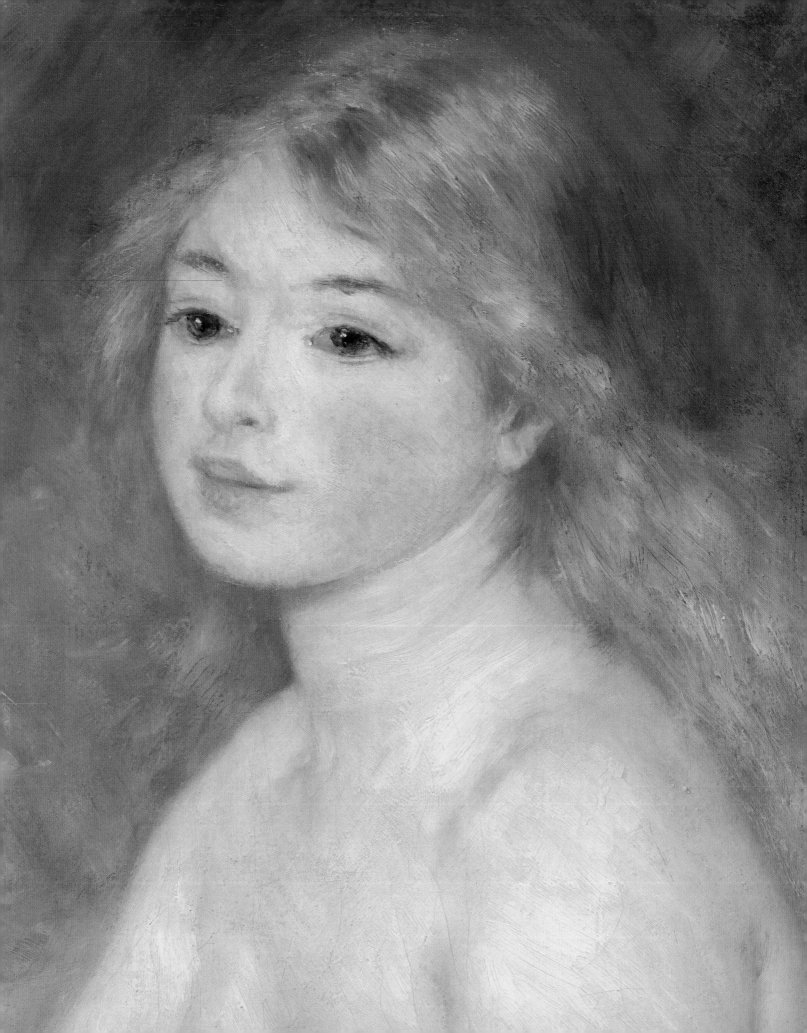

Portrait of Madame Monet (Madame Claude Monet Reading)

c. 1874

Oil on canvas
61.6 x 50.3 cm
Signed lower left:
A. Renoir.
1955.612

Camille Doncieux (1847–1879) married Claude Monet in 1870, three years after the birth of their first son, Jean. From 1866 onward, she appeared frequently in Monet's paintings, in portraits, genre subjects, and outdoor scenes, and finally in his rapid sketch of her lifeless figure on her deathbed in 1879 (Musée d'Orsay, Paris).

In Renoir's canvas, Camille Monet is depicted seated on a sofa, reading a paper-covered book. Her body creates a virtually straight line, a shallow diagonal axis, as she leans back against two large cushions while her feet rest on a third. Cushions and sofa alike are boldly patterned with flowers and leaves set against an off-white background, and a large bird, perhaps a crane, appears on the left cushion. Camille's dress is equally richly patterned but on a smaller scale; its front panels pick up the soft pinks and greens of the sofa, but the surrounding blue fabric frames the figure and sets it apart from its setting, linking it visually to the blue wall behind the sofa. The figure creates a dominant pyramidal shape nearly central in the canvas, while the narrow blue band down the front of the dress anchors the figure within the composition and hints at the form of the sitter's body. The volume of her body and the space within the scene are further suggested by the side lighting, which creates shadows beneath the sofa and the cushions, and down the right side of the figure.

Beyond this, though, there is little conventional modeling: the technique acts to dissolve the forms, rather than suggest their solidity. Throughout the canvas, small, fleck-like touches animate the surface. These serve in part to suggest the textures of the surfaces represented and complement their patterning; but at the same time, though varied in shape and direction, they lend an overall vibrancy and liveliness to the whole picture.

Although the painting has normally been dated to c. 1872, its small-scale, fragmented brushwork, and richly interwoven color accents suggest a rather later date, perhaps the summer of 1874, when Renoir was working alongside Monet at Argenteuil, ten miles to the northwest of Paris. In the autumn of 1874, Monet moved into a new house there,[1] in which, as we can see from his *Japonnerie* such as *La Japonaise (Camille Monet in Japanese Costume)* (Museum of Fine Arts, Boston) of 1875–76, he installed flights of Japanese *uchiwa* fans on the wall. We cannot, though, tell whether the present canvas represents this house, or whether fans were similarly installed in his previous residence at Argenteuil.

Monet was an enthusiast for the Japanese *objets d'art* that became so fashionable during the 1860s. From the later 1860s onward he began to assimilate the lessons of Japanese pictorial composition into his canvases,[2] and Japanese objects first appear in his depictions of the interiors of his residences during his stay in London in 1870–71, in *Meditation. Or Madame Monet on the Sofa* (Musée d'Orsay, Paris). It seems, though, that Renoir was less interested in Japanese décor and pictorial effects[3] (however, see also *Girl with a Fan* [cat. 9]), and the presence of the fans on the background wall here is probably more a reflection of Monet's interests than his own. The dress that Camille wears in the painting appears to be a variation on a Turkish caftan—another form of exoticism that complements the Japanese-inspired décor.[4] Renoir depicted her wearing the same dress in two other canvases painted around 1874 (Calouste Gulbenkian Foundation, Lisbon; private collection)[5], and she may be wearing the dress again in Monet's *Camille Monet Embroidering* of 1875 (Barnes Foundation, Merion, Pennsylvania);[6] the dates of these works further support a date of c. 1874 for the present painting.

Both the format of the picture and the presence of Japanese artifacts are reminiscent of Édouard Manet's

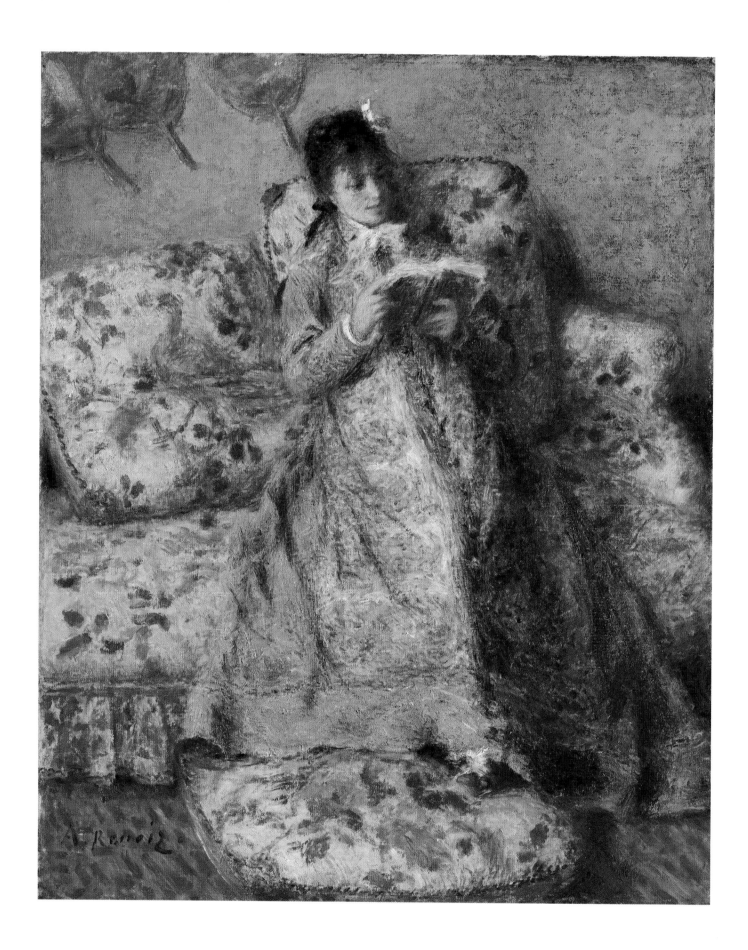

The Genius of
RENOIR

PAINTINGS
FROM THE CLARK

John House
With an essay by James A. Ganz

STERLING AND FRANCINE CLARK ART INSTITUTE
Williamstown, Massachusetts

MUSEO NACIONAL DEL PRADO
Madrid

DISTRIBUTED BY YALE UNIVERSITY PRESS
New Haven and London

Produced by Museo Nacional del Prado in association with the Sterling and Francine Clark Art Institute, in conjunction with an exhibition at the Prado, 18 October 2010–6 February 2011

IN SPAIN

Coordination and Spanish edition by Lola Gómez de Aranda, José Riello, and Carmen Hevia, *Museo Nacional del Prado*
Production by Sergio Aguilar, *Museo Nacional del Prado Difusión* and Ignacio Fernández del Amo, *Tf Editores*

Design by Francisco J. Rocha
Composed in Electra LH and SansSerif FLF by Lucam
Color separations by Lucam
Printing by Tf Editores

IN USA

Curtis R. Scott, *Director of Publishing and Information Resources*
Katherine Pasco Frisina, *Production Editor*
Dan Cohen, *Special Projects Editor*
Michelle Noyer-Granacki, *Publications Intern*
Index by Kathleen M. Friello

Distributed by Yale University Press, New Haven and London
www.yalebooks.com

COVER ILLUSTRATIONS

FRONT Detail of *Marie-Thérèse Durand-Ruel Sewing* (cat. 23)
BACK *Venice, the Doge's Palace* (cat. 18)

DETAILS

PAGE 2 *Blonde Bather* (cat. 21)
PAGE 6 *Girl Crocheting* (cat. 6)
PAGES 8-9 Visitors in the central gallery at the Sterling and Francine Clark Art Institute
PAGES 12-13 *Onions* (cat. 20)
PAGES 40-41 *Low Tide, Yport* (cat. 24)
PAGES 130-31 *Portrait of Madame Monet* (cat. 2)

PRINTED AND BOUND IN SPAIN
10 9 8 7 6 5 4 3 2 1

Library of Congress Cataloging-in-Publication Data

Sterling and Francine Clark Art Institute
The genius of Renoir: paintings from the Clark / John House; with an essay by James A. Ganz
p. cm.
"Produced by Museo Nacional del Prado in association with the Sterling and Francine Clark Art Institute, in conjunction with an exhibition at the Prado, 18 October 2010–6 February 2011"
Includes bibliographical references and index

ISBN: 978-0-931102-90-5 (Clark hardcover: alk. paper)
ISBN: 978-0-931102-92-9 (Clark softcover: alk. paper)
ISBN: 978-0-300-11105-7 (Yale: alk. paper)

1. Renoir, Auguste, 1841–1919 — Exhibitions 2. Painting — Massachusetts — Williamstown — Exhibitions 3. Sterling and Francine Clark Art Institute — Exhibitions I. Renoir, Auguste, 1841–1919 II. House, John, 1945– III. Ganz, James A. IV. Museo del Prado V. Title.

ND553.R45A4 2010
759.4—dc22 2010039583

Contents

Directors' Foreword

Sterling Clark purchased his first work by Pierre-Auguste Renoir—*Girl Crocheting*—in 1916, and his enthusiasm for the artist persisted for decades. Over the course of thirty-five years, Sterling and his wife, Francine, whom he married in 1919, assembled one of the most important private collections of paintings by Renoir in history.

This exhibition provides the first opportunity for Spanish audiences to enjoy the full breadth of the Clark's collection of paintings by Renoir, presented in the grand galleries of Juan de Villanueva's original museum amid the magnificent Spanish royal collections. The exhibition also marks the first step in a unique cultural exchange between the Museo Nacional del Prado and the institute that Sterling and Francine Clark founded in the academic community of Williamstown, Massachusetts, three hours north of New York and a similar distance west of Boston. The two institutions could not be more different in size and scope, but the holdings of both can be described as "collections of artists." By lending these works to the Prado, the Clark is enabling the international public to discover this remarkable modern painter within the context of the Prado's own rich collections of Old Masters. The Prado will lend the Clark major pictures by Titian, Rubens, Velázquez, and others for a forthcoming exhibition exploring Spanish royal taste in collecting, the importance of the nude in the development of western painting traditions, and the strategies of display and public presentation in the royal collections. Thus, this exchange will provide audiences in both Spain and the United States the opportunity to explore not only new artists but also the history of institutional collecting in public and private collections of a very different origin.

Sterling Clark once remarked that Renoir was "perhaps the greatest artist that ever lived." His enthusiasm for the artist has few parallels, and hence the Clark is best known for its collection of early Renoirs. We are delighted to present these important works to new audiences in Madrid and to share Sterling Clark's passion for this great late-nineteenth-century artist, one of the foremost Impressionist painters.

MICHAEL CONFORTI
Director, Sterling and Francine Clark Art Institute

MIGUEL ZUGAZA
Director, Museo Nacional del Prado

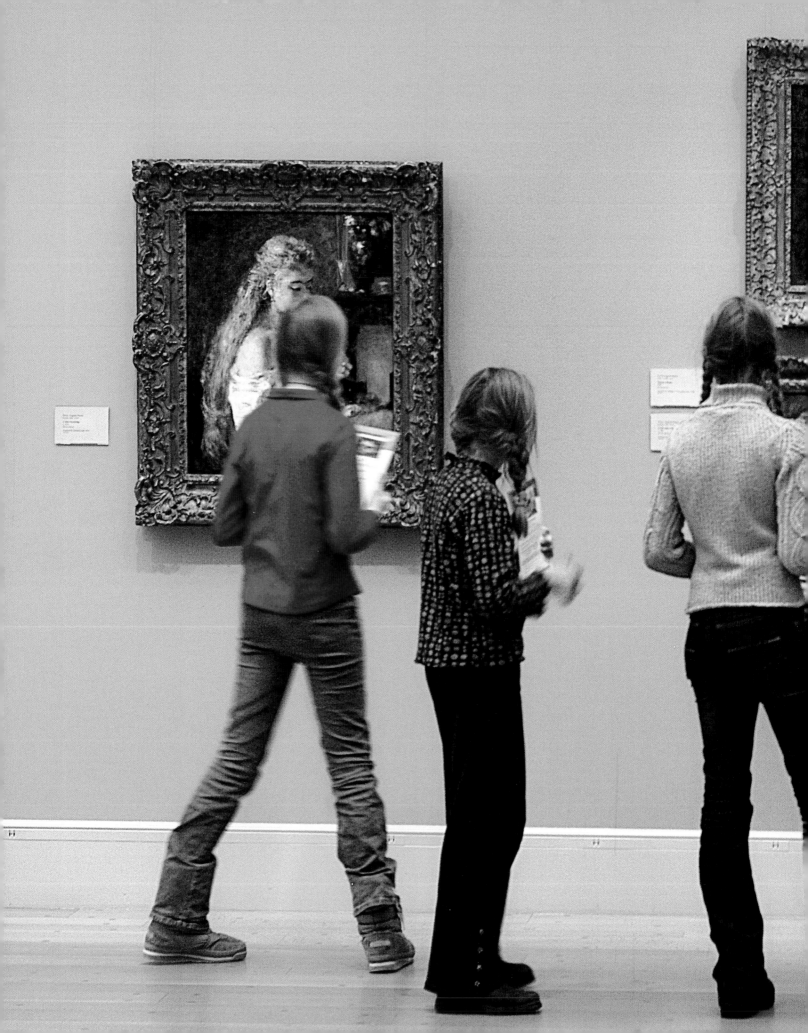

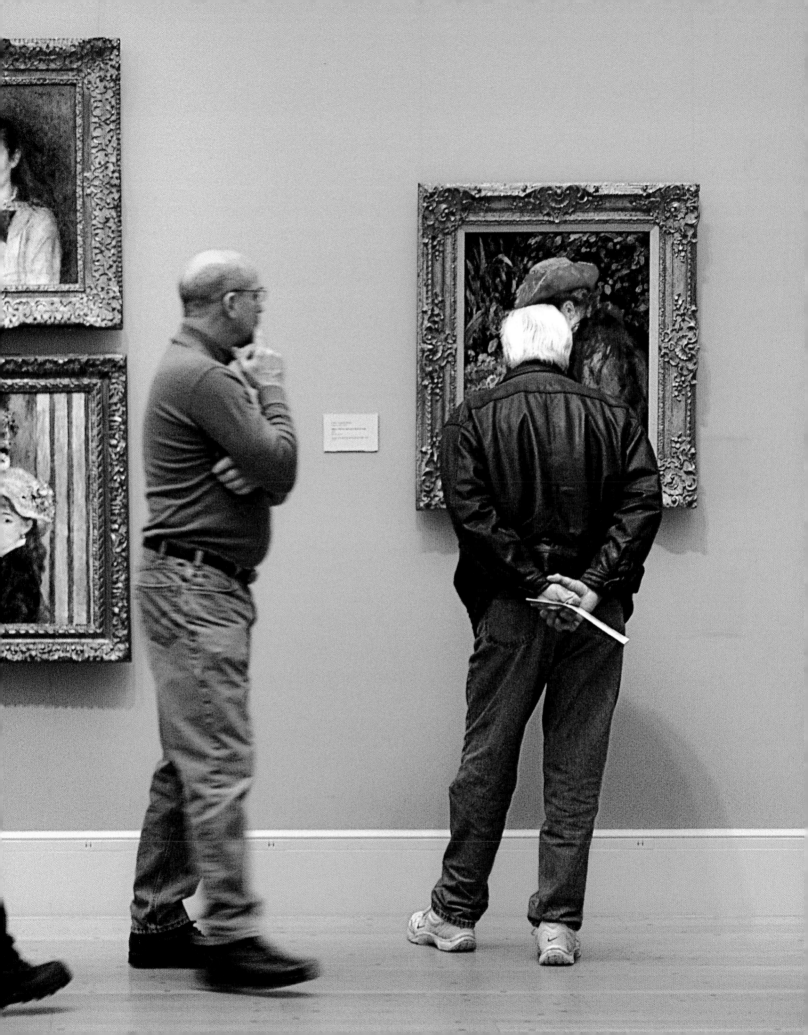

An Introduction to the Clark

MICHAEL CONFORTI

Director
Sterling and Francine Clark Art Institute

The Clark is one of the few institutions in the world with an ambitious dual mission as both an art museum and a center for research in the visual arts. Its superb collections, distinctive exhibitions, extensive library, and scholarly community foster an environment that might best be described as a "greenhouse for ideas." From its 140-acre woodland campus in the Berkshire Hills of western Massachusetts, the Clark has close ties to nearby Williams College, the foremost liberal arts college in the United States. The Clark and Williams jointly offer a graduate program in art history which, together with the Clark's visiting Fellows program, brings students and scholars from around the world to this important intellectual community, easily accessible from the urban centers of Boston and New York. For many of America's most respected and influential scholars and museum professionals, the Clark has been and remains an important and regular part of their lives.

Throughout the world, the Clark is perhaps best known for its Impressionist paintings, especially its more than thirty works by Pierre-Auguste Renoir. The core of the collection—European and American paintings, master prints and drawings, English silver, and porcelain—is the legacy of its founders, Sterling and Francine Clark. A self-trained connoisseur, Sterling Clark learned through reading, visiting galleries, attending auctions, and developing relationships with art dealers—most no-

tably the Durand-Ruel family. Clark once wrote, "I like all kinds of art if it is good of its kind." He also relied heavily on the opinion of his wife, Francine, describing her as "an excellent judge, much better than I at times," and referring to her as his "touchstone in judging pictures." The museum they founded together opened to the public in 1955, and in the years since, the collections have been thoughtfully enriched with select new acquisitions and have also expanded into new areas, such as early photography. Visitors to the Clark are amazed by the quality of Impressionist and Old Master paintings that are part of the permanent collection and by the groundbreaking exhibitions the Clark organizes, such as the critically acclaimed *Picasso Looks at Degas*.

Intellectual engagement and scholarly inquiry define the Clark's Research and Academic Program, which has achieved international distinction as a place where both established leaders in the field and young scholars can encounter and directly engage in the changing methods, practices, and theoretical strategies of art history and visual culture. In the past decade, its residential visiting Fellows program has hosted well over two hundred scholars from more than two dozen different countries. With interests ranging from contemporary performance art to Classical studies to feminist theory, the Fellows themselves testify that some of their most important and groundbreaking work has been a direct result of their experience at the Clark. A wide-ranging program of lectures, colloquia, symposia, and conferences brings additional voices to the campus on a regular basis, fostering countless formal and informal exchanges.

In planning for its future, the Clark is currently engaged in a campus expansion that includes new buildings designed by the Japanese architect Tadao Ando, as well as major renovations to the existing buildings that house the art museum and research center. These initiatives will reinforce the Clark's ability to realize its program through enhanced gallery spaces, expanded facilities for its research program, and improved visitor amenities. The occasion also affords the Clark the opportunity to engage new audiences by sharing some of its most important works in a series of exhibitions that will travel throughout North America, Europe, and Asia over the next few years.

A recent visiting scholar observed that "the Clark is where ideas happen." Within its galleries, on its walking trails, and within its library, curators, scholars, students, and visitors engage with art in myriad ways. And yet, as much as the sense of place resonates with visitors to the campus, it is the ideas and experiences *generated* at the Clark that contribute to the greater intellectual advancement of museums and research institutes worldwide.

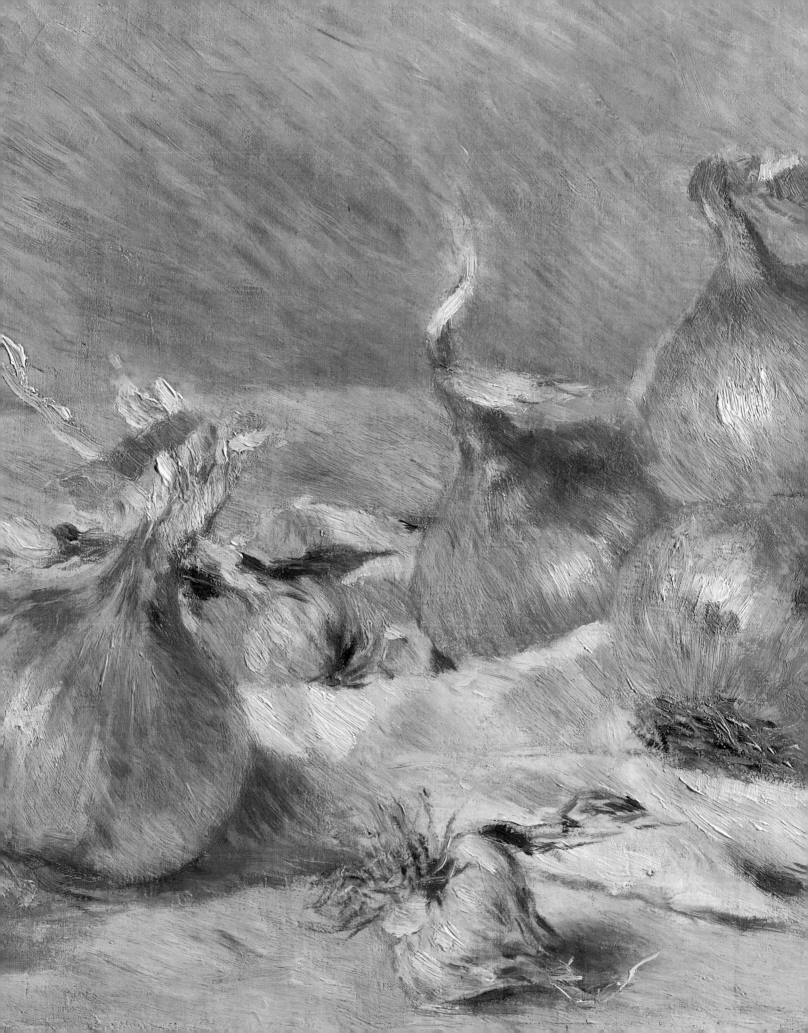

The Genius of **RENOIR**

Sterling Clark as a Collector

JAMES A. GANZ

Robert Sterling Clark was an enigmatic figure. Born into a life of privilege and wealth, he set himself on an independent course from a young age, breaking free of his family's New York ties to live in Europe and travel the world. He was a man of contradictions, a private figure who shunned the spotlight but founded an institution to share his art collection with the public. His death came shortly after the opening of the museum bearing his name, and in the years that followed, the identity of the man became subsumed by the institution. Clark's own diaries and correspondence provide a rich, if fastidious, personal archive that gives insight into how the events of his life shaped the choices he made, and how his art collection and its final disposition in Williamstown reflect his idiosyncratic personality.

FAMILY AND EARLY YEARS

Sterling Clark (fig. 1) was born in 1877 the second of four children of Alfred Corning Clark and Elizabeth Scriven Clark. The family's fortune originated with Sterling's grandfather, Edward Clark, a young lawyer who was hired by the inventor Isaac Merritt Singer in 1848 to secure the legal status of Singer's improvements to existing sewing machines. Soon the two became business partners, and in the 1850s I. M. Singer and Company became the world's leading sewing machine manufacturer. Much of the company's commercial success is credited to Clark's introduction of an installment plan for payment that made the machine financially viable for the ordinary consumer. By the time Edward died in 1882, he left his family an estate worth over $50 million, including an entire city block in Manhattan for each of his four grandsons.

Growing up in a life of luxury, Sterling split his time between New York City and his family's home in rural Cooperstown, New York. He attended Cutler's School in New York and the Sheffield Scientific School at Yale, where he graduated from the civil engineering program in the class of 1899. He immediately volunteered for the army and was sent to China, seeing action in the Boxer Rebellion. After retiring from the army in 1905, Clark went back to China in 1908, leading a research expedition on horseback through the mountains of the Shaanxi and Gansu provinces, west of current Beijing (fig. 2). He published an account of this trip titled *Through Shên-kan* in 1912.

After his adventures in the Far East, Sterling decided that instead of returning to New York and his family, he would settle in Paris. For a thirty-two-year-old army veteran and adventurer who had traveled extensively during his twenties in such far-flung locales as Manila, Peking, and the West Indies, Paris was hardly exotic. The French capital represented, rather, the height of Western civilization, while providing a convenient outpost for a series of projected expeditions funded by his inheritance and fueled by an insatiable wanderlust. For Clark, relocating to Paris was also the means to another end: his escape from the family manse. Although he communicated regularly with his brothers during the 1910s, and continued to frequent Cooperstown through the early 1930s, the move to Europe marked the beginning of a process of distancing himself from his family. In one of his first letters sent from Paris to an agent based in New York working for the Clark Estates, he confessed: "Cooperstown does not interest me in the slightest and were I alone in all of this I would sell out of every

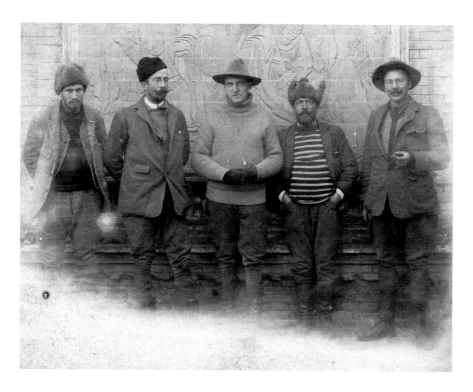

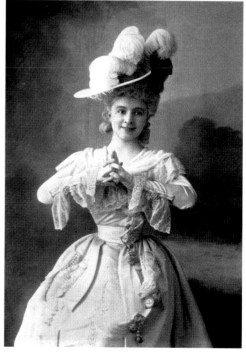

stick I had in the place. . . . I consider that the family has done quite enough and too much for Cooperstown already."[1]

The death of Clark's mother in 1909 added considerably to the fortunes already inherited by Sterling and his three brothers. The windfall enabled Sterling to set himself on a new and entirely independent course. His decision to settle in Paris the following year may have been related to a chance encounter that would further alter the course of his life. For beyond the many attractions of the "City of Light," its relative proximity to the Middle East, and its comfortable distance from the Clarks of Cooperstown, it was Sterling's deepening relationship with an actress of the Comédie Française that may have clinched his decision to establish his primary residence in Paris.

The cultural and socio-economic backgrounds of the American bachelor and the French actress could not have been more different. Francine Clary (fig. 3) was born Francine Juliette Modzelewska on 28 April 1876, the daughter of a Parisian dressmaker. A year older than Sterling, Francine had graduated from the Paris Conservatoire in 1897 and assumed the stage name "Clary" in her first appearance at Sarah Bernhardt's Théâtre de la Renaissance in the play *Service Secret* (October 1897). Her career was interrupted by the birth of her only child, Viviane, in 1901. She resumed acting in 1902 and made her debut at the prestigious Comédie-Française in 1904. At the time of Sterling Clark's visit in March 1910 she was appearing in both Tristan Bernard's *L'anglais tel qu'on le parle* and Gaston Arman de Caillavet and Robert de Flers's *L'amour veille*.

While the exact circumstances of the couple's early relationship are shrouded in mystery, it is clear that by 1911 the intense bond the two would share was already forming. Sterling's youngest brother Stephen visited Paris in December of that year and noted that although Francine kept her own apartment, she took all of her meals with Sterling and occasionally spent the night in his newly completed residence. "Apparently they lived a good deal by themselves," he observed.[2] This insularity would become one of the couple's enduring traits for the rest of their lives together.

BEGINNINGS OF THE COLLECTION

In the fall of 1910, Clark purchased a modest Second Empire–style *hôtel particulier* at 4 rue Cimarosa in the fashionable sixteenth arrondissement in Paris. He took pleasure in overseeing renovations of the house, and spent much time scouring Paris for appropriate furnishings, lighting, fixtures, and wall treatments. The most impressive room in the house was the grand salon on the first floor, which afforded hanging space for a dozen paintings (fig. 4). Clark called this room his "galleria" and it would become the personal showcase for a selection of his favorite works.

Clark lost no time in filling his new house with art. This proclivity likely grew out of his childhood exposure to fine art, as both of his parents actively collected and displayed art throughout their homes.[3] In June 1911, he had a shipment of paintings sent from New York, including pictures by Jean-François Millet, Mariano Fortuny y Carbó, Gilbert Stuart (fig. 5), George Inness, and Julian Walbridge Rix.[4] These paintings originated from the estate of Sterling's mother, and their arrival in Paris marked the resolution of an early dispute between Stephen and Sterling. Of these pictures, only the Millet and Fortuny had been assigned to Sterling during the original dispersal of the art collection that Stephen had overseen. At the time, Sterling was traveling in China, and in his absence his siblings were given priority in selecting works of art from their parents' estate. In light of his brother's nomadic lifestyle, Stephen reasoned that he would have little interest in receiving a large group of paintings, but as the second-born son, Sterling felt that his choices should have superceded those of his two younger brothers. Although it was settled amicably, this dispute aroused feelings of resentment on both sides.

At this time Clark also began turning his attention to expanding the small collection he had inherited, and at first, he proceeded conservatively. His earliest documented acquisitions, made in February 1912, were a bronze of the *Medici Venus* after the Mannerist sculptor Giambologna, and a pastel portrait

FIG. 4

The grand salon of Sterling Clark's house at 4, rue Cimarosa, Paris, c. 1913

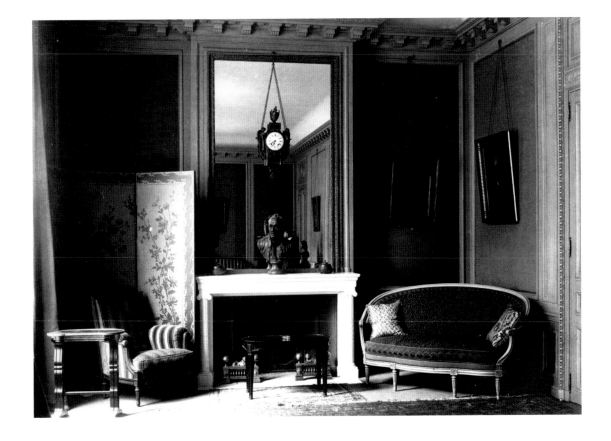

by Jean-Baptiste Perroneau.[5] The next month he bought a seascape by Jacob van Ruisdael (now attributed to a follower) and a devotional panel attributed to Matteo di Giovanni from the London firm P. & D. Colnaghi & Obach. During the fall, he returned to New York for the first time since his move to Paris, and while there, he made his first purchase from Colnaghi's American partner, M. Knoedler & Co., a dealer with whom he would have a long and lucrative relationship. A panel by the Netherlandish Master of the Legend of Saint Lucy would join the Matteo di Giovanni to form the nucleus of a significant collection of Italian and Northern Renaissance paintings in the Paris residence. He also began purchasing works on paper, and by 1920 had amassed an impressive group of Old Master drawings, including Albrecht Dürer's stunning *Sketches of Animals and Landscapes* (fig. 6).

With this enthusiasm for Old Master paintings and drawings, Clark quietly—and quickly—rose from an inconspicuous American in Paris furnishing his new house to become a player in a field of collecting that had been previously dominated by such figures as J. P. Morgan, Henry Clay Frick, and Joseph Widener. In November 1912 he bought Anthony van Dyck's *Portrait of Ambrogio Spinola* and a *Madonna and Child* by Giovanni

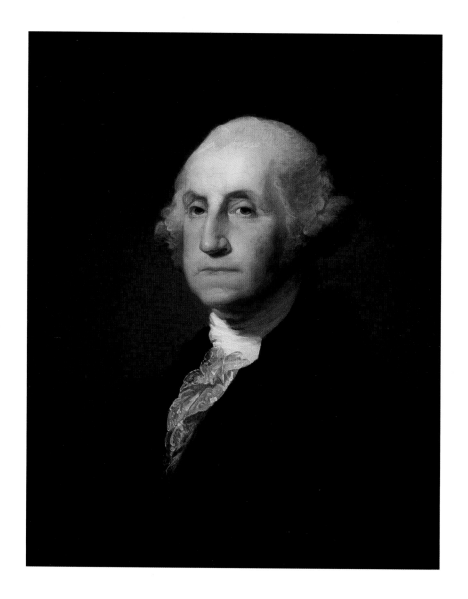

FIG. 5

Gilbert Stuart
(American, 1755–1828),
George Washington,
after 1796.
Oil on canvas,
73.5 x 61.1 cm.
Sterling and Francine
Clark Art Institute,
Williamstown,
Massachusetts (1955.16)

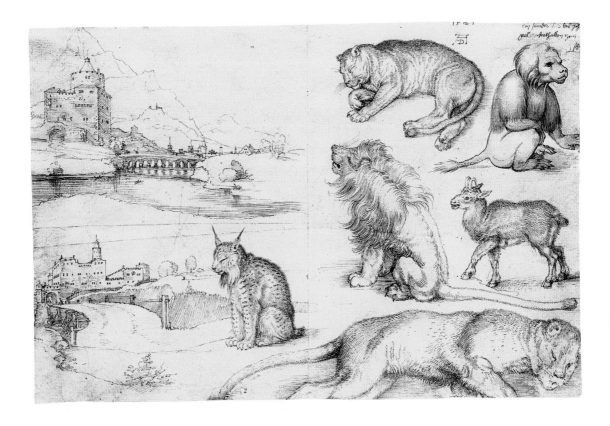

Bellini, paying $70,000 for the Bellini alone.[6] In acquiring these two paintings, Clark had taken his place on a competitive playing field of multimillionaire collectors who were setting new standards of luxury consumption and taste, and whose activities were eagerly reported in the newspapers. But unlike these other leading figures, Clark succeeded in maintaining his privacy and anonymity as he slowly built his collection within the domestic environment of his residence, which happened to be in Paris rather than New York.

Among Sterling and his brother Stephen's transatlantic correspondence of the early teens is a significant exchange, in the early months of 1913, on the subject of collecting art toward establishing a private museum. Sterling's letter of 4 February gives insight into the motivations and goals driving this new passion:

> You remember the subject on which we had a conversation last year, namely my idea of founding a gallery in Cooperstown. And also that you thought it would be probably better to have it in N.Y. I have been thinking it over and although I have not arrived at any definite conclusion, I rather think that it would be better to have it as I first planned.[7]

He went on to enumerate the relative advantages of New York ("more people would see it"; "it would be better known") and Cooperstown ("it would help the town"; "it would be better lighted"), concluding "in N.Y. it would be compared with some of the famous collections and some of the best known works of art and would suffer in comparison before the eyes of the common man, even though the art as art might be just as good."[8] Stephen's response was decidedly measured. After pointing out the difficulties of establishing a museum in Cooperstown ("owing to climatic conditions, there would be scarcely a single person who would go to see it during the winter time"), he advised his brother to build his collection first, and his museum later.[9] So ended the discussion for the time being, but this conversation is significant in establishing that the seeds of the Sterling and Francine Clark Art Institute were sewn in Clark's mind as early as 1912.

As Clark continued building his collection, he quickly became disillusioned with the advice of outside advisors and experts. In 1913 he bought *Portrait*

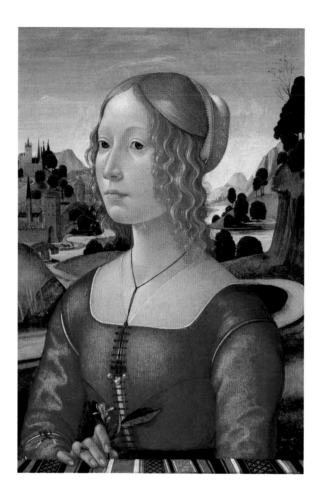

of a Lady by Domenico Ghirlandaio (fig. 7) and *Walking Horse*, a bronze by Giambologna. Both purchases were facilitated by the American sculptor George Grey Barnard, who had been a friend of Clark's father. After being assured that the Ghirlandaio had not been retouched and that the *Walking Horse* was a unique cast, Clark subsequently found that both of these claims were false. On a trip to Italy in the summer of 1913 he discovered a postcard of the Ghirlandaio in an altered state, and a copy of the *Walking Horse* in the Bargello in Florence. This experience would color his attitude toward outside experts for the rest of his life, and he quickly learned to rely on his own judgment rather than their advice. Soon after his trip to Italy he wrote to Stephen warning him that "except for Knoedler and Colnaghi you have got to know the game yourself and that its what I am trying my best to learn."[10]

Clark's taste for Old Masters continued to grow, and just weeks after his trip to Italy, he bought Piero della Francesca's sensational *Virgin and Child Enthroned with Four Angels* (fig. 8) from Colnaghi for an astounding 35,000 pounds sterling, which translated at the time to roughly $170,000. The Piero immediately became the focal object in his rapidly growing collection. Clark's collecting of Italian Renaissance paintings peaked in 1914, with the purchase of panels by such masters as Luca Signorelli, Perugino, and Bartolomeo Montagna. A snapshot of the collection in that year would suggest that he might follow in the footsteps of Isabella Stewart Gardner or James Jackson Jarves. Clark, however, was about to change his course.

At the important sale of the Antony Roux collection held in Paris on 19 and 20 May, Knoedler bid successfully on his behalf for a group of nineteenth-century French paintings and sculptures, including a

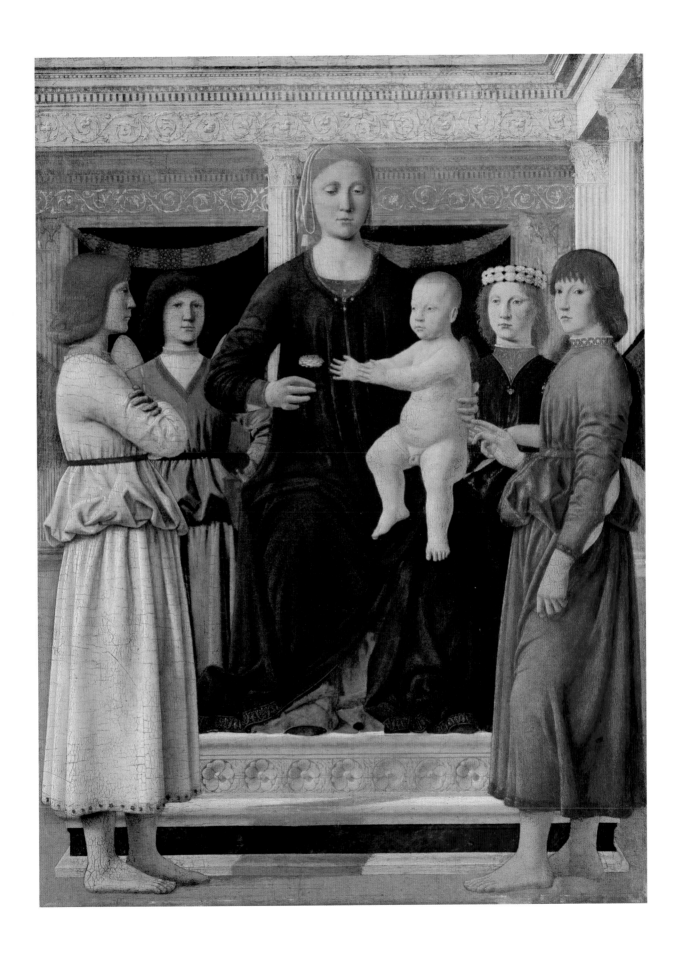

magnificent plaster and bronze by Auguste Rodin of *Man with a Serpent*. Clark's burgeoning interest in the "moderns" was also reflected in his purchases of early works by the living American painter John Singer Sargent, beginning in the fall of 1913 with the purchase of *Venetian Interior* from M. Knoedler & Co. Paris. He would eventually acquire twelve paintings and two drawings by Sargent, including his orientalist masterpiece *Fumée d'ambre gris* (fig. 9).

PARIS: WORLD WAR I

Germany's declaration of war on France in August 1914 curtailed Clark's collecting activities and forced him to put his most valuable works into storage. As the war raged on in Europe, Clark maintained his residence in Paris and was able to make several trips to London and New York. He bought only two paintings in 1915. In 1916, however, Clark made two momentous purchases while visiting New York: Winslow Homer's *Two*

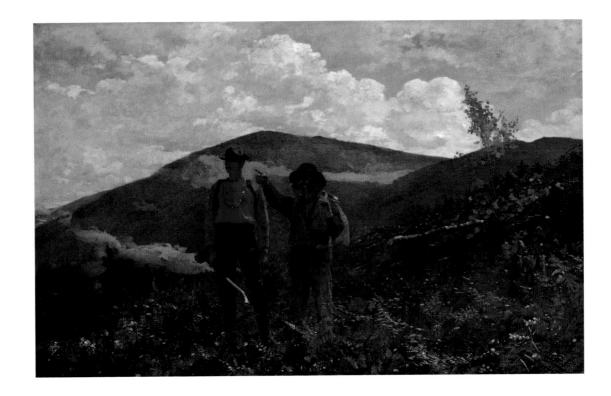

Guides (fig. 10), and his first Renoir, *Girl Crocheting* (cat. 6). Compared with the prices he was accustomed to paying for important Old Master paintings, the Homer (at $10,000) and Renoir (at $20,000) must have appeared as relative bargains. Even so, he hedged his purchase of the Renoir by requesting a written guarantee from the gallery to buy back the picture at its purchase price within five years if he should decide to return it.[11] Little did Clark realize at the time that instead of returning *Girl Crocheting*, he would go on to become one of the premier collectors of Renoir's work, eventually acquiring over thirty paintings by the Impressionist master.

Clark's taste for Renoir was relatively advanced for his time, although it would not be long before the field of collectors became crowded. In the first line of his article in *Art News* titled "The Renoirs in America" (1937), Henry McBride stated, "the Renoir cult in America is a story of quiet and steady progress." He went on to single out the silk-weaving magnate Catholina Lambert as "the first American collector to take Renoir seriously," noting that "Mr. Lambert's

Renoir was sold [at auction] to the Messrs. Scott & Fowles for $16,200—a price that must have been impressive in 1916."[12] The picture in question was *Girl Crocheting*. Clark took this canvas off of Stevenson Scott's hands just ten months later, following the lead of Dr. Albert Barnes, who bought his first Renoir painting in 1912, and Henry Clay Frick, who acquired his first Renoir in 1914.

Upon the entry of the United States into the First World War, Clark rejoined the military at the rank of major in the Inspector-General Corps in May 1917 and for the next two years exploited his command of the French language as a liaison officer between the American and French forces. In June of 1919 Sterling and Francine married at the local town hall in a civil ceremony, and the next day Francine became an American citizen. That spring and summer, Clark was among a handful of American collectors to make purchases directly out of the Degas atelier sales, which had surpassed all expectations in attracting enormous crowds and high prices.[13] With Roland Knoedler bidding on his behalf, he acquired three drawings in the

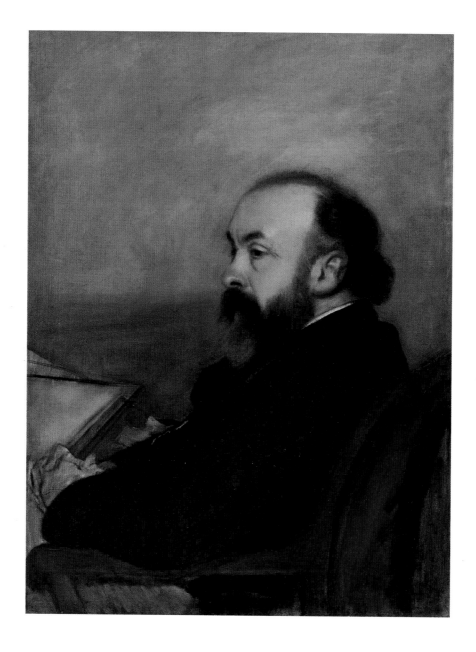

third sale, including a pair of late bather studies executed in charcoal on yellow tracing paper. At this early date the taste for this type of drawing was not widespread and Clark's selection of these studies was, for him, so advanced as to be almost out of character. To these works he added eleven more drawings and his first painting by Edgar Degas, *Portrait of a Man* (fig. 11), from the fourth sale held in July 1919.

With the end of the war and the start of a new decade, Clark had reason to look back on his Paris years with feelings of both accomplishment and relief. He had

published a book on his China expedition; renovated and furnished a fine house to his own exacting specifications; fallen in love with and married a beautiful French actress; immersed himself in French culture; saw his financial assets grow back home; built a remarkable art collection; served his country for the second time in the Allied forces' victory over Germany; and escaped a world war without suffering losses to either his family or his property. In a very real sense, Clark was a changed man. While he remained technically an American citizen, he had become a Parisian. The

experience of living abroad during the war, and of finding himself in a position of defending not only his country but his personal effects and his new extended family, had a profound effect on his world outlook, as well as his sense of personal comfort and well-being. Clark had entered the decade a loner, an independent-minded adventurer with unbridled energy and big plans to conquer the world, if only as an explorer. The war placed him on the defensive, forcing him to adjust his priorities. Never one to fall into a rut, at the age of forty-two Clark decided that it was time to get out of Paris for at least part of the year and establish a presence in New York.

NEW YORK CITY AND THE GROWTH OF THE COLLECTION

As France began the slow process of rebuilding its damaged infrastructure and digging out of debt, New York entered a vibrant new age of prominence and prosperity, and the Clarks made a decision to set up a part-time residence there. In June 1920, Sterling and Francine disembarked together for the first time in New York. Within a year they had settled in a luxurious eighteen-room apartment at 300 Park Avenue and East Forty-ninth Street, the present site of the Waldorf–Astoria Hotel. At the same time Sterling began buying parcels of farmland in Bowerstown, a small community southeast of Cooperstown, where he would spend much time consumed in his passion for riding, training, and breeding horses. Now that he had a new apartment to furnish in New York City, Clark's collecting activities picked up, although he continued to export certain of his major acquisitions to install among his primary collection in Paris. One of the realities of collecting in the 1920s was the escalation in prices that applied not only to Old Master paintings but also to the work of modern and even contemporary artists. Faced with this more challenging and expensive marketplace, Clark altered his pattern of collecting. He slowly retreated from the pre-eighteenth-century works that he had favored in the teens and bought increasingly in New York, which had become the center of the global art market.

Although until the outbreak of World War II the Clarks' pictures moved frequently between their New York and Paris homes, rarely did the couple lend to exhibitions, and then only when strongly encouraged to do so by dealers, like Knoedler, with whom they had a significant relationship. In these instances, Clark refused to have his name associated with the loans, and he became known in certain circles as "Mr. Anonymous." Sterling Clark's reluctance to lend was based in part on his general disdain for art historians, but even more on a desire to stay out of the public eye. This reticence distinguishes him from his American contemporaries like Barnes, Duncan Phillips, and even his brother, Stephen, who allowed their names to be publicized along with works in their collections.

Sterling's relationship with his brother Stephen became strained during the early 1920s and broke down completely in 1923. The root cause of the conflict was the distribution of the family trusts related to shares and interests in the Singer Manufacturing Company. Sterling grew increasingly angry at the way the trusts were organized—Francine and his stepdaughter Viviane were excluded from inheriting Sterling's stock—and at Stephen's refusal to modify the trusts to address this issue. One morning in June 1923 at the New York offices of the Clark Estates, Sterling's dissatisfaction with the state of affairs boiled over, and a verbal confrontation between the brothers over the issue of breaking the Singer Trusts escalated into physical violence. So began a family feud that would divide the family for the next three decades. The brothers broke off all direct communication, relying on attorneys and other third parties to relay messages. The differences, it would seem, were irreconcilable.

In the aftermath of the break with his brother, Clark reconsidered the scheme to establish an art museum in either Cooperstown or New York City. No firm plans had been drawn up, but the conversations that he had with Stephen on this topic must have echoed in his mind as he began to sift through the terms of his father's will and to contemplate his

own mortality. Of great concern to him was the possibility that his assets might fall into the hands of his brothers. On the eve of sailing from New York to Paris in the spring of 1924, he signed a new will specifying that in the event that he and Francine should die together, his Paris house and art collection should be donated to the Petit Palais and the rest of his estate to Viviane.[14] Clark's choice of the Petit Palais is especially interesting, as it suggests his continuing attachment to the French capital even as he spent less time there. Established in 1902 as the "Palais des Beaux-Arts de la Ville de Paris," the Petit Palais had distinguished itself as a lively art institution with a dynamic exhibition program. Clark must have felt that his collection would maintain its identity and stand out among the eclectic holdings of the Petit Palais, which consisted of some 20,000 works spanning Egyptian and Greek sculpture, medieval ivories, Renaissance jewels, eighteenth-century furniture, seventeenth- and eighteenth-century prints, drawings, and paintings,[15] as well as notable works by Millet, Courbet, Gauguin, Pissarro, Sisley, and Moreau.

At the same time that he was becoming increasingly aware of the importance of maintaining the unity of his collection, Clark began a decided shift in his collecting strategies from serious Old Master purchases toward French Impressionism and academic and genre painting of the late nineteenth century. In October of 1923 Clark wrote of his disappointment in the selection of Old Masters at Knoedler's New York gallery declaring that "they have not been able to buy many good pictures. Stock low. And they could sell if they had them. There is no doubt about it the old master is a thing of the past. The big American collections like Frick, Widener, Taft, Altman, Huntington have absorbed most of the available ones."[16] Illustrating Clark's growing interest in nineteenth-century painting are his purchases in 1924, which included paintings by Giovanni Boldini, Jean-Louis Forain, and Edgar Degas. As in so many aspects of life, Clark bucked the trend of collectors like Frick and Widener who started out buying Salon pictures and moved on to Old Masters.

The global depression that began with the American stock market crash in 1929 did little to curtail Clark's leisure pursuits, either in the realm of art collecting or horse breeding. This latter interest led him to open up stud farms in both Normandy and Virginia, and while he would never spend much time in Normandy, his horse farm in Virginia became his primary escape from city life. Although he fretted about the heavy tax burden imposed under the New Deal and railed against the economic policies of President Roosevelt, the Depression turned into the collecting opportunity of a lifetime for Clark.

Taking advantage of the dip in art prices caused by the economic downslide, Clark dramatically increased the pace of his acquisitions. Many collectors were hurt by the crash and began to liquidate their holdings, flooding the market with quality paintings at discount prices. Clark bought J. M. W. Turner's *Rockets and Blue Lights* (fig. 12) in 1932 from Charles M. Schwab, who was forced to sell it at half of what he had been offered during the "boom period."[17] In 1933 alone Clark bought a dozen paintings from Durand-Ruel in New York, and five more from Knoedler in New York and Paris, including major works by Monet and Pissarro.

It was during this period that Clark began seriously cultivating a passion for the paintings of Renoir. While he had been collecting Renoir's work since the teens, and already owned such iconic pictures as *A Box at the Theater (At the Concert)* (cat. 14) and *Sleeping Girl* (cat. 15), between 1930 and 1940 he would acquire no fewer than twenty pictures by the artist. What is perhaps more phenomenal than the number of paintings is their consistently high quality. From the bravura brushwork of *Marie-Thérèse Durand-Ruel Sewing* (cat. 23) (acquired in 1935) to the sheer intensity of the c. 1875 *Self-Portrait* (cat. 5) (acquired in 1939), each work stands out as a superb example of the artist's craft.

Renoir was undoubtedly Clark's favorite painter from the 1930s on. One can follow this growing passion in Clark's increasingly effusive praise for the artist in his diaries. In an almost lyrical entry from 1939, Clark writes:

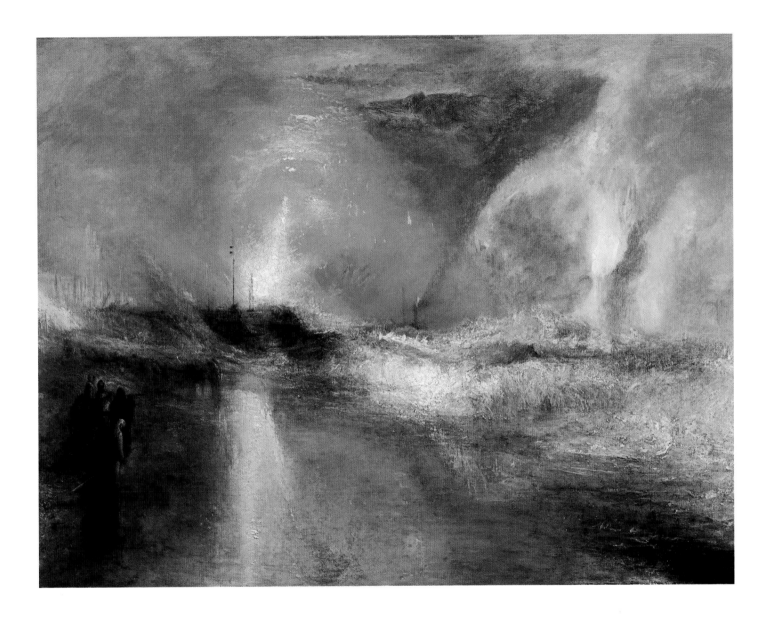

What a great master!!!! Perhaps the greatest that ever
lived— certainly among the first 10 or 12—And so
varied—Never the same in subject, color, or com-
position both in figures, portraits and landscape!!!!—
As a colorist never equaled by anyone—No one so
far as we know ever had an eye as sensitive to har-
mony of color!!!! . . . And his greys are as fine as Ve-
lasquez & his reds as fine as Rubens—His flesh both
dark and light as fine as Rubens or the Venetians—
the only thing the Venetians, the Primitives, the
people like Velasquez and Van Dyck were superior
in line, the suave line like Leonardo, Ingres, Degas,
Bouguereau etc. but Renoir could draw & his best
pictures are good in line—But as a painter I do claim
he has never been surpassed—As a colorist he has
never been equaled.[18]

Passages such as this one make it clear that Clark
not only viewed Renoir as a great Impressionist
painter, but saw his work as a continuation of the Old
Masters.

Clark's collection of Renoirs also highlights his
tenacity in acquiring only the paintings in which
he saw quality. While collectors such as Barnes
bought paintings by Renoir almost by the truckload
and sometimes seemingly without discretion, Clark
was very careful about the paintings he bought. His
overwhelming tendency was toward Renoir's work of
the 1870s and early 1880s, particularly the artist's por-
trayals of young women, although he collected still

lifes and landscapes as well. Despite the contemporary fashion for Renoir's later works, Clark did not care for them, once deridingly referring to the "'sausage' bloody Renoirs of the late period,"[19] and later describing the artist's later figures as "limbs filled with air."[20] In the end, while Clark amassed neither the largest collection of Renoir's paintings (Barnes owned 181) nor the most important work (Duncan Phillips, who purchased *Luncheon of the Boating Party* in 1923, had that distinction), his highly personal eye for paint and subject matter, and his con-

viction in his own judgments, turned Clark into one of the greatest private collectors of the French Impressionist's work.

Although Sterling was the primary force behind the growing collection of art, he highly valued Francine's opinion, and often vetted purchases through her. There were times, however, when Francine assumed a more active role in acquisitions. The clearest example of this concerns the purchase of Henri de Tolouse-Lautrec's *Jane Avril* (fig. 13). Sterling first saw the picture in 1939 at Wildenstein, unaccompanied

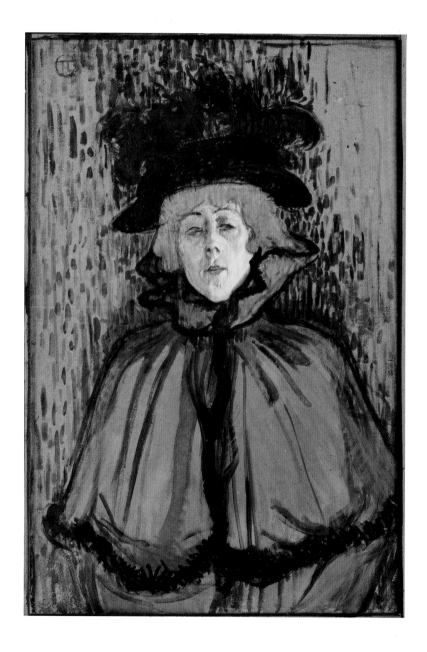

FIG. 13
Henri de Toulouse-Lautrec
(French, 1864–1901),
Jane Avril, c. 1891–92.
Oil on cardboard, mounted
on panel, 63.2 x 42.2 cm.
Sterling and Francine
Clark Art Institute,
Williamstown,
Massachusetts (1955.566)

by Francine. He was shown it again in late Januuary 1940, when he noted its "excellent quality" but also remarked that he considered the asking price double its actual worth.[21] Nine days later, while visiting Wildenstein with Francine, the painting was brought out again, and Francine reacted immediately. Sterling still felt the price was too high, but upon leaving the shop Francine pressed him to make the purchase. He recalled in his diary that "we got as far as the corner— F. very strong for buying the 'Jeanne Avril'—a Chef d'oeuvre she said—we returned & said we would like it."[22] Evidently, such strong advice from Francine was rare as the episode caused Sterling to comment: "Never saw Francine more enthusiastic about a picture!"[23]

In addition to amassing an excellent collection of "blue chip" artists like Renoir and Sargent, Clark built up a large collection of nineteenth-century cabinet paintings by such lesser-known figures as Jean-Louis-Ernest Meissonier, Alfred Stevens, Giovanni Boldini, and Raimundo de Madrazo y Garreta. In contrast to the Impressionists, who represented the vanguard in their day, this group of artists painted for a broader audience, relying on anecdotal subject matter handled in a slick manner. Clark also admired the highly finished and larger-scale paintings by forgotten academicians like Jean-Léon Gérôme (fig. 14) and William-Adolphe Bouguereau, but acquired their works in much smaller quantities. In his taste for these unseen painters, whose works hung in the storerooms of French and American museums alike, Clark may not have been alone but was in very small company.

OUTBREAK OF WORLD WAR II: PLANNING FOR THE FUTURE

Clark's strong bond with dealers grew from years of patronage and in-depth conversations. But it was a very small circle of dealers, like George Davey of Knoedler and Herbert Elfers of Durand-Ruel, whom Clark trusted with intimate knowledge of the scope of his collection and with whom he could share his views

FIG. 15

William-Adolphe
Bouguereau
(French, 1825–1873),
Nymphs and Satyr, 1873.
Oil on canvas,
260 x 180 cm.
Sterling and Francine
Clark Art Institute,
Williamstown,
Massachusetts (1955.658)

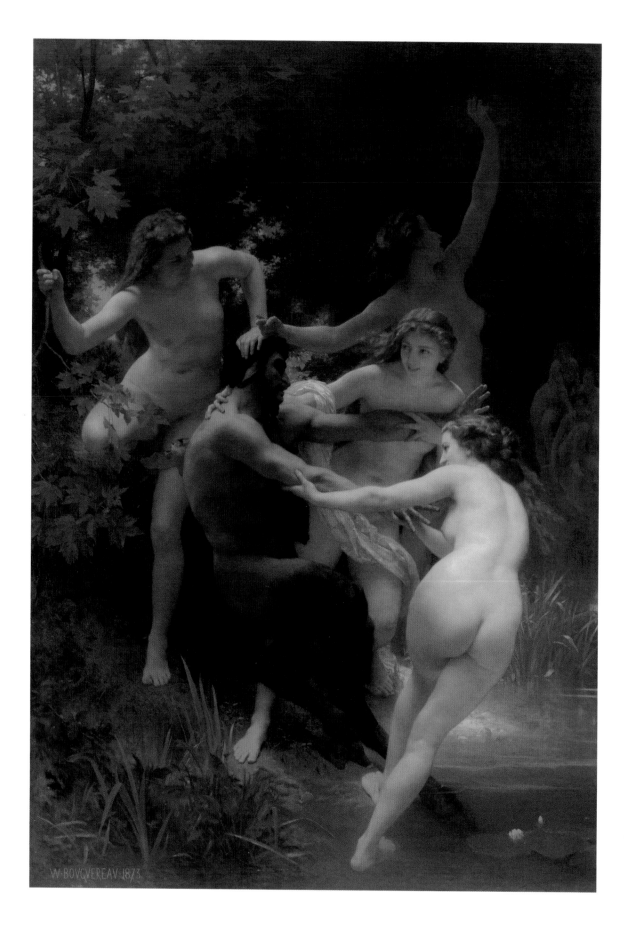

on art. These dealer friends rallied to Clark's aid when the anticipation of war forced him to evacuate his collection from Paris. Davey handled most of the arrangements from France starting in the summer of 1938. The first pictures to go were the Renoirs, including the *Blonde Bather* (cat. 21) and *Sleeping Girl*. By the year's end, all of the most important paintings had been packed and shipped by ocean liner to a warehouse in Montreal.[24] The next summer, the paintings in the Clarks' New York apartment and their "reserves" at Durand-Ruel and Manhattan Storage were transferred to a secure storage facility in the mountains near Denver, Colorado, that Clark shared with the gallery. The bulk of the collection remained in Montreal and Denver for nearly a decade, during which time the Clarks made several trips to see their objects. Even after the war, the Clarks maintained a group of paintings in Montreal.[25]

In the summer of 1939 the Clarks paid their final visit to France prior to the war. As the normally sleepy month of August wore on, the atmosphere in Paris grew increasingly tense, and soon the Clarks found themselves again in a war zone. Sterling filled his days packing his most valuable silver and porcelain objects, which he arranged to store at the Musée de Sèvres, and took inventories of his books and other possessions. Although most of the important pictures had already been shipped to Canada, there were numerous preparations to be made at the farm in Normandy and the house on the rue Cimarosa. On 11 August, Clark wrote in his diary, "What times with the cursed airplanes & the terrible material destruction ahead of us all of so many beautiful things!!!! — It made me sad to think of how much has left the house — Collections of 30 odd years — No rest for the weary."[26]

On 3 September, when England and France declared war on Germany, the Clarks were still in Paris. Walking on the terrace of the Trocadéro, they took in its sweeping panorama of the French capital. They noted how the view had been altered by signs marking bomb shelters dotting the cityscape.[27] The next day they were fitted for gas masks, and when the sirens wailed in the middle of the night, they found themselves huddled in an air-raid shelter in a cellar on the avenue Kléber with a group of their neighbors. With some difficulty, they finally booked a passage back to New York. After their departure on the third of October, seven years would elapse before their return to Paris.

Wary of crossing the Atlantic in wartime, Clark made his final order of business prior to embarking for New York to update his will. With the situation in Paris looking grim, he made the decision to leave all of his collections to the city of Richmond, Virginia, in the event that he and Francine should die together.[28] The choice of Richmond at this date is an interesting one. Although Clark did not specify the Virginia Museum of Fine Arts, it was the only art museum in the city, having opened to the public just three years earlier, and was actively seeking collectors like Clark to pledge gifts that would enhance its modest holdings. The museum's core collection consisted of some fifty Old Master paintings donated to the state by John Barton Payne, a prominent judge and secretary of the Interior under President Wilson. No evidence has yet been found that the museum was specifically aware of Clark or made a direct appeal to him, but rather he may have arrived at this decision through his own knowledge of Richmond's ambitions. From his point of view, the Virginia Museum of Fine Arts would have made an excellent site for his art collection for the same reasons that had led him to select the Petit Palais in 1924; in the context of its relatively small and eclectic permanent collection, Clark's potential donation would have stood out as the museum's main attraction.

The Clarks spent the war years shuttling back and forth between an apartment in the old Ritz-Carlton Hotel in New York and their Virginia farm, while their art collection remained divided among Paris, Montreal, and Denver. An unusual and historic event, however, occurred at Chrichton Brothers in New York during the first week of June 1940. Peter Guille, a dealer in fine silver who had become friendly with the Clarks, convinced the couple to mount an exhibition of their silver collection. Sterling had been acquiring silver at a rapid

pace throughout the 1930s but, like the bulk of their other collections, it was mostly sitting in storage. This would be the first public exhibition of any aspect of the couple's collections.

The exhibition opened with a dollar admission charge as a benefit for the English and French relief organizations. A reviewer in *The Connoisseur* raved:

> A private collection of silver, chiefly English in origin, which an anonymous owner generously permitted to be shown in a benefit exhibition in June at the galleries of Peter Guille, is without doubt one of the finest to be brought together in America, and as its existence has been known to comparatively few, the showing of the collection constituted an event of outstanding importance.[29]

The Clarks seem to have been delighted with the outcome, as it gave them the first opportunity to see their own objects installed all together.

In the beginning of 1944, Clark began seriously considering creating a museum of his own. It is clear from the beginning that the Frick Collection on the corner of Fifth Avenue and East Seventieth Street was his primary inspiration. On Clark's first visit in 1939 he recorded his general enthusiasm for the institution:

> What a collection of very fine things—with some 25 percent subtracted a collection of chefs-d'oeuvre!!!! And even the exceptions not bad—The false Rembrandt bought when Frick would not speak to Carstairs & the Pieter de Hoogh false both labeled "School of"—Some English portraits overcleaned by Duveen—Two out of 4 Whistlers terribly dark and these are about all to find fault with—But what real masterpieces the 2 Rembrandts, the Goya "Forge," the Wonderful Fragonard of Grasse, the Van Dycks etc. etc.!!!! I forgot the Velasquez & the 2 Greco's!!!![30]

Clark's attorneys and business associates began to make discrete inquiries on his behalf and arranged tours of several Manhattan townhouses. Clark's most important consideration was to find a building with a large façade that received a generous amount of unobstructed sunlight. Eventually he redirected his attention to a plot two blocks away on the corner of Seventy-second Street and Park Avenue, and instructed his lawyer to make an offer, which was accepted.[31]

In the midst of his search for a place to house his collection, Clark made the fortuitous acquaintance of Chester Dale, and found him to be a sympathetic collector with informed opinions concerning estate planning and bequests to museums.[32] Like Clark, he was an outwardly gruff personality who spoke his mind in no uncertain terms. Unlike Clark, Dale was a benefactor of a number of major museums and had placed portions of his collection on long-term loan to the Art Institute of Chicago and Philadelphia Museum of Art, prior to moving them to the newly opened National Gallery of Art in Washington.

When they met at Durand-Ruel's, the two collectors bonded immediately. After dinner, they left the others and stole down to the third floor, where Clark's great Bouguereau *Nymphs and Satyr* (fig. 15) was installed in a private gallery. He had acquired the painting in 1943 and had exhibited it at Durand-Ruel's, anonymously, to raise money for the Free French Relief Committee. Dale himself owned three large decorative panels by Bouguereau, and the two hard-nosed collectors got lost in a discussion of the artist's supreme craftsmanship until they were discovered by Durand-Ruel and ushered back to the party upstairs.

After bonding over Bouguereau, Clark and Dale extended reciprocal invitations to each other's New York apartments. During the course of their budding friendship, Dale discussed his unhappy experiences attempting to find a permanent home for his collection at the Metropolitan Museum of Art and Columbia University, neither of which could meet his terms. The National Gallery was more receptive and agreed to show his paintings as an inviolable collection in a suite of four galleries. "Chester said his pictures were his children & he had wanted them settled before his death—Urged me to take similar steps,"[33] Clark noted with great interest. After this conversation, he pushed his attorneys to move forward and contact the lawyers of the Frick Foundation to obtain information on founding his private museum in New York.[34]

Clark's passion for "high Impressionism" was unabated during the war years, but the supply of important masterpieces had been disrupted. Among the few ad-

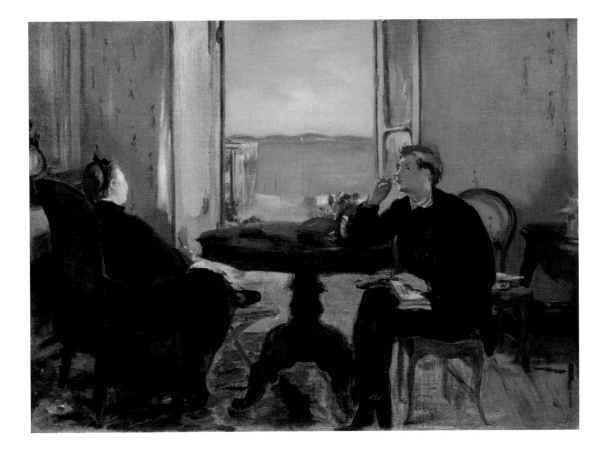

FIG. 16
Édouard Manet
(French, 1832–1883),
Interior at Arcachon, 1871.
Oil on canvas, 39.2 x 54 cm.
Sterling and Francine Clark
Art Institute, Williamstown,
Massachusetts (1955.552)

ditions were Pissarro's *Road to Versailles at Louveciennes* and Manet's *Interior at Arcachon* (fig. 16). Clark also continued to add to his collection of Renoirs, acquiring eight paintings during the war. Two of his Renoir purchases during the 1940s were particularly gratifying to Clark and reveal the tenacity with which he scoured the art market. In 1939, he had been shown a Renoir still life of white roses at Wildenstein's and regretted letting it slip through his fingers. He spent the next three years looking for a still life of comparable quality until one day Charles Henschel of Knoedler showed him *Peonies* (cat. 16). Clark was delighted with the picture and the successful conclusion to his search, describing it as a "really fine picture."[35] Another triumph for Clark came with the acquisition of the *Thérèse Berard* (cat. 10), this time for more personal reasons. Sterling knew that the picture was consigned to Durand-Ruel by his brother Stephen, and reveled in taking the "treasure" out of his brother's collection. How much the picture's provenance contributed to his declaration that the picture was

"one of the best portraits I have ever seen by Renoir" is arguable, but it nevertheless stood out in Sterling's mind as a painting of the finest quality.[36]

In preparation for his first trip abroad since 1939, Clark once again met with his attorneys to draw up a new will, which would be the first and only document to spell out his plans to establish a museum in New York City. Clark's 1946 will provided for the creation of a non-profit institution called the R. Sterling Clark Collection "for the purpose of establishing and maintaining a gallery of art and of encouraging and developing the study of the fine arts and advancing the general knowledge of kindred subjects; such gallery of art to be a public gallery to which the entire public shall always have access."[37]

The will goes into some detail concerning the potential uses of the endowment fund. The trustees were empowered to apply it to the construction, upkeep, and expansion of the physical facility, as well as "the acquisition of other suitable works of art to form part of such gallery of art, and the maintenance of a non-profit school

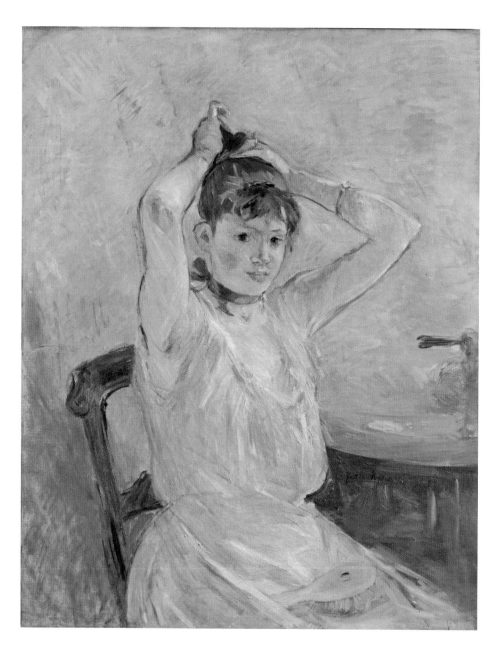

from unforeseen causes, and that none of them be sold, exchanged or otherwise disposed of; also that in the acquisition of additional property, they be guided by my desire to restrict additional acquisition to works of artists who have died twenty-five years or more prior to such acquisition and to the best works of such artists.[38]

The restriction on buying works by artists dead for more than a quarter of a century was based on the same limitation originally imposed at the National Gallery of Art in Washington, and was clearly meant to keep out the painters of the School of Paris who Clark felt were overrated and overpriced.

AFTER THE WAR: PARIS AND NEW YORK

In 1946, the Clarks returned to France for the first time in seven years. The Normandy farm had been bombarded by Allied forces and was a total loss. The Paris house at 4 rue Cimarosa was, however, remarkably intact. The homecoming was marked with relief as well as sadness, for the couple had decided that the time had come to close their beloved Paris house.

Returning to New York, the Clarks moved into a larger apartment in the Carlton House that could accommodate the furnishings from Paris.[39] As the painting collection began to emerge from storage, they had the pleasure of reacquainting themselves with works that they had not lived with for years. They created a new "galleria" to replace their grand painting salon on the rue Cimarosa. The pace of new acquisitions slowed considerably with an average of only three to four new paintings entering the collection each year from 1948 through the mid-1950s. While the quantity dropped, the quality remained higher than ever; among these late acquisitions was a remarkable number of major additions to the paintings collection, including Morisot's *The Bath* (fig. 17), Remington's *Friends or Foes? (The Scout)*, and Toulouse-Lautrec's *Waiting*.

or schools for the study of the fine arts and kindred subjects." The stated guidelines for collection care and acquisitions give insight into Clark's own views of conservation and his criteria for adding to his collection:

> It having been my object in making said collection to acquire only works of the best quality of the artists represented, which were not damaged or distorted by the work of the restorers, it is my wish and desire and I request, the said Trustees . . . permanently maintain in said gallery all works of art bequeathed hereunder in the condition in which they shall be at my death without any so-called restoration, cleaning or other work thereon, except in case of damage

Throughout these last years, the nature of Clark's collecting changed, as he imagined his objects installed in multiple galleries large enough to present his entire collection. He was determined to add works of quality that would both build on the strengths of the existing collection, and, if possible, fill gaps. It is important to note that none of these acquisitions represented a compromise in Clark's taste. He still bought only what he liked. In the spring of 1951, he paid a visit to Knoedler and purchased his final Renoir, *Apples in a Dish* (cat. 26). Just a few months earlier he had acquired another Impressionist still life from Knoedler, *Apples and Grapes in a Basket* (fig. 18) by Alfred Sisley, an artist he had only come to admire during the 1940s. The Sisley was still in Clark's storeroom at the gallery when he was shown the Renoir, and it seems likely that he saw the two pictures as complementing each other.

In 1950 the Clarks learned that the Ritz-Carlton, where they had been living since 1934 had been sold to make way for an office building, so they moved their residence to 740 Park Avenue. The Clarks were attracted to the apartment largely because it reminded them of the layout of their Paris home and had ceilings tall enough to hang their enormous Bouguereau.

As they settled in their new surroundings, Clark, evidently pleased in his new abode, wrote:

> The new apartment is a real 'galleria.' . . . Believe it or not 3 Géromes, 2 Claude Monets, a Pissarro, a Mary Cassatt, a Ziem, a Madrazo, a Sisley, 4 Renoirs in the same room go quite well together. And in Francine's bedroom 2 Stevens . . . 2 Corots, a Manet, a Sargent, and 2 Renoirs look extremely well together.[40]

While this somewhat eclectic arrangement pleased Clark, it comprised only a portion of the over 200 paintings that eventually hung in the apartment.

WILLIAMSTOWN: STERLING CLARK'S LEGACY

As he entered his seventies, Clark decided that the time had come to move forward with his museum, so that he could actively participate in creating the institution, rather than handing it down to his executors. Although he owned a plot of land in Manhattan that had been earmarked for this purpose, he had grown increasingly

FIG. 18
Alfred Sisley
(English, active in France,
1839–1899),
*Apples and Grapes
in a Basket*, c. 1880–81.
Oil on canvas, 46 x 61 cm.
Sterling and Francine
Clark Art Institute,
Williamstown,
Massachusetts (1955.543)

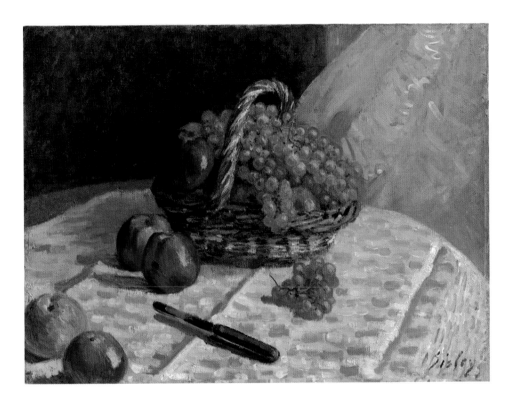

concerned about modern methods of warfare that had radically changed the threat to civilians since his early days fighting the Boxers in China. Clark had spent the First World War in France, assisting the Allies and protecting his own property. Less than twenty years later, he found himself caught in France during the outbreak of World War II and was forced to secure his irreplaceable collection in advance of the Nazi invasion. He considered himself a lucky man that the allied bombing of his French farm caused his only real losses. But these experiences had instilled in Clark a sense of anxiety. More than any other American collector of his generation, he had experienced the ravages of war firsthand.

Having miraculously safeguarded his collections through two world wars, Clark had reason to be concerned. If and when World War III broke out, he felt that New York City would be a primary target. What he needed was a small New England village a safe distance, but reachable, from New York. Cooperstown was now out of the question as a potential site for his museum. The Clark family had earlier ties to Williams College, his grandfather's alma mater. Both his grandfather, Edward Clark, and his father, Alfred Corning Clark, had been trustees, and the family had erected a building on campus called Clark Hall. These ties, however, may not have been Sterling Clark's primary attraction to Williamstown, Massachusetts. After some forty years of imagining a home for his works of art in such far-flung locales as Cooperstown, Paris, Richmond, and New York City, the final resting place for the collection, and the collector, would be a site not on the radar, and that is precisely what Clark found so appealing.

Clark's plan was nothing more than an idea until late 1948, when his attorney contacted William Sidley, a Chicago lawyer and alumnus of Williams College, and mentioned that he had a client who was searching for a home for his art collection.[41] The college administration and its savvy art professors lost no time in pursuing this lead, and in January 1949, retired professor Karl Weston and his successor (and former student) S. Lane Faison, Jr., traveled to New York to meet the Clarks and view their collection. What they found astonished them, and the duo returned to the Berkshires with the thrilling prospect that an extraordinary and virtually unknown collection might be destined for their community.

After this meeting, the pace accelerated toward the founding of the museum. The warm personal relationships that developed between Sterling Clark and both Karl Weston and J. Phinney Baxter, president of Williams College, were crucial to the plan moving forward. The Clarks paid their first visit to Williamstown in the fall of 1949, and by February 1950 a suitable site was identified. In April the "Robert Sterling Clark Art Institute" was officially incorporated as a charitable and educational organization. The original charter clearly stated the Clarks' intentions that the museum would be much more than a treasure house to showcase their art collection, but would serve as an educational institution promoting the study of the fine arts. Williamstown offered a bucolic setting not unlike Cooperstown, where Clark had first imagined building an art museum, but with the added benefit of a prestigious college at its doorstep. After developing a rapport with members of its administration, Clark recognized that his museum could only benefit from its proximity to Williams College.

During the course of 1950–51, Clark rejected two different architectural firms, and the project was at a standstill. Clark's demands for a modestly scaled, classically organized building with natural light were finally met when Daniel Perry, an architect introduced to Clark by Guille, submitted his preliminary plans in December 1951. Clark took Perry to see the Frick Collection, which he admired for the domestic scale of the gallery spaces, something he wanted to emulate, but found its ornamentation excessive. Perry worked diligently to understand and meet the approval of his demanding client.

Site work commenced in late 1952, and in August 1953, a simple ceremony was held marking the laying of the cornerstone (fig. 19). A month later, the name of the institution was changed to include Francine's name as well. Clark himself wrote: "It is a particular gratification to me that the Institute . . . bears not only

1 Van Dyck; 1 Goya; 1 Gilbert Stuart; 1 Gains-borough; 1 Carolus-Durand; 1 Claude Lorrain; Perhaps Renoir "Fournaise"—The Degas portrait; these last simply to show a representative lot of men's portraits by good artists.[44]

The eclecticism of this selection echoes the installations that Clark had made in his own residences. Most surprising was the emphasis on American art and French Academic painting and the relative scarcity of Impressionism in the opening display; while only a single Renoir was included, seven Homers and three Gérômes were placed on view. The decision to hold back what would certainly be the most crowd-pleasing portion of the collection was a calculated one on the part of the founder. Writing to Charles Durand-Ruel of the first installation, "I think you would be surprised to see how well the Gérômes look among much more expensive pictures—I am keeping the Renoirs & Impressionist pictures for later on—I expect the critics will give me the works! But I also expect I shall be amused."[45]

Francine Clark cut the ribbon on opening day, 17 May 1955, before an invited crowd of sixty. Just two galleries were unveiled, containing thirty-three paintings, seven sculptures, and an assortment of silver. At the time of the opening, the museum building included a suite of rooms that the Clarks intended to use as a private apartment when they were visiting Williamstown, and this ended up becoming Sterling Clark's final permanent home. They stayed in the Berkshires to greet the many friends who came through to see the new museum, and in September, Clark suffered a stroke and remained hospitalized for four months. He spent the last year of his life in his museum, tended by Francine and a professional nurse. He was present for the second summer season and the opening of the large Impressionist gallery in the fall of 1956, which at last revealed his extraordinary

my name but also that of Mrs. Clark. Her constant enthusiasm for the Institute's objectives, her participation in the accumulation of the collections which the Institute will house and her contributions to the planning of the project, make the new name wholly appropriate."[42] Sterling had always called Francine his "touchstone" in judging pictures, and now the world would know her role in forming the collection.

Construction of the museum took nearly two years at a cost of just under $3 million.[43] The Clarks monitored the progress, and as the building neared completion in the spring of 1955, they began the complex process of moving their collection from their New York apartment, their storeroom at Knoedler, and the storage facility in Montreal that they had retained since the war. Peter Guille was the founders' choice to be the first director, although in the selection and arrangement of the inaugural installations, Clark maintained control. In correspondence with Herbert Elfers dating from March 1955, just two months prior to the opening, he described his participation:

> We have just returned from 6 days in Williamstown. We hung 19 pictures & expect to have in all about 30—6 or 7 Winslow Homers; 2 Sargents; 2 Remingtons; 2 Inness; 1 Mary Cassatt; 1 Puvis de Chavannes; 3 Gérômes; 1 Dagnan-Bouveret; 1 Chartran (Calvé); 1 Ruysdael; 1 Troyon; 1 Géricault;

A BASEMENTFUL OF BEAUTIES

Clark Art Institute unveils a prize portion of its rich hidden trove

collection of Renoirs, an event that garnered national coverage in the press (fig. 20).

It was in his temple of art, surrounded by his treasures, that Sterling Clark died on 29 December 1956. A private funeral service was held in the museum's central gallery, with his remarkable collection of paintings by Renoir providing an idyllic backdrop. In his final years he had seen his prize thoroughbred, Never Say Die, win the prestigious Epsom Derby, and had created a fine museum to house his cherished collections. If he had any regrets, he kept them to himself. Clark's cremated remains were interred in a marble vault beneath the front steps of the museum.

Francine Clark continued to sit on the museum's board until her own death in April 1960. Correspondence reveals that she asserted her opinions on the arrangement of paintings in the galleries, looking to maintain her husband's wishes.[46] She also supported the appointment in 1958 of the museum's first curator, William Collins, formerly of Knoedler in London and New York, who was put in charge of prints and draw-

ings. Under Collins's guidance, the Clarks' large collection of works on paper, still stored in the portfolios that had been kept at Knoedler's for many years, was inventoried and organized, and a gallery for changing exhibitions of prints and drawings was inaugurated.

In creating the Sterling and Francine Clark Art Institute, the founders established an institution with a unique personality, one that reflected a true labor of love. Acquiring remarkable works in a variety of media—paintings, sculptures, drawings, prints, silver, porcelain, and books—was more than a hobby for the Clarks: it was a joint project through which they bonded over the course of nearly fifty years. With both of their names carved in the lintel, and their tombs beneath the front steps, the museum in Williamstown marked the end of their long adventure together, many miles from their families, but with their "children."

In the half century that followed, the Clark has evolved into an institute with an expansive mission that reaches well beyond the limits of the small New England town in which it is situated. Sterling Clark did not intend

Catalogue

JOHN HOUSE

Portrait of a Young Woman (L'Ingénue)
c. 1874

Oil on canvas
55.7 x 46.4 cm
Signed upper right:
Renoir.
1955.606

A bust-length image of a fashionably dressed young woman is set against an open-air background; her eyes look to her left, her right hand is raised to her breast, and the index finger of her left hand is poised beneath her lips. The background is almost entirely undefined, treated as little more than a backdrop of broadly brushed soft greens and blues; its very lack of definition, however, suggests that we should view the setting as open countryside, and perhaps as a hillside rather than as a cultivated park or garden.

The figure is treated with great fluency. For the most part, the paint layers are thin and broadly brushed, but denser virtuoso dabs of color suggest her neck-scarf and bonnet, and a finer and more delicate touch defines the focal points of the composition: her face and raised left hand. Her hair seems to be golden-blonde, but it is treated with a wide range of colors—greens and blues as well as reds, oranges, and yellows—that suggests its curls and textures wholly without recourse to detail. The warm hues of her skin and hair are framed by the cool blues and greens that dominate the remainder of the picture, while the deep blue of her eyes and the red of her lips provide central pivots to the whole composition. The handling of the figure is very comparable to *La Parisienne* (National Museum of Wales, Cardiff), the full-length figure that Renoir exhibited at the first Impressionist group exhibition in 1874; this suggests that the present picture should be dated to c. 1874, rather than its traditional dating of c. 1876.

In subject, format, and treatment, the picture relates to French eighteenth-century genre painting. The fluent brushwork has evident affinities with the work of Jean-Honoré Fragonard, and especially with his freely brushed female half-lengths such as *A Young Girl Reading* (National Gallery of Art, Washington); the body language of the figure is closer to the work of Jean-Baptiste Greuze. It seems that Sterling Clark recognized this

affinity with the eighteenth century; after buying the picture in 1940, he wrote in his diary: "I may have paid a bit high & of that I am not so sure but it surely is a 'Fancy Picture' as Scott says!!!! And always saleable."[1]

As Renoir would have known well, nineteenth-century commentators regarded the whole body as a vehicle for the expression of moods and emotions. In this context, the hand gestures and directed gaze of this figure, combined with the outdoor setting, would immediately have invited some form of anecdotal or sentimental reading. The position of her hands hints at nervousness or uncertainty, while her attention, apparently focused on something outside the field of the picture, suggests the possibility of an encounter or an assignation. As always in Renoir's genre paintings of the 1870s, however, there is no specific clue that allows the viewer to posit a single reading for the image.

The interpretation of the picture has been complicated by the titles that it has been given. When first exhibited publicly in the retrospective of Renoir's work at the Salon d'Automne in 1904, it bore the neutral title *Portrait de jeune femme*,[2] and it is this title that is preferred here. It was published by Théodore Duret in 1906 as *Jeune parisienne*,[3] and then appeared in the Viau sale in 1907 as *L'Ingénue*, a title that has stuck with the picture in more recent years. The earliest traced naming of the canvas, in Paul Alexis's 1887 inventory of the collection of Eugène Murer, the painting's first owner, is more informal, listing it as "*Blondinette, l'ingénue, la femme au doigt*" (Little blonde girl, the ingénue, the woman with the finger).[4]

It seems very likely that Alexis's text was the origin of the *L'Ingénue* title. However, all the evidence that we have suggests that this is not a title that Renoir would have sanctioned. There is no indication that he ever gave such evocative, even sentimental, titles to any of his works; they seem, rather, to have been applied to paintings in order to help them sell. Responding to the title

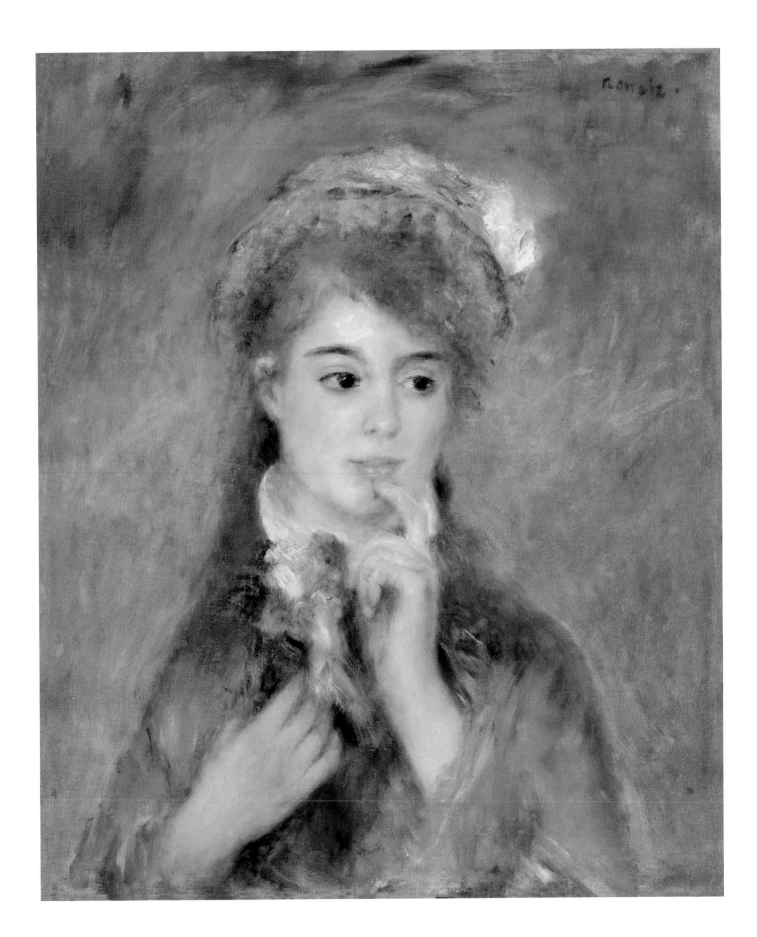

La Pensée that was given in an auction sale to a similar canvas showing a young woman with her finger to her lips (Barber Institute, Birmingham), Renoir commented: "I was horrified when they baptized one of my canvases 'la Pensée'";[5] repeating the story to Jean Renoir, he commented: "Those picture-dealing scoundrels know perfectly well that the public is sentimental. They stuck a blasted title on my poor girl, who can do no more about it than I can. They called her *La Pensée*. . . . *My* models don't think at all."[6] The changing titles of that canvas are particularly revealing. It appeared as *La Pensée* in the Doria sale in Paris in 1899 but was then loaned by its next owner, Jules Strauss, to the 1900 Exposition Universelle with the neutral title *Portrait*; at the Strauss sale in 1902, however, it appeared once again as *La Pensée*; the "sentimental" title recurred precisely when the picture was for sale.

It seems likely that the model for the present canvas was the actress Henriette Henriot (born Marie Henriette Grossin, 1857–1944), who modeled for Renoir very frequently during the mid-1870s. Though identification of his models is notoriously difficult, as a result of his tendency to make all his female figures look alike, the close resemblance that the canvas bears to the face in *La Parisienne*, for which Henriot modeled, makes the identification plausible. As Colin Bailey has shown, Henriot was only beginning to establish a career at the time Renoir was closest to her; she was briefly celebrated as a leading actress in the productions of André Antoine from 1889 onward but left the stage after her daughter Jane was killed in a fire at the Comédie-Française in 1900.[7]

Eugène Murer (1841–1906), the first owner of the painting, was one of the more unusual early collectors of Impressionist paintings. Proprietor of a pastry-cook's shop in Paris, he also published a number of novels in the "naturalist" mode; after retiring to live at Auvers-sur-Oise in 1881, he also began to paint.[8] Around 1877, Renoir painted portraits of Murer (Metropolitan Museum of Art, New York) and his son Paul, and two of his half-sister Marie Meunier; Murer and Meunier were also painted by Camille Pissarro.

PROVENANCE

Eugène Murer, Paris (before 1887; d. 1906); George Viau, Paris; his sale, Durand-Ruel, Paris, 4 March 1907, no. 61, sold to Bernheim-Jeune; [Bernheim-Jeune, Paris]; [Paul Rosenberg, Paris]; Jacob Goldschmidt, Berlin; Alphonse Kann, Paris (by 1911; until at least 1926); J. Horace Harding, New York (d. 1929); Charles B. Harding, New York, his son, by inheritance (1929–until at least 1937); [Carroll Carstairs, New York; sold to Clark, 28 Nov. 1940]; Robert Sterling Clark (1940–55); Sterling and Francine Clark Art Institute, 1955.

REFERENCES

Vollard 1918, vol. 1, no. 385; Meier-Graefe 1929, p. 96, fig. 77; Daulte 1971, no. 225; Williamstown 1996, pp. 19, 24, 48, ill. p. 47; Dauberville 2007, no. 336.

NOTES

1 RSC Diary, 16 Dec. 1940.
2 Despite this neutral title, the painting can be firmly identified as no. 6 in the Renoir display at the 1904 Salon d'Automne through a reference in the 1907 Viau sale catalogue (Durand-Ruel 1907, no. 61); it also appears in an installation photograph of the 1904 display.
3 Duret 1906, p. 139.
4 (Paul Alexis) Trublot, "À minuit. La collection Murer" *Le Cri du people*, 21 Oct. 1887, reprinted in Gachet 1956, p. 171.
5 André 1928, p. 32: "On m'a fait prendre en horreur une de mes toiles en la baptisant 'la Pensée.'"
6 Renoir 1962, p. 66.
7 See Ottawa 1997, pp. 134–36, 284–85, where further details of her career are recorded.
8 On Murer, see Gachet 1956, pp. 145–88; Distel 1990, pp. 207–15; Ottawa 1997, pp. 152–54, 291.

for his museum to function as a glorified mausoleum; indeed, he left a large endowment combined with a liberal charter that has enabled the institution to grow into a world-renowned research center in the field of art history, a place where objects, ideas, and people come together. The unique personality of the Clark is defined not merely by its art collection but by an atmosphere of intellectual vitality that builds upon its founders' vision. ∎

1 Robert Sterling Clark to W. Beach Day, 13 Jan. 1911.

2 Stephen Carlton Clark, unpublished memoir (Private collection, c. 1935), p. 2.

3 For an in-depth discussion of the collecting activities of Alfred Corning Clark and Elizabeth Scriven Clark, see Michael Conforti, "The Clark Brothers: An Introduction," in Williamstown 2006, pp. 7–23.

4 Douglas Johnston to RSC, 21 June 1911. The paintings are as follows: Jean-François Millet's *The Water Carrier* (Sterling and Francine Clark Art Institute, 1955.551); an unidentified work by Mariano Fortuny y Carbó; Gilbert Stuart's *George Washington* (fig. 5) (Sterling and Francine Clark Art Institute, 1955.16); an unidentified work by George Inness; and Julian Walbridge Rix's *Road Through the Woods* (location unknown).

5 The bronze is in the collection of the Clark. The Perroneau pastel was sold by Clark at an unknown date.

6 Soon after buying the Bellini, however, Clark became dissatisfied with the painting's seriously compromised state and traded it back to the dealer, who eventually sold it to the Boston collector Isabella Stewart Gardner.

7 Robert Sterling Clark to Stephen Carlton Clark, 4 Feb. 1913.

8 Ibid.

9 Stephen Carlton Clark to Robert Sterling Clark, 26 Feb. 1913.

10 Robert Sterling Clark to Stephen Carlton Clark, 12 Aug. 1913.

11 Scott & Fowles dealer's file, Sterling and Francine Clark Art Institute Archives.

12 McBride 1937, p. 60.

13 Atlanta 2000, pp. 27, 30. Gardner bought eight drawings in four lots from the fourth sale through her agent Fernand Robert. Paul Sachs was in attendance for at least one of the sales, but did not make any purchases; see Cambridge 1965, p. 10.

14 RSC Diary, 4 and 10 Mar. 1924. No copy of the will of 1924 has been found.

15 Lapauze 1910; Juliette Laffon, "Avant-propos," in Laffon 1981, vol. 1, pp. 7–10.

16 RSC Diary, 2 Oct. 1924.

17 Robert Sterling Clark to George H. Davey, 13 Jan. 1933.

18 RSC Diary, 21 Jan. 1939.

19 RSC Diary, 21 May 1937.

20 RSC Diary, 22 Jan. 1942.

21 RSC Diary, 25 Jan. 1940.

22 RSC Diary, 3 Feb. 1940.

23 Ibid.

24 Clark's TFR-500 form, a census of his property in foreign countries filed with the U.S. Treasury Department in November 1943, itemizes the works in his collection that remained in Paris, as well as the objects stored in Montreal. A copy is in the archives of the Sterling and Francine Clark Art Institute.

25 An inventory dated 15 July 1955, shortly after the opening of the museum in Williamstown, lists forty-three paintings still in Montreal, including Ghirlandaio's *Portrait of a Lady* (fig. 7), Monet's *Tulip Fields at Sassenheim*, and Renoir's *Portrait of Madame Monet (Madame Claude Monet Reading)* (cat. 2).

26 RSC Diary, 11 Aug. 1939.

27 RSC Diary, 3 Sept. 1939.

28 RSC Diary, 19 Sept. 1939.

29 Comstock 1940, p. 72.

30 RSC Diary, 23 Apr. 1939.

31 The plot was located at 754–56 Park Avenue on the southwest corner of East Seventy Second Street, and contained three four- and five-story dwellings. Clark kept the site until 1950, when he turned it over to a developer. The sale was reported in *New York Times* 1950.

32 RSC Diary, 28 Sept. 1945.

33 Ibid.

34 RSC Diary, 7 Nov. 1945.

35 RSC Diary, 31 Jan. 1942.

36 RSC Diary, 27 Nov. 1945. Why Stephen decided to sell the picture is not clear, although according to Sterling, "Francine I think gave the true explanation—young girl reminded him too much of Betsy, his daughter, who died a few months ago! But Mlle. Berard does not look like Betsy."

37 RSC Will, dated 12 July 1946, Sterling and Francine Clark Art Institute Archives.

38 Ibid.

39 Robert Sterling Clark to Paul L. Clemens, 20 and 23 Apr. 1947.

40 Robert Sterling Clark to Clemens, 28 Apr. 1950.

41 See Conforti 2001, p. 16.

42 Sterling and Francine Clark Art Institute, Report of President for Fiscal Year Ending February 28, 1954, p. 2, Sterling and Francine Clark Art Institute Archives.

43 Predictably, Clark did not want the construction costs released to the media. The George A. Fuller Company of New York was hired as the general contractor for the project and submitted an estimate of $2,450,000 on 8 October 1952 based on Daniel Perry's designs; Robert Sterling Clark Art Institute Minutes, vol. 1, Sterling and Francine Clark Art Institute Archives. Land, building, and construction costs indicated in the corporation's balance sheets between 1952 and 1956 amount to approximately $2,917,000.

44 Robert Sterling Clark to Herbert Elfers, 19 Mar. 1955.

45 Robert Sterling Clark to Charles Durand-Ruel, 20 Mar. 1955.

46 See correspondence between Peter Guille and Hugo Kohlmann from Jan. 1957, concerning Francine Clark's objections to moving the Rubens painting *Holy Family Under an Apple Tree* from the "Primitives Gallery" to the "Dutch and Flemish Gallery," Sterling and Francine Clark Art Institute Archives.

An expanded version of this essay was published as "From Paris to Williamstown: Robert Sterling Clark's Life as a Collector," in Williamstown 2006, pp. 35–121. Unless otherwise indicated, original correspondence and diaries are in the archives of the Sterling and Francine Clark Art Institute, Williamstown, Massachusetts.

Repose (Rhode Island School of Design), painted around 1870 and exhibited at the Salon in 1873, in which a female figure, posed by Berthe Morisot, reclines on a sofa, with a Japanese triptych print on the wall behind her. The informality of this pose — indecorous by the standards of contemporary etiquette — is echoed in Renoir's canvas. Another canvas by Manet, *Woman with Fans* of 1873 (Musée d'Orsay, Paris), shows its sitter in a comparably informal attitude, reclining on a sofa, with an elaborate arrangement of Japanese fans behind her, set against a Japanese wall-hanging that depicts a crane. In Manet's canvas, it has been suggested that there is a play on the French word *grue*, also popular slang for a prostitute,[7] but, as Colin Bailey has noted, it seems most implausible that the presence of a bird that may be a crane on the cushion in Renoir's canvas should be viewed in these terms.[8]

The subject of *Portrait of Madame Monet* is on the borderline between portraiture and genre painting. Unlike Manet's *Repose*, it represents a specific individual whose initials were given in its title when it was first exhibited; it appeared with the title *Portrait de Mme M . . .* as no. 20 in the retrospective of Renoir's work at the Salon d'automne in 1904.[9] However, it does not focus on Camille Monet's physiognomy but rather presents her as if caught unawares in her private, domestic space, absorbed in her reading.

The theme of a woman reading carried many associations for viewers at this date. Alongside a rapidly burgeoning market for fiction aimed at women readers, moralists were concerned about the effects of such reading on supposedly impressionable women; the character of Emma Bovary in Gustave Flaubert's *Madame Bovary* of 1857 plays on just these issues. These questions about appropriate reading matter

for women were treated very explicitly in a group of semi-humorous paintings by Auguste Toulmouche. In *Forbidden Fruit*, shown at the 1866 Salon, four young women search eagerly, and evidently illicitly, through the books in a private library, while his two canvases of 1874 and 1875, *The Amusing Book* and *The Serious Book*, contrast one pair of young women who are engaged and amused by a book with another pair who have been lulled to sleep by their reading matter. Renoir's canvas invites no such explicit interpretation, but the decision to present Camille Monet absorbed and seemingly amused by her reading marks out the sitter as belonging to the class of fashionable young women who were a target audience for contemporary publishers of fiction.

PROVENANCE

[Durand-Ruel, Paris, bought from the artist, 25 July 1891]; [Durand-Ruel, New York, until 1933; sold to Clark, 2 Feb. 1933]; Robert Sterling Clark (1933–55); Sterling and Francine Clark Art Institute, 1955.

REFERENCES

Meier-Graefe 1929, p. 57, fig. 35; Daulte 1971, no. 73; Williamstown 1996, p. 35, ill. p. 37; Ottawa 1997, no. 16; Dauberville 2007, no. 364; Distel 2009, pp. 96, 99, fig. 79.

NOTES

1 See Wildenstein 1974–96, vol. 1, pp. 71–72.
2 See House 1986, pp. 47–59; Canberra 2001.
3 See Rivière 1921, p. 58; Vollard 1938, p. 196.
4 See Ottawa 1997, p. 127.
5 Daulte 1971, nos. 77, 78.
6 See Adriani 1999, p. 106; see also Ottawa 1997, p. 281, n. 11.
7 See Reff 1976, pp. 85–86.
8 See Ottawa 1997, pp. 127, 281.
9 It was a convention that the names of female sitters were indicated only by their initials in exhibition catalogues, even if their identity was widely known.

Wash-House Boat at Bas-Meudon

c. 1874

Oil on canvas
50 x 61 cm
Signed lower left: *Renoir.*
1955.610

Wash-House Boat at Bas-Meudon is one of the most experimental and unexpected of Renoir's landscapes of the mid-1870s. It shows the branch of the river Seine that passes below the town of Meudon, about seven miles southwest of Paris. Although the setting appears unspoiled and rural, these wooded riverbanks were sited in the midst of a set of towns on the left bank of the Seine — Meudon, Bellevue, and Sèvres — that were increasingly being absorbed into the larger patterns of work and leisure of the capital. In *Wash-House Boat at Bas-Meudon* we are looking downstream toward Sèvres, with Meudon itself out of sight to the left and one of the islands in the Seine on the right. Meudon was famous as the site of one of Louis XIV's châteaux that had been very recently destroyed by the Germans during the Franco-Prussian War of 1870–71. Its terrace offered one of the most spectacular views over the city, and it had been a key base for the government troops as they prepared to recapture Paris from the Communards in the spring of 1871.[1] Renoir, however, turned his back on both the view and the historical associations of the place, focusing instead on the nondescript boats on the river below; it is the informality of the subject and the unpicturesqueness of the boats that mark out the modernity of the scene.

The central position is occupied by the wash-house boat, used by poorer classes for washing clothes in the river water. Although the open side of the boat, where the clothes were washed, cannot be seen, its shape would have made it readily recognizable by its original viewers as a *lavoir*. No feature is given any special significance by the way in which the subject is treated, however; all forms are lightly and softly brushed, and there is no particular focal point in the composition. The viewer's eye is not given a straightforward path of entry to the scene: we see it from the top of a steep bank (there was no bridge at this point on the river) and scan the view in various ways, either by following the line of the bank from bottom center and swinging in an arc to the left and around the background, or by jumping in irregular movements from boat to boat. The few figures, small and very summarily notated, create no special point of interest. The trees at top left and top right act as frames for the view, but, below them, the inexplicit space at bottom left and the open margin at lower right, where the river flows uninterrupted out of the picture, leave the whole image particularly loosely structured.

The dominant play of color is greens and blues, quite rich in hue, with the very light tone of the off-white canvas priming lending luminosity throughout. The soft, deep reds and purples that appear particularly on the boats, as well as the little red accent on the flag above the wash-house, unobtrusively draw the viewer's attention to the central zone of the picture. The closely integrated harmonies of greens and blues, set off by this sequence of small warm accents, are reminiscent of the color schemes of Jean-Baptiste Camille Corot's later work, though more intense in coloring.

The subject and treatment of the picture make it a quintessential example of the Impressionist landscape. The everyday subject is treated in a way that gives no special significance to anything in it; everything is translated into delicate flecks and strokes of color that convey the painter's immediate visual experience of the scene without any sense of prior knowledge of what is depicted. And yet, by the very choice of subject and treatment, a canvas like this challenged the values for which conventional landscape painting stood in these years, as an expression of the permanent beauties of the French countryside.

The canvas cannot be firmly dated, but its softly brushed surface, thinly worked over an off-white priming whose presence is felt throughout the canvas, can be compared with *La Parisienne* of 1874 (National

Museum of Wales, Cardiff) and with *Portrait of a Young Woman (L'Ingénue)* (see cat. 1). Thus it can plausibly be dated to the summer of 1874.[2]

PROVENANCE

[Possibly Durand-Ruel, Paris]; Anna Thompson (until 1909; sold to Durand-Ruel, 17 Apr. 1909); [Durand-Ruel, New York, 1909–37; sold to Clark, 10 Apr. 1937]; Robert Sterling Clark (1937–55); Sterling and Francine Clark Art Institute, 1955.

REFERENCES

Williamstown 1996, pp. 72, 76, ill. p. 75; Dauberville 2007, no. 132.

NOTES

1 Baedeker 1874, p. 237.
2 A photograph of *Wash-House Boat at Bas-Meudon* appears among the first photographs made in the early 1890s by the dealer Paul Durand-Ruel of paintings in his stock, but the canvas cannot be securely identified with any recorded in the Durand-Ruel stock books.

4

Bridge at Chatou

c. 1875

Oil on canvas
51.1 x 65.4 cm
Signed lower right: *Renoir.*
1955.591

It was in 1875 that Renoir began to paint at the Restaurant Fournaise, located on an island in the Seine alongside the village of Chatou, about nine miles west of Paris. His portraits of the proprietor Alphonse Fournaise (see cat. 7) and his daughter Alphonsine (*Woman Smiling*; Museu de Arte de São Paulo) are both dated 1875, and it seems very likely that *Bridge at Chatou* was painted in the same summer. The canvas represents the village as seen from alongside the Maison Fournaise, with the bridge that then ran across the river just to the north of the Maison and the entrance to the rue de Seine (the present bridge is sited further to the south and the buildings have been destroyed); a late-nineteenth-century photograph confirms this identification.[1]

Writing in 1886, Louis Barron described the river crossing at the Chatou bridge as the transition between Paris's "rough banlieue" and the "civilized countryside"—between the realms of work and recreation, between the factories on the east bank of the river and the "coquettish villas" of Chatou on the west bank.[2] Viewed in these terms, Fournaise's restaurant on the island in the middle of the river could be seen as an emblem of this transition from labor to leisure. Chatou was also a "favorite site, a paradise" for fishermen, even if they caught few fish there;[3] the two figures in the rapidly sketched boat in the center of Renoir's canvas do indeed seem to be fishing. La Grenouillère, one of the most celebrated recreational sites of the surroundings of Paris, painted by both Renoir and Claude Monet, was only a short distance downstream from Chatou. In *Bridge at Chatou*, however, Renoir presents a thoroughly urbanized view of the place, closing off the entire background of the canvas with rows of humdrum buildings and showing no trace of the "artificial paradise" that Barron found there. This is one of the land-

FIG. 4.1

Claude Monet (French, 1840–1926)
The Bridge at Argenteuil, 1874
Oil on canvas, 60 x 79.7 cm
National Gallery of Art, Washington, D.C.
Collection of Mr. and Mrs. Paul Mellon (1983.1.24)

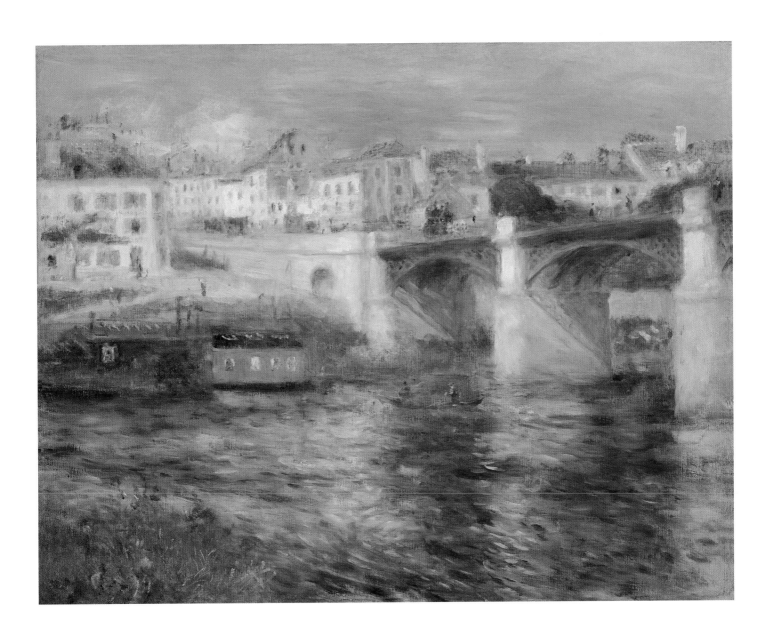

scapes in Renoir's oeuvre where the natural world plays the smallest part.

 Bridge at Chatou is very comparable to the views of the Argenteuil bridge that Monet had painted the previous year (e.g. *Le Pont d'Argenteuil*, Musée d'Orsay, Paris; *The Bridge at Argenteuil* [fig. 4.1]); the resemblance is so close that in this instance Renoir was presumably deliberately following Monet's example. The bridge frames the composition on the right and leads the eye into the pictorial space, while the area of grass at bottom left gives the viewer a visual foothold. The brushwork throughout is lively and variegated, suggesting the diverse textures of the scene. Nevertheless, as so often in his work (see *Venice, the Doge's Palace*, cat. 18), Renoir paid less close attention than Monet to the detailed play of reflections in the water; their forms here do not closely match the positions of the structures above them, but seem, rather, to be arranged in such a way as to maximize the contrast between the reflections and the intense blue of the open water. This distinction between blue and yellow is reiterated in the upper half of the canvas, with the single orange-red building at the far end of the bridge acting as a sort of pivot against which the remainder of the color composition contrasts.

The painting was bought, presumably directly from Renoir, by Ernest Hoschedé, proprietor of a company that made fabrics for women's clothing, and one of the Impressionists' principal supporters in the mid-1870s. At the auction sale following his bankruptcy in 1878, it was bought by another of the pioneer Impressionist collectors, the homeopathic doctor Georges de Bellio, for the derisory sum of 42 francs.[4]

PROVENANCE
Ernest Hoschedé, Paris; his sale, Drouot, Paris, 6 June 1878, no. 74, sold to de Bellio; Georges de Bellio, Paris (1878–94); Victorine and Eugène Donop de Monchy, Paris, de Bellio's daughter and son-in-law, by inheritance (from 1894); Georges Hoentschel, Paris; [Knoedler, Paris; sold to Clark, 13 Oct. 1925]; Robert Sterling Clark (1925–55); Sterling and Francine Clark Art Institute, 1955.

REFERENCES
Williamstown 1996, pp. 55–58, 72, ill. p. 74; London 2007, pp. 166–67, no. 32, ill.; Dauberville 2007, no. 136; Distel 2009, pp. 117–18, fig. 100.

NOTES
1 Musée de l'Ile de France, Sceaux, reproduced in Washington 1996, p. 37; see also the postcards reproduced in Los Angeles 1990, p. 145.
2 Barron 1886, p. 493: "la banlieue fruste," "la campagne civilisée."
3 Joanne 1872, p. 176: "leur lieu de prédilection, leur paradis."
4 See Bodelsen 1968, pp. 339–40.

Self-Portrait

c. 1875

Oil on canvas
39.1 x 31.6 cm
Signed lower right: *Renoir.*
1955.584

Despite its small scale and informal, improvised execution, *Self-Portrait* was one of the seventeen canvases that Renoir exhibited at the second Impressionist group exhibition in April 1876. Émile Porcheron's review of the show makes it clear that it was included, describing a self-portrait by Renoir "painted entirely in hatching";[1] the present canvas is the only one that fits this description. It seems likely that this was the painting displayed with the title *Tête d'homme*.[2] It was among the six works by Renoir loaned to the show by the collector Victor Chocquet, who had first met Renoir and bought his work at the auction sale organized by Renoir and his colleagues in March 1875. Chocquet sold the canvas to another of Renoir's early collectors, the homeopathic doctor Georges de Bellio, probably soon after the exhibition. Renoir himself later gave a perhaps romanticized account of this transaction: "Do you remember that little portrait I did of myself, that paltry sketch that everyone praises nowadays? At the time, I had thrown it in the rubbish bin, but since Chocquet asked me to let him take it, I had to agree, even though I was sorry that it was no better than it was. A few days later, he brought me a thousand francs. Monsieur de Bellio had seen the painting at his house, fallen in love with it, and paid him this enormous sum of money. That's how art lovers were in those days!"[3]

Renoir depicts himself smartly dressed, with a blue-striped starched collar and a dark blue *lavallière* necktie, but the treatment of his face is somewhat at odds with his clothing.[4] His hair, moustache, and beard appear unkempt, and his expression seems alert and even nervous, as he looks past the viewer (unusual for a self-portrait; see, by contrast, cat. 32), his eyes seemingly fixed on something in the distance. The brushwork of the face and hair complements his expression; the crisp, animated strokes of impasto do not model the face in a straightforward way, by fol-

lowing its contours, but suggest the textures of skin and hair with broken, irregular rhythms that convey both his inward alertness and the neglect of personal grooming that many of his friends noted.[5] The face is given added relief by the contrast between its thick paint layers and the very thinly brushed background. Blues and yellows are freely used to suggest the textures of flesh and hair and the play of light, along with the warm flesh tones.

The overall treatment of the painting is quite unlike the softer, gentler handling that Renoir normally deployed in his portraits of both male and female sitters; it would have stood out from the other portraits of men that he exhibited in 1876, notably his canvas depicting Claude Monet at work, holding his palette (Musée d'Orsay, Paris), and is very unlike his roughly contemporary portrait of Alphonse Fournaise (see cat. 7). In some ways, in this one canvas Renoir's treatment of his own face comes closer to Paul Cézanne's recent self-portraits, which evoke the intensity of the painter's vision without self-adornment (see, for example, those in the Musée d'Orsay, Paris, and Phillips Collection, Washington, D.C.). *Self-Portrait* is also conspicuously unlike another canvas that Renoir painted around the same date that has come to be considered as a self-portrait (Fogg Museum, Harvard University Art Museums, Cambridge, Massachusetts). In this unfinished painting depicting an artist seemingly holding his brushes as he turns to look at the viewer, the sitter's facial features are much softer, his eyes larger, and the brushwork far smoother and more supple. This canvas was not recognized as a self-portrait in Renoir's lifetime, and it remains very possible that it represents one of his friends.[6] Comparison with a contemporary photograph of the artist confirms the verisimilitude of the present painting and casts further doubt on the identity of the sitter in the Fogg canvas.

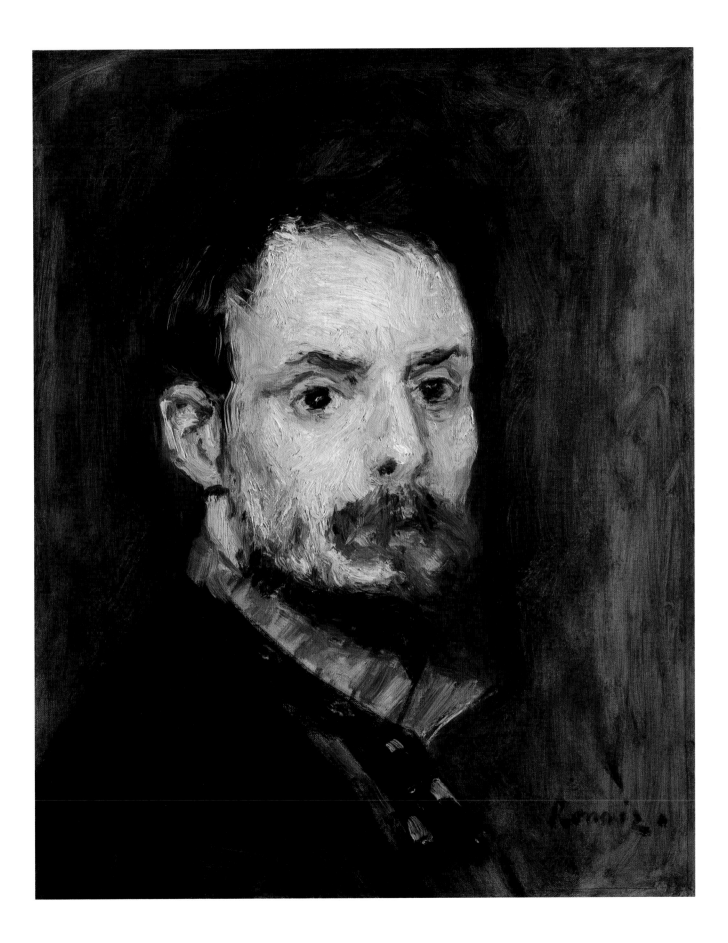

PROVENANCE
Victor Chocquet, Paris, from the artist (in 1876; sold to de Bellio); Georges de Bellio, Paris (1876–d. 1894); Victorine and Eugène Donop de Monchy, Paris, de Bellio's daughter and son-in-law, by inheritance (from 1894); [Paul Rosenberg, Paris, by 1917]; Henry Bernstein, Paris (by 1929–39; sold to Clark, 14 Feb. 1939, with Durand-Ruel, New York, as agent); Robert Sterling Clark (1939–55); Sterling and Francine Clark Art Institute, 1955.

REFERENCES
Vollard 1918, vol. 1, no. 383; Meier-Graefe 1929, p. 85, fig. 58; Daulte 1971, no. 157; Williamstown 1996, pp. 55, 58, ill. p. 56; Ottawa 1997, no. 24; Dauberville 2007, no. 540; Distel 2009, pp. 2, 120, 124, fig. 106.

NOTES
1 Émile Porcheron, "Promenandes d'un flâneur: Les Impression-nistes," *Le Soleil*, 4 Apr. 1876, reprinted in Berson 1996, vol. 1, p. 103: "un portrait de l'auteur tout en hachures."
2 See Ottawa 1997, p. 145.
3 Vollard 1938, pp. 184–85, translated in Ottawa 1997, p. 145.
4 See Ottawa 1997, p. 148.
5 See John House in London 1985, pp. 12–13.
6 For further discussion, concluding that the Fogg canvas should indeed be regarded as a self-portrait, see Ottawa 1997, pp. 148, 289.

6

Girl Crocheting

c. 1875

Oil on canvas
73.5 x 60.3 cm
Signed lower right: *Renoir.*
1955.603

A young woman sits in a domestic interior; she is viewed in near profile, and her attention is focused on her cro-cheting as her figure is brightly lit from a light source—presumably a window—behind her right shoulder. Her long red-blonde hair hangs loose, and she is humbly dressed in a plain skirt and a shift that has slipped from her shoulder, baring her skin to the light. Her dress suggests that we should view her as a servant; the fire-place behind her and the glass and vase placed on it would appear to belong to a bourgeois household.

Images of women sewing were common in French genre painting in these years. Jean-François Millet, among others, had popularized the theme in his images of peasant interiors. Yet the associations of Renoir's canvas are rather different. By placing the figure in a bourgeois interior, Renoir brought the figure emphati-cally within the realm of the art viewer, rather than rele-gating her to the seemingly remote world of the rural peasant. We, the viewers, are invited to imagine that we are observing her unawares within this private space, which heightens the sexual charge of her undress. Yet this seeming informality is carefully staged; the detail

of the chemise slipping from the model's shoulder was a regular topos in mildly eroticized genre painting, notably in the work of Jean-Honoré Fragonard and Jean-Baptiste Greuze, and was repeated, in a more overtly erotic and voyeuristic way, in *Sleeping Girl* (see cat. 15).

It seems likely that the model who posed for *Girl Crocheting* was Nini Lopez, who sat for many of Renoir's paintings in the mid-1870s, including, it seems, *La Loge* (Courtauld Gallery, London).[1] Georges Riv-ière, a close friend of Renoir in these years, noted that Nini modeled for many of his paintings between 1874 and 1880. He commented that she had "an admirable head of golden-blonde hair" and was "the ideal model, punctual, serious, discreet," though finally she disap-pointed her watchful mother by marrying a minor actor.[2] While she was modeling for Renoir, Rivière noted, the artist often depicted her as she sat sewing or reading in the corner of his studio after a formal posing session. It seems likely that *Girl Crocheting* is the result of one of these occasions, though the model here is, of course, posing, just as she is in more formally conceived canvases such as *La Loge*. The treatment

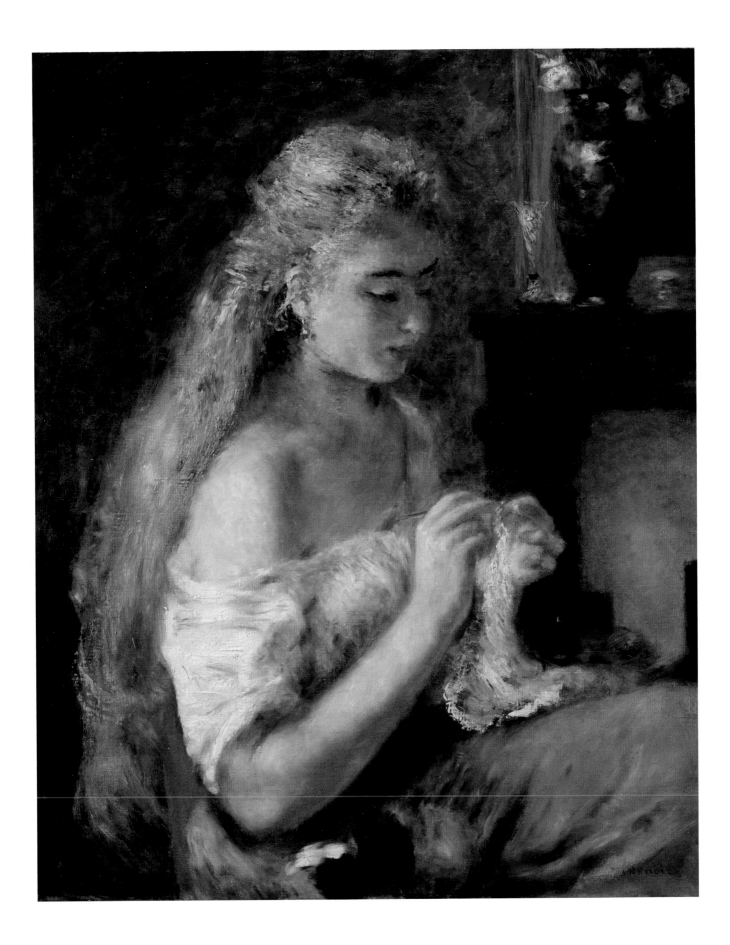

of the figure makes it clear that this is a genre painting, not a portrait, and the fact that the same model posed as a servant here and in a fashionable evening gown in *La Loge* shows that both canvases should be analyzed in terms of the role that the female figure is asked to play, rather than as images of a specific individual. The features of the face, seen in shadow, are relatively generalized, and the focus is instead on the play of light across her shoulder and cheek and on her hair and shift.

The lit flesh is painted with a full impasto, and varied colors—yellows and blues as well as pinks and reds—are introduced in the shadowed areas of her neck; the color in her hair, too, is richly varied, with yellows, oranges, and reds set against some darker hues that suggest the fall of shadow. Rich sweeps of white describe her chemise and the material that she is working, with loosely applied streaks of blue to suggest their folds. The rich impasto can be compared with *Woman Reading (La Liseuse)* (Musée d'Orsay, Paris), another informal study of a half-length female figure painted around the same date, while the complex and very assertive color modulations in the flesh painting are comparable to *Study: Nude in the Sunlight* of 1875 (Musée d'Orsay, Paris), the study of a nude posed outdoors, her skin dappled with the play of sunlight and shadow, for which Nini Lopez may again have posed; this was described by Albert Wolff when it was exhibited in 1876 as "an accumulation of decomposing flesh with patches of green and purple that suggest the state of total putrefaction in a corpse."[3]

The treatment of the figure in *Girl Crocheting*, as in *Woman Reading* and *Study*, marks the extreme point of Renoir's rejection of conventional notions of tonal modeling in favor of forms, lighting, and space suggested by modulations of color. Any conventional sense of contour, too, is abandoned; the figure's margins are suggested by contrasts of color and tone. The

treatment of the face here offers a vivid comparison to *Marie-Thérèse Durand-Ruel Sewing*, a canvas of a similar subject painted about seven years later (see cat. 23), where the silhouette of the face is sharply demarcated from the background.

Girl Crocheting holds a special place in the Clark's collection as the first Renoir Sterling Clark purchased. At the time that Clark bought the canvas in 1916, he was unsure of his commitment to the painting, so much so that he had the dealer sign an agreement to buy back the purchase if Clark was unsatisfied with it. Little did he realize that, rather than return the painting, he would go on to acquire over thirty more paintings by Renoir, eventually describing him as "perhaps the greatest [painter] that ever lived."[4]

PROVENANCE

[Durand-Ruel, New York]; Catholina Lambert, Paterson, New Jersey (by 1896); his sale, American Art Galleries, New York, 22 Feb. 1916, no. 152, bought by Scott and Fowles; [Scott and Fowles, New York; sold to Clark, 16 Dec. 1916]; Robert Sterling Clark (1916–55); Sterling and Francine Clark Art Institute, 1955.

REFERENCES

Daulte 1971, no. 154; Williamstown 1996, pp. 12, 13, 27, 42, 44, 48, ill. p. 43; Dauberville 2007, no. 390; London 2008, pp. 32–33, fig. 17.

NOTES

1 Although Daulte 1971, no. 154 and p. 416, states that Renoir had two models named Nini in these years, the three firsthand accounts of his models in these years mention only one; it seems likely that this was Nini Lopez (see London 2008, p. 32).
2 Rivière 1921, pp. 65–66: "une admirable chevelure d'un blond doré et brillant," "C'était le modèle idéal: ponctuelle, sérieuse, discrète."
3 Albert Wolff, "Le Calendrier parisien," *Le Figaro*, 3 Apr. 1876, reprinted in Berson 1996, vol. 1, p. 110: "un amas de chairs en décomposition avec des taches vertes violacées qui dénotent l'état de complète putréfaction dans un cadavre!"
4 RSC Diary, 21 Jan. 1939.

Père Fournaise

1875

Oil on canvas
56.2 x 47 cm
Signed and dated right
center: *Renoir.75.*
1955.55

Alphonse Fournaise (1823–1905) was the proprietor of a restaurant and boat-rental business on an island in the river Seine at Chatou, nine miles to the west of Paris. Renoir, whose mother lived nearby at Louveciennes, may have frequented the place from the late 1860s onward,[1] and between 1875 and 1881 he set a number of his scenes of riverside recreation and boating at Fournaise's establishment, notably *Luncheon of the Boating Party* of 1880–81 (Phillips Collection, Washington, D.C.). The present portrait of Fournaise of 1875 belongs to the first group of paintings that he executed there, along with a dated portrait of Fournaise's daughter Alphonsine (*Woman Smiling*, Museu de Arte de São Paulo). Ambroise Vollard later recorded that Renoir told him that Fournaise had commissioned these two portraits to thank Renoir for bringing Fournaise many new clients.[2] It seems, too, that his first representation of luncheon on a terrace by the river, *Lunch at the Restaurant Fournaise (The Rowers' Lunch)* (Art Institute of Chicago) dates from this summer;[3] *Bridge at Chatou* (cat. 4), was also presumably painted around the same time.

Here Fournaise is posed, smoking a pipe, his left elbow on a café table, with two glasses of beer in front of him, suggesting that we have caught him in a moment of informal conviviality—a moment that we can, perhaps, imagine that we are sharing with him, though his attention is directed outside the picture, to our left, which might imply that he is in conversation with a third person. Wearing a dark waistcoat over his loose white shirt and a dark cap, he appears in an informal garb, perhaps evoking his role as a boatman, though his cravat is carefully pinned.

As it stands, the composition revolves around the warm flesh tones of Fournaise's face and wrist, enlivened by a few more intense red touches, notably on his lip; the deep blues of his cap and waistcoat (the latter lightly brushed over with soft yellow tones while wet) are set against the whites of his shirt, which is modeled with soft blues and yellows. The left and bottom edges of the canvas that have not been exposed to the light show that originally both the background wall and the foreground table included far more deep purplish red than is now visible in the exposed areas, suggesting that the overall color balance of the picture has changed due to the instability of this particular pigment, probably a lake color.

The brushwork throughout is fluent and informal, parading the improvisatory freedom of the artist's touch, even in the flesh areas where the marks are smaller and finer in texture. Fournaise's eyes are brought to life by a sequence of light flecks of the greatest delicacy. The painterly handling of the picture, together with the sitter's informal pose, seem particularly appropriate for this image of the proprietor of a place for leisure and entertainment.

Renoir's half-length image of a pipe-smoking beer drinker carries clear echoes of *Le Bon Bock* (fig. 7.1), the canvas that had won Édouard Manet real success at the Salon in 1873; this reference is so close that it must have been deliberate on Renoir's part. Beyond this, both canvases look to the precedent of the male figure-studies of Frans Hals. Yet in crucial ways Renoir also differentiated himself from Manet's example. The tonal and color range of the canvas, fresh and luminous, animated by blues and whites, is an overt rejection of the Old-Masterly tonality of Manet's picture. Moreover, Manet presented *Le Bon Bock* as a genre painting rather than a portrait; although his model has been identified, the picture's title shows that he should be viewed as a type, not as an individual. By contrast, Renoir's Fournaise was exhibited explicitly as a portrait in Renoir's one-artist show in Durand-Ruel's gallery in 1883, with the title *Le père Fournaise*—as a depiction of this specific named individual, whose identity and profession would have been known to many of the painting's first viewers.

In conversation with Vollard, Renoir later used the portrait of Fournaise as an example of changing attitudes toward his work: "This canvas, which was then thought to be the height of vulgarity, suddenly became distinguished in its handling when I began to fetch high prices at the auctions at the Hôtel Drouot. The same people who now talk with the greatest conviction about the refined treatment of the portrait of *Père Fournaise* wouldn't have shelled out five louis [one hundred francs] for a portrait, at a time when five louis would have been so useful to me."[4] Presumably this comment was triggered by the fact that the dealer Durand-Ruel paid 11,000 francs for the canvas in 1905, soon after Fournaise's death.

Shortly before buying the canvas from the Durand-Ruel gallery in 1939, Sterling Clark noted in his diary: "A fine picture—I told him [Charles Durand-Ruel] to telephone Francine & ask her to come in and pass on it whether she wanted it or not—no question about its quality—only subject."[5] Sterling's reticence about the subject matter betrays his overwhelming preference for Renoir's portraits of women rather than men. In fact, outside of *Père Fournaise*, the only other male portraits by Renoir that Clark purchased were two self-portraits (see cats. 5 and 32).

PROVENANCE

Alphonse Fournaise, the sitter, Chatou (d. 1905); [Gaston-Alexandre Camentron, Paris, in 1905; sold to Durand-Ruel, Paris, 4 Dec. 1905]; [Durand-Ruel, Paris, from 1905]; [Durand-Ruel, New York, probably by 1934; sold to Clark, 26 June 1939]; Robert Sterling Clark (1939–55); Sterling and Francine Clark Art Institute, 1955.

REFERENCES

Vollard 1918, vol. 1, no. 340; Meier-Graefe 1929, pp. 152n1, 161, fig. 139; Daulte 1971, no. 158; Williamstown 1996, p. 55, ill. p. 59; Ottawa 1997, pp. 140, 286, fig. 157; Dauberville 2007, no. 515.

NOTES

1 Vollard's presentation of his conversations with Renoir juxtaposes his account of his relationship with Fournaise with mention of his painting at nearby La Grenouillère in the late 1860s (Vollard 1938, pp. 164–65); there is no firsthand evidence, however, that he frequented the Maison Fournaise before 1875.

2 Ibid., p. 165; the accuracy of Vollard's account is perhaps called into question by his inaccurate description of the painting itself, as showing Fournaise "in the white vest of a café owner (*limonadier*), drinking his absinthe" (avec sa veste blanche de limonadier et en train de prendre son absinthe).

3 See Washington 1996, p. 37; London 2007, p. 170.

4 Vollard 1938, p. 165: "Cette toile, qui passait pour le comble de la vulgarité, est subitement devenue d'une facture distinguée, lorsque j'ai commencé à faire de gros prix à l'Hôtel Drouot. Et ces mêmes gens qui parlent aujourd'hui avec le plus de conviction de la manière raffinée du portrait du *Père Fournaise* ne se seraient pas fendus de cinq louis pour un portrait, à une époque où cinq louis m'auraient été utiles!"

5 RSC Diary, 13 Jan. 1939.

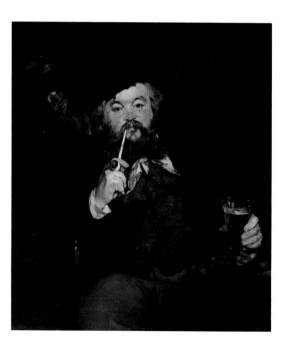

FIG. 7.1

Édouard Manet (French, 1832–1883)
Le Bon Bock, 1873
Oil on canvas, 94.6 x 83.3 cm
Philadelphia Museum of Art.
The Mr. and Mrs. Carroll S. Tyson, Jr.,
Collection, 1963 (1963-116-9)

8

Tama, the Japanese Dog
c. 1876

Oil on canvas
38.3 x 46.2 cm
Signed lower right: *Renoir*.
1955.597

Tama, a Japanese Chin, was brought back to France from Japan in 1873 by the celebrated collector Henri Cernuschi, who traveled through Japan with Renoir's friend and supporter Théodore Duret. Both Édouard Manet, once, and Renoir, twice, painted Tama. In Manet's canvas (National Gallery of Art, Washington, D.C.) the dog is standing, alert and poised above a Japanese doll that lies on the floor—a parody victim of this tiny hunter. By contrast, Renoir on both occasions depicted Tama sitting, in one facing the viewer (private collection) and in the present canvas in half profile, raising a paw in a seeming greeting or appeal to the viewer.

The origins of the Japanese Chin, alternatively known as the Japanese spaniel, remain obscure, but for many centuries it was a favorite breed of the Japanese imperial family. It was introduced into the west in 1853 by Commodore Matthew C. Perry, who brought back a number of dogs from his pioneering voyage to Japan; one pair was sent to the President of the United States but failed to survive the voyage. Chins quickly became fashionable among western dog-loving travelers as a trophy to bring back from Japan. Duret later described how he and Cernuschi had acquired Tama (meaning "jewel" in Japanese) in the town of Kōriyama, between Nara and Osaka; Duret himself commissioned Manet's painting of the dog, while Renoir's was painted for Cernuschi.[1] Not all European visitors to Japan were charmed by the Chin, however; one traveler, Sir Rutherford Alcock, described the dog as "a little pug-nosed, goggle-eyed monster, which has no merit, so far as I know, unless it be its extreme ugliness."[2]

In both Manet's and Renoir's canvases, the dog's name is inscribed in stenciled letters at the top of the canvas, in a form comparable to many sixteenth- and seventeenth-century court portraits (the inscription at top left of Renoir's canvas is now only faintly visible).

This may hint at the breed's imperial origins; however, it may instead refer to the relationship between the Japanese spaniel and the King Charles spaniels painted by Anthony van Dyck for Charles I of England, an affiliation signaled by Duret in his account of the picture.[3] Indeed, the pose of the dog, with its raised paw, can be seen as a witty reprise of the raised front hoof of equestrian portraits such as Van Dyck's images of Charles I.

Renoir set Tama against a loosely brushed background, in soft reds and yellows and deep blues, which may suggest a piece of furniture such as a sofa, rather than a floor covering. Against this, the strong tonal contrasts of the dog's form stand out boldly: a parade of painterly virtuosity conveys the areas of white fur, while the dark areas are made up of a mixture of deep reds and blues rather than pure black. The pink stroke to the right of Tama's neck—probably a ribbon—adds a crucial colored accent that links the animal with the warm hues in the background.

It was presumably this canvas that Renoir had in mind when he talked to his son Jean about the pleasure he had found in painting Pekinese dogs; Jean quoted him saying, "They can be exquisite when they pout."[4]

PROVENANCE
Possibly Théodore Duret, Paris; Paul Roux, Paris; [Knoedler, Paris; sold to Clark, 1 May 1930]; Robert Sterling Clark (1930–55); Sterling and Francine Clark Art Institute, 1955.

REFERENCES
Williamstown 1996, p. 70, ill. p. 71; Ottawa 1997, p. 47n94; Dauberville 2007, no. 53; Distel 2009, p. 17, fig. 8.

NOTES
1 Duret 1924, pp. 61–62. Duret refers to Kōriyama as "Coryama" in his description.
2 Alcock 1863, p. 111.
3 Duret 1924, p. 62.
4 Renoir 1962, p. 67.

9

Girl with a Fan

c. 1879

Oil on canvas
65.4 x 54 cm
Signed lower left: *Renoir.*
1955.595

Girl with a Fan is at the same time one of the most appealing and the strangest of Renoir's paintings of young Parisian women. The figure is placed unusually low in the picture, and the bouquet of chrysanthemums attracts as much attention as the young woman's face. The vase in which the flowers stand and the table below it are scarcely indicated, and the figure is wedged into the foreground; only the scroll-like form to the lower right—presumably the top of a chair—gives some sense of three-dimensional space. Nor can we tell at once what is represented by the bold vertical stripes down the right side.

The model for the picture was, it seems, Jeanne Samary (1857–1890), a celebrated actress at the Comédie-Française who specialized in the roles of servant girls and coquettish soubrettes.[1] Between 1877 and 1880 Samary acted as model for Renoir in around a dozen canvases. Three of these can be classified as portraits, including the elaborate full-length image that Renoir exhibited at the Salon in 1879 (State Hermitage Museum, St. Petersburg); in these, her features more closely resemble her appearance as recorded in contemporary photographs and in portraits by other artists.[2] In the present canvas, by contrast, the face, as we see it, is so generalized in features, so close to Renoir's archetypal image of pretty girlhood, that it is hard to identify the model with confidence. The first recorded owner of the canvas, however, was Samary's husband, Marie-Joseph Paul Lagarde; moreover, the setting closely resembles Samary's dressing room at the Comédie-Française, as depicted in an engraving of c. 1880, whose walls were decorated with bold stripes like those we see down the right side of Renoir's canvas.[3] The distinctive detail of the chair-back at lower right can also be related to the two chairs with striped covers seen in the engraving.

The more generalized treatment of Samary's face in *Girl with a Fan*, together with the fact that it ap-

peared at the Lagarde sale in 1903 with the title *Femme à l'éventail*, shows that the present canvas should be viewed as a genre painting, not a portrait.[4] Presumably Renoir's decision to play down his model's distinctive features implies that this was his intention when he conceived the picture.

The Japanese fan that the figure holds overtly evokes the fashionable vogue for Japanese decorative arts, which had been given a fresh boost by the Paris Exposition Universelle of 1878; the ceiling of Samary's dressing room, in fact, was decorated with similar fans. The composition of the picture may also reflect the impact of Japanese art on Renoir, with its asymmetrical emphases and its strong surface patterning. Although later Renoir claimed to have disliked Japanese art, for a short period between around 1877 and 1880 he seems to have explored such devices, though they were far more significant in the work of his friends Edgar Degas and Claude Monet. Indeed, the composition of the picture also recalls Degas's *Woman with Chrysanthemums*, completed in 1865 (Metropolitan Museum of Art, New York), a canvas that in these years was still in Degas's studio.[5]

Overall, the composition of the picture, with the flowers and face competing for attention and the strangely condensed space, is one of the most self-consciously artful of Renoir's career; it directly contrasts with the centralized pyramidal form of most of his single-figure subjects (see, for example, *Portrait of a Young Woman* [cat. 1] and *Girl Crocheting* [cat. 6]). It seems likely that the arrangement of the canvas was intended in some sense to evoke the artifice of the theatrical world in which Samary was immersed.

The painting is thinly worked, and the white canvas priming lends luminosity to many areas of it. The face is delicately modeled, but its contours are slightly softened, with none of the harshness of contouring that emerged in Renoir's work in the early 1880s.

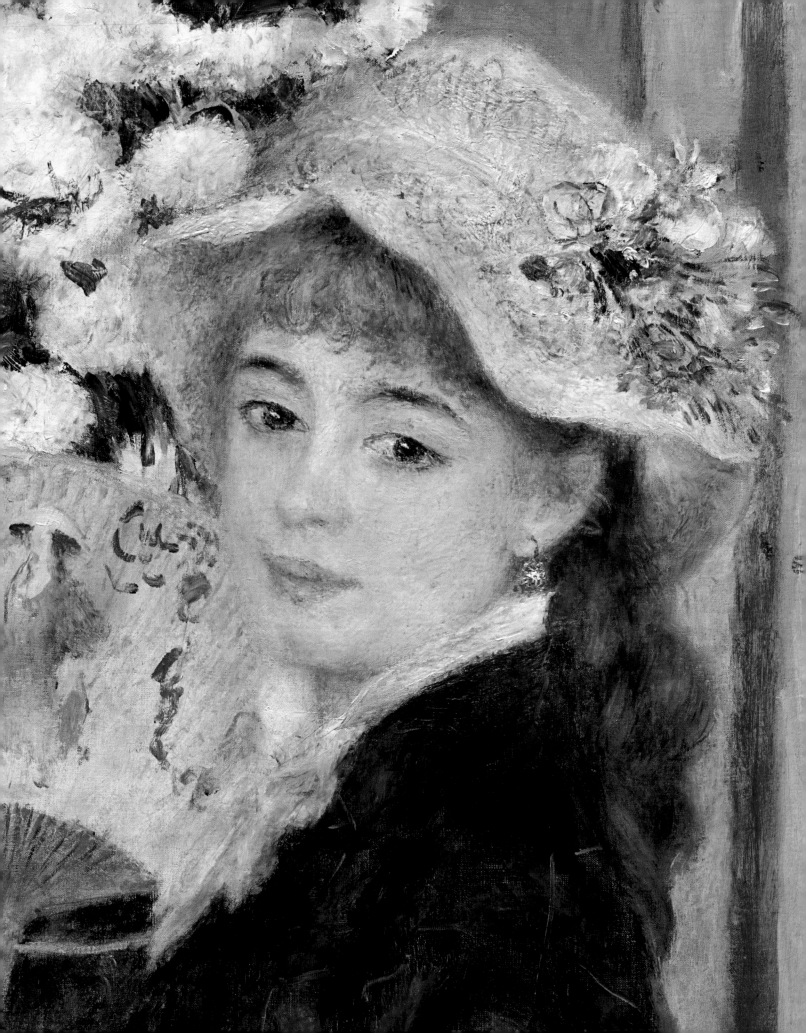

FIG. 9.1

An infrared reflectogram
of *Girl with a Fan* reveals traces
of an erased figure on the right
side of the canvas

how the two figures could have been integrated into a single composition.

Sterling Clark knew the picture for several years before it became available for purchase. He noted in his diary in December 1938: "I have been thinking for some time of the fine Renoir 'Girl with flowers' about 1878 or 1879 which I saw some 3 or 4 years ago at Mme. Coinsé's—Such a fine picture and such a pretty charming girl." A month later, after buying the canvas, he wrote: "I only saw it once about 5 or 6 years ago at Mme. Coinsé's when it was not for sale—I was quite right in buying it from memory. . . . Francine was delighted with it and said I had done right!!!!—It must have been painted between 1878 and 1880—VERY fresh and young in sentiment & a lovely young girl—Miss ____ the stenographer said Charles D-R quite in love with it!!!!"[6]

It is delicately brushed in a way that is comparable to *Thérèse Berard* of 1879 (cat. 10), with fine streaks of paint whose color serves to model it and to suggest the soft shadows; the chrysanthemums are painted far more thinly than the flowers in *Peonies* (cat. 16), probably executed in 1880. The overall sparseness of the impasto and finesse of the brushwork suggests that this canvas, too, was painted in 1879, rather than 1881 as it has generally been dated.

An infrared reflectogram of the painting (fig. 9.1) shows clear traces of an erased figure just over halfway up the right side, to the right of and slightly above the present head, perhaps representing a woman in a high-collared dress looking down at something in her hands. It is impossible to be certain, however, whether this belonged to a first version of the present composition or is the remnant of a previous false start on the canvas; the latter seems more likely, since it is difficult to see

PROVENANCE

[Possibly Durand-Ruel, Paris, in 1883]; Marie-Joseph Paul Lagarde, Paris (d. 1903); sale, Drouot, Paris, 25–27 Mar. 1903, no. 19, sold to Durand-Ruel; [Durand-Ruel, Paris, Mar.–Apr. 1903; sold to Paul Rosenberg, 10 Apr. 1903]; [Paul Rosenberg and Co., Paris, from 1903]; Louis-Alexandre Berthier, prince de Wagram, Paris (in 1913); H. J. Laroche, Paris; Jacques Laroche, Paris (by 1937, until 1938; sold to Durand-Ruel, 20 Dec. 1938); [Durand-Ruel, Paris and New York; sold to Clark the same day, 20 Dec. 1938]; Robert Sterling Clark (1938–55); Sterling and Francine Clark Art Institute, 1955.

REFERENCES

Meier-Graefe 1929, p. 151, fig. 136; Daulte 1971, no. 360; Williamstown 1996, pp. 35, 41, ill. p. 58; Ottawa 1997, pp. 155, 295, fig. 180; Dauberville 2007, no. 344.

NOTES

1 For details of Samary's career, see Ottawa 1997, pp. 155–58, 292–95.
2 See ibid., pp. 294–95, for both photographs and paintings by other artists.
3 Hôtel Drouot 1903, no. 19.
4 This comparison was first made by Eliza E. Rathbone in Washington 1996, p. 47.
5 See Paris 1988, p. 116.
6 RSC Diary, 7 Dec. 1938, 10 Jan. 1939.

Thérèse Berard
1879

Oil on canvas
55.9 x 46.8 cm
Signed and dated upper
right: *Renoir. 79.*
1955.593

In 1879, Renoir stayed for the first time at the Château de Wargemont, to the northeast of Dieppe, with Paul Berard, the Protestant banker who was to become a close friend and one of his principal patrons. As well as executing his first commissions for Berard (see cats. oo and oo) in that year, Renoir also painted the present portrait of Thérèse Berard (1866–1959), daughter of Paul's elder brother, Édouard (1823–1899), who lived at the nearby Château de Graincourt; two years later he painted Thérèse's elder brother, Alfred, standing in a wood, dressed in hunting gear, with a dog and a gun (Philadelphia Museum of Art).

In comparison to his recent work, the portrait of Thérèse is relatively conventional in terms of both conception and execution. As with Renoir's first painting of one of Paul Berard's children, the portrait of the nine-year-old Marthe (Museu de Arte de São Paulo), he perhaps felt constrained when working for a new patron, recognizing, as he put it later, that with a portrait "it's necessary for a mother to recognize her daughter."[1] The thirteen-year-old Thérèse faces us, her eyes demurely lowered, her long hair loose but carefully parted. Much is made of her blouse with its blue bow and elaborate lace collar, but apparently Thérèse used to claim that it was because of this blouse that she had never liked the picture. As her son explained this many years later, "She was still in what we call the ungrateful age; she was wearing a blouse of the type that children wore on their vacations in the country and which she did not find elegant."[2]

The painting is thinly worked over a white priming whose luminosity is felt throughout. Infrared reflectography reveals that the whole image was initially drawn with graphite before Renoir began to paint; this is a further indication of his care in conceiving the work and the conventional means that he used to achieve a likeness. The brushwork is very delicate throughout and largely invisible on the face, defining Thérèse's features with considerable precision but with no sign of the harsher contours that Renoir introduced into his portraiture after his trip to Italy in 1881 (see, for example, *Marie-Thérèse Durand-Ruel Sewing*; cat. 23). The palette is relatively muted, apart from the bold blue on the blouse, but the overall tonality of the picture — the background and the blouse, as well as her hair — has a soft mauve-purple tint, which would have marked the canvas as belonging to the "Impressionist" camp, in contrast to the more somber, brown tone of conventional Salon portraiture.

When Sterling Clark bought the canvas from the Durand-Ruel gallery, it had recently been consigned to the dealer by Sterling's brother Stephen, because, Francine Clark believed, the sitter resembled Stephen's daughter who had recently died; on seeing it, Sterling Clark noted: "It's a real treasure . . . in bluish tones and white mostly — one of the best portraits I have ever seen by Renoir — pleasant subject, alive, beautiful coloring, and well drawn."[3]

PROVENANCE
Édouard Berard, father of the sitter, Paris (from 1879); Thérèse Berard, later Mrs. Albert Thurneyssen, Paris (until 1938; sold to Clark, Sept. 1938); Stephen C. Clark, New York (1938–45; sold to Durand-Ruel, 21 Nov. 1945); Durand-Ruel, New York (1945–46; sold to Robert Sterling Clark, 2 Jan. 1946); Robert Sterling Clark (1946–55); Sterling and Francine Clark Art Institute, 1955.

REFERENCES
Daulte 1971, no. 284; Williamstown 1996, pp. 17, 25, 61–62, 65, ill. p. 63; Ottawa 1997, pp. 38–39, fig. 55; Dauberville 2007, no. 502.

NOTES
1 Blanche 1933, p. 292: "c'est un portrait, il faut que la maman reconnaisse sa fille." For a photograph of Thérèse that suggests that her mother might indeed have been able to recognize her, see Ottawa 1997, p. 39 (fig. 56); on his "prudent" treatment of the portrait of Marthe, see Duret 1924, p. 63.
2 Letter from C. Thurneyssen to Jeanne Berggreen, 20 Apr. 1976, in Sterling and Francine Clark Art Institute Archives, Williamstown, Massachusetts, quoted in Williamstown 1996, p. 62.
3 RSC Diary, 27 Nov. 1945.

Bouquet of Roses
1879

Oil on canvas
83.1 x 63.8 cm
Signed and dated lower
right: *Renoir. 79*
1955.592

Renoir met the protestant banker and diplomat Paul Berard early in 1879 at the salon of his patron Marguérite Charpentier, through the intermediary of their mutual friend Charles Deudon.[1] The two men quickly struck up a friendship, and Berard invited Renoir to spend an extended period with him and his family at the eighteenth-century Château de Wargemont, to the northeast of Dieppe, in the summer of 1879. During this stay, Renoir painted portraits of members of the Berard family and landscapes of the surrounding countryside and coastline, in addition to a sequence of decorations in various rooms of the house.

Bouquet of Roses was painted on a wooden door panel in the library at Wargemont; a very similar panel can be seen in a photograph of the library interior. Renoir also painted two decorative compositions on the paneling in the dining room, representing *Hunting in Summer* and *Hunting in Autumn*, showing the appropriate game for each season, as well as further compositions of flowers in other rooms in the house. Taken together, these provided an effective complement to the architecture of the house—formally closely in tune with its classicizing decor but introducing a distinctively Impressionist range of colors. Renoir's son Jean recorded that these decorations were undertaken almost by accident: "When he had run out of canvas and paper, he painted the doors and the walls, to the great annoyance of the good Mme Berard, who did not share her husband's blind admiration for their guest's painting."[2] This account, however, ignores the great care and planning that went into the decor of Berard's homes; Claude Monet later remembered visiting Berard one morning, seeking to sell him a canvas, when he found him "in his dressing gown having spent the morning arranging the eighteenth-century porcelain, metalwork, miniatures, and curios from his collections that adorned an interior to which he was very deeply attached."[3]

On the gray-painted panel of *Bouquet of Roses*, Renoir added a soft layer of blue beneath much or all of the primary area where the bouquet was to be placed. Traces of this blue can be seen in many parts of the painting; blues are used in addition for a number of leaves set behind the principal part of the bouquet. The flowers and leaves in the bouquet itself are largely depicted using local colors, with red and white flowers set off against green leaves, but the underlying blue retains a significant role, both in heightening the sense of space within the bouquet and as a contrast to the warmer hues of the flowers.

The brushwork throughout is variegated and freely improvised. Certain details are indicated by relatively fine strokes, but much of it is treated broadly and with a full impasto that hints at the three-dimensionality of the central flowers. Yet, beneath this fluent and informal paint surface, the composition of the bouquet is clearly ordered within the panel; the crisscrossing stems at the base anchor the arrangement, and a sequence of unobtrusive diagonals structures the rest of the bouquet.

After buying the panel in 1933, Sterling Clark wrote in his diary, "We looked at my bunch of flowers by Renoir—It is really fine, such a variety of color and so light and airy, just like the French 18th century things."[4]

PROVENANCE
Paul Berard, Wargemont; Mme. Angelot, Paris; [Knoedler, New York (by 1932); sold to Clark, 25 May 1933]; Robert Sterling Clark (1933–55); Sterling and Francine Clark Art Institute, 1955.

REFERENCES
Williamstown 1996, pp. 29, 61, 94, 97, 99, ill. p. 95; Dauberville 2007, no. 9; Distel 2009, pp. 166–68, fig. 151.

NOTES
1 Berard 1939, p. 9; however, in a later article Maurice Berard dated their meeting around 1877. See Berard 1956, p. 239.
2 Renoir 1962, p. 138.
3 Berard 1939, p. 240: "Nous le trouvions en robe de chambre ayant passé sa matinée à ranger des porcelaine du XVIII siècle, des pièces d'orfèvrerie, des miniatures, des bibelots de ses collections qui paraient un intérieur auquel il était attaché de toute son âme."
4 RSC Diary, 6 Oct. 1933.

Study for "Scene from *Tannhäuser*—Third Act"
1879

Oil on canvas
54.8 x 65.7 cm
Signed lower left: *Renoir.*
1955.608

While staying with Paul Berard at Wargemont near Dieppe in 1879, Renoir was introduced to the famous psychiatric doctor Émile Blanche, whose son Jacques-Émile, born in 1861, himself became a celebrated painter. Dr. Blanche commissioned Renoir to paint two decorative panels depicting episodes from Wagner's opera *Tannhäuser* for the family's house in Dieppe, to be installed on a balcony that housed modern casts after the antique.[1] Renoir painted two pairs of canvases for the commission—the second pair apparently because the first was the wrong size. The two scenes represented were, first, Tannhäuser lying in Venus's arms, from the first scene of the opera, and, second, the moment in the final scene when Tannhäuser, who has failed to gain absolution from the pope, seeks to return to Venus's realm but is restrained by his companion Wolfram. The moment depicted is when Venus welcomes his return, just before Elizabeth's prayer stops him in his tracks and begins the process of redemption with which the opera ends.[2] The Clark canvas is a preparatory study for the latter of these scenes, focusing on its primary subject—the interchange between the three figures—without exploring the way in which this might be fitted into the format of the decoration.

Since 1861, when the aborted performances of *Tannhäuser* led to Baudelaire's celebrated essay on Wagner, this opera had been the focus of French debates about the composer and his music. Effectively taboo in the 1870s, after France's defeat in the Franco-Prussian War, Wagner's music remained the focus of admiration among a significant group of art-lovers in France, including Dr. Blanche. Among Renoir's artist associates, Henri Fantin-Latour was Wagner's primary promoter. Fantin-Latour's first Wagnerian painting, *Scene from Tannhäuser*, exhibited at the 1864 Salon, and its related lithograph show the same scene that Renoir depicted in the first of the Blanche decorations. These were followed at the 1877 Salon by more sub-

jects from Wagner, including a new version of the *Tannhäuser* lithograph.[3] Renoir was not himself an enthusiast for Wagner's music, but he had many contacts in Wagnerite circles, and he would presumably have been aware of Fantin's prints before receiving the Blanche commission.

Renoir's visualization of his *Tannhäuser* subjects adopts a somewhat similar approach to Fantin's; his compositions are woven together with animated groups of figures treated with an informality that wholly avoids the static figure groupings and tight draughtsmanship of neoclassical allegorical painting. Beyond this, Renoir's artistic models were primarily from the French eighteenth century, and especially the decorative compositions of François Boucher and Jean-Honoré Fragonard; Jacques-Émile Blanche described the decorations as being "in the Fragonard mode."[4]

In the Clark canvas, the gestures of Tannhäuser and Wolfram are rapidly sketched, evoking in an almost caricaturized way the intensity of Tannhäuser's desire, but the primary focus is on the figure of Venus. Renoir had depicted a modern-life Venus in his Salon exhibit in 1870, *Bather with a Griffon* (Museu de Arte de São Paulo), showing his companion Lise Tréhot in a pose derived from the antique Knidian Venus; but here the figure is far less monumental, her pose more informal, reminiscent of some of the modern-life nude studies that he was making in these years. In the final canvas, the pose of the figure is somewhat more formal and artificial. It is not clear in the Clark painting what the gesture of her raised arms is meant to signify—whether it is meant to suggest welcome or surprise.

The picture is painted on a thick white priming, somewhat unevenly applied with the palette knife over a commercially prepared ground. It is very likely that this second priming was added by Renoir himself; such primings occur in a number of his canvases

in these years, seemingly for the first time in 1879. The priming is felt through the thinner areas of paint, and lends luminosity to the whole composition. The figure is softly brushed, with a light, variegated touch that suggests her form by variations of texture and color but quite without conventional modeling. Its dominantly warm hues are set off against the rich blue that suggests the starlit sky beyond; the somewhat duller color around her head may suggest that its position was modified during the execution of the painting.

PROVENANCE
Possibly Jacques-Émile Blanche, Paris and Dieppe; Eugène Blot, Paris; [Knoedler, New York; sold to Clark, 5 Apr. 1950]; Robert Sterling Clark (1950–55); Sterling and Francine Clark Art Institute, 1955.

REFERENCES
Vollard 1918, vol. 1, no. 49; Daulte 1971, no. 313; Williamstown 1996, pp. 97–99, ill. p. 96; Dauberville 2007, no. 241.

NOTES
1 Blanche 1949, pp. 151–52.
2 See Wagner 1861, pp. 168–71, for the libretto and descriptions of the scenes and settings.
3 See Ottawa 1983, pp. 147–62, 275–88.
4 Blanche 1927, p. 64: "dans le genre de Fragonard."

13

Sunset

1879 or 1881

Oil on canvas
45.7 x 61 cm
Signed lower right: *Renoir*
1955.602

Unlike the other landscapes by Renoir in the Clark collection, *Sunset* is a rapid sketch of a dramatic light effect, rather than a depiction of a specific site; in this, it is unusual in Renoir's oeuvre. The date of *Sunset* is uncertain; it bears some relationship, in tonality and viewpoint, to the far more highly finished canvas *Seascape* (Art Institute of Chicago), dated 1879 and painted during Renoir's first and extended stay with his patron Paul Berard near Dieppe in the summer of 1879. Nevertheless, *Sunset* may well have been executed during one of Renoir's subsequent visits to the Normandy coast in the early 1880s. Indeed, it is very possible that this canvas is the "effect of sunset painted in ten minutes" that Jacques-Émile Blanche mentioned in a letter in July 1881; Blanche's mother saw this as merely "wasting paint."[1]

Sunset invites comparison with Monet's celebrated *Impression, Sunrise* (Musée Marmottan, Paris), whose title led to the naming of the group as Impressionists when it was exhibited at the first group exhibition in 1874. Monet's canvas was shown again at the fourth group exhibition in the spring of 1879, and it is possible that *Sunset*, in some sense, represents Renoir's response to the challenge that Monet's canvas posed. Yet the two

canvases are different in significant ways. Though the effect is misty, Monet's *Impression* depicts an identifiable site, the port of Le Havre, while there is no clue to the location of Renoir's scene. All we can tell is that we are looking out from an elevated point, probably a cliff, and only the little boat gives a sense of scale and an indication of a human presence. Nor is the effect depicted as precise and specific as Monet's image of sunrise. The elevated viewpoint of this canvas and *Seascape* distinguish them from Monet's canvases of breaking waves of the early 1880s, in which the spectator is placed on the beach face-to-face with the sea; only in *The Wave* of 1882 (Dixon Gallery and Gardens, Memphis) did Renoir engage so directly with the forces of the sea.

In Monet's canvas, the play of reflections on the water is closely observed; by contrast, in *Sunset*, the surface of the sea primarily acts as a foil to the light effect in the sky above. There is little close attention to the movement of the water itself; indeed, as in other depictions of water by Renoir, the direction of some of the brushwork—here, the softly diagonal strokes in the lower part of the canvas—seems to work against a sense of the horizontality of the water surface (see also *Bay of Naples,*

Evening [cat. 19]). The sky is rapidly brushed, evidently executed wet-on-wet and very probably at a single sitting; the sea, by contrast, is more heavily worked, with superimposed layers of color, though it does not seem to have been reworked after the first layers had had time to dry. The coherence of the canvas is achieved through color— through the relationship between the boldly juxtaposed swathes of blue, orange, and cream in the sky and the same colors scattered in smaller strokes across the sea below. The boat, though small and treated only in two seemingly casual dabs of darker blue, plays a crucial role as the pivot around which the play of color of the rest of the canvas revolves.

Examination of the margins of the picture that have not been exposed to light indicate that the red pigments, probably red lakes, have faded significantly (see also *Père Fournaise* [cat. 7]); many of the blue tones would have been more purple in hue, and some of the whites more pink. We must imagine that originally the whole canvas would have had a stronger red and purple tinge.

Despite having painted it so sketchily, Renoir signed *Sunset*, thus indicating that he saw it as a canvas that was complete in its own terms. It seems likely that its first owner was Renoir's close friend Edmond Maître, who died in 1898; the Durand-Ruel records indicate that it was purchased from "Madame Maistre" in 1899. If Maître was its first owner, it is a fine example of the type of informal sketch that the Impressionists regarded as suitable for sale or gift to friends but not for sale on the open market.[2]

PROVENANCE

Madame Maistre (until 1899; sold to Durand-Ruel, Paris, 19 May 1899); [Durand-Ruel, Paris, 1899–1921; transferred to New York, 29 Mar. 1921]; [Durand-Ruel, New York, 1921–40; sold to Salz, 20 Sept. 1940]; [Sam Salz, New York, 1940–41; sold to Durand-Ruel, 23 May 1941]; [Durand-Ruel, New York, in 1941; sold to Clark, 22 Sept. 1941]; Robert Sterling Clark (1941–55); Sterling and Francine Clark Art Institute, 1955.

REFERENCES

Williamstown 1996, pp. 81, 83, 106, ill. p. 82, and ill. on back cover.

NOTES

1 Jacques-Émile Blanche to Dr. Émile Blanche, 20 July 1881, in Blanche 1949, p. 445: "effet de soleil couchant en dix minutes"; "gâcher de la peinture."
2 On this in relation to Monet's work, see House 1986, p. 159.

A Box at the Theater (At the Concert)
1880

Oil on canvas
99.4 x 80.7 cm
Signed and dated upper
left: *Renoir. 80*; signed
center left: *Renoir.*
1955.594

A Box at the Theater is the last of Renoir's sequence of ambitious canvases of theater boxes, a sequence that began with *La Loge* (Courtauld Gallery, London), exhibited in the first Impressionist group show in 1874.[1] *A Box at the Theater* was bought by Paul Durand-Ruel from his fellow dealer and associate Dubourg in November 1880; Dubourg had presumably bought it directly from Renoir. It was first exhibited in the seventh Impressionist group show in March 1882 and remained with the Durand-Ruel company until it was sold through William Holston to Sterling Clark in 1928.

This seemingly simple story conceals the complexity of the picture's origins. According to Durand-Ruel, the canvas was initially a portrait of the daughters of Edmond Turquet, then Under-Secretary of State for Fine Arts, but Turquet disliked the canvas and rejected it.[2] This account is complicated by the infrared and X-ray photographic evidence provided by the picture itself (fig. 14.1); in its original state, the canvas included a male figure in the upper-right corner, seen in profile and leaning toward the figure on the left. This may well have been an image of Turquet himself.

It seems very likely that it was after Turquet's rejection of the canvas that Renoir reworked it and sold it as a genre painting. Something similar happened to Renoir's first portrait of Madame Léon Clapisson of 1882. In this case, after it was rejected by the sitter, Renoir reworked it as a genre painting, making the face less specific in its features, and then executed a second, more sober and conventional portrait.[3] In the present instance, the changes were more dramatic. He removed the male figure and completely reworked the background. The X ray shows softly and freely brushed forms across the top left corner of the picture, above and to the left of the head of the left figure, in the area that now shows a pilaster and a hanging curtain; based on the X-ray evidence, it is clearly very possible that in its original state the painting represented a domestic interior, not a theater. Moreover, the X ray shows extensive dried brushwork beneath the right figure that ignores her position and seems to relate to the deleted figure of the man; it seems possible that this female figure was wholly added, together with the bouquet she holds, and that the canvas originally showed only a man and a woman, perhaps Turquet and his daughter or Turquet and his wife. Beyond this, Renoir presumably reworked the left figure to ensure that she was no longer recognizable; she was originally wearing full evening dress, as now, but reworking around her head suggests that her hair was very different or she was wearing some sort of headdress.

A further complexity arises from the various titles by which the present picture has been known. Durand-Ruel purchased it in 1880 as *Une Loge au théâtre*; when it appeared at the 1882 group show, however, it was titled *Une Loge à l'Opéra*. At subsequent exhibitions it has appeared as *Au théâtre* or simply as *La Loge*, giving rise on occasion to confusion with the Courtauld canvas. The picture itself does not clarify this issue; the women are holding a musical score, but the setting is clearly not the Paris Opéra, since the pilaster in the background bears no relationship to the lavish neo-Baroque décor of the Opéra Garnier. Hence its original title is preferred here.

As the picture now stands, there is a clear differentiation between the two figures in terms of dress and body language. The older figure on the left wears a full evening gown and looks confidently out into the viewer's space, holding a music score in her gloved right hand; the younger girl on the right is seen in profile, wearing a simpler white dress, looking downward as if in shyness or modesty, evidently not engaging with the wider space of the theater interior. The sense of her enclosure, in contrast to her companion's expansiveness, is emphasized by the large bouquet of flowers on her lap and also by the somewhat

uncomfortable proximity of her profile to her companion's elbow. There is no communication between the two figures, who seem to be occupying different worlds.

Despite Turquet's rejection of the canvas, it bears the stamp of its origins in its relatively conventional tonality and, in parts, its careful finish. The primary effect of the picture is that it is composed of blacks, whites, and mellow reds. Although soft blues appear in the predominantly white zones in the foreground, the painting as a whole emphatically rejects the atmospheric blue-dominated palette that had characterized Renoir's work over the previous five years. This cannot simply be attributed to the fact that the canvas represents an indoor setting seen in artificial light, since *At the Theatre* of c. 1876 (National Gallery, London) has a strongly blue tonality.

The relatively subdued and conventional tonality of *A Box at the Theater* is reminiscent of Renoir's *Portrait of Madame Georges Charpentier and Her Children* (Metropolitan Museum of Art, New York), the fashionable group portrait that had won him success at the Salon in 1879, and it is possible that initially he hoped that the present canvas could prove an effective

follow-up at the Salon. Instead, and perhaps because Turquet rejected the picture, the interior scene that he sent to the Salon in 1880 was *Sleeping Girl* (cat. 15).

The strong tonal contrasts also give *A Box at the Theater* a clear articulation that *At the Theatre* lacks. The oppositions between the dark hues of the woman's dress and the girl's hair and the light zones are very emphatic, although soft-colored nuances appear in the dress and especially in the long swathe of hair that frames the right side of the composition, which is enlivened by soft blues and purples. Soft color modulations are introduced into the flesh tones, but with far less assertive hues or touch than in his recent work. The comparative finesse of the treatment of the faces and the woman's dress can be contrasted with the broadly brushed area across the foreground. Here, the boundaries between the music score, the girl's dress, and the wrapping of the bouquet are quite unclear.

Since, unlike the Courtauld *Loge*, the canvas does not include the front edge of the box, we must assume that our own position is inside the box in the company of the two women. Although the image does not establish a legible sense of space within the box in which we can imagine the two figures and ourselves to be seated, our apparent position within the box serves to defuse the issues about viewing and being viewed that *La Loge* had raised; we receive the gaze of the woman in black as part of her own social group.

Opinions were markedly divided when the canvas was exhibited in 1882. Significantly, none of them raised the questions of social class and morality that had preoccupied the reviewers of *La Loge* in 1874;[4] rather, their focus was primarily on questions of technique. Armand Sallanches reiterated familiar criticisms in describing as "crudely drawn" this scene "where two elegant women converse about everything except what is taking place on the stage."[5] By contrast, Émile Hennequin

FIG. 14.1

An X ray of *A Box at the Theater* shows that the canvas once included a male figure in the upper-right corner

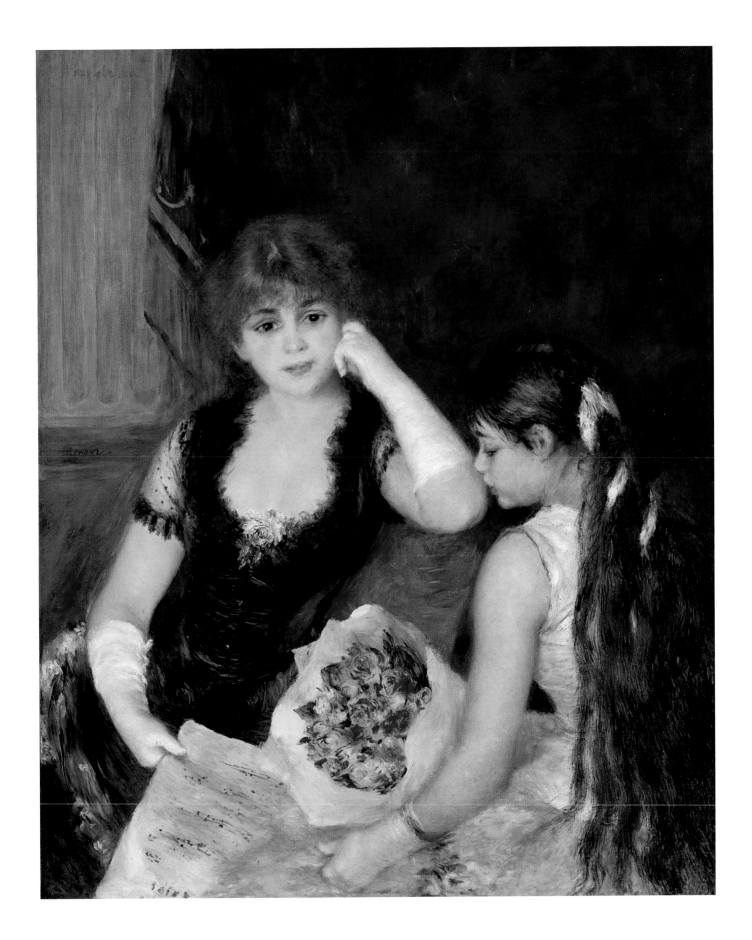

commented, "He is the only [impressionist] who seems to me to paint accurately the colors he sees. His *Box at the Opera* contains a young girl in black whose eyes and smile are deliciously lively." He did, though, recommend Renoir to concentrate on figure painting rather than landscape.[6] Paul Leroi made this contrast explicit: "The good people who, on seeing *A Box at the Opera*, think that he is beginning to see sense, will fall into complete despair [on seeing his views of Venice]."[7] The same contrast, between the incoherence of the Venice views (which included *Grand Canal, Venice* [Museum of Fine Arts, Boston]) and the present canvas was developed at some length by Louis Leroy: "Strangely, the same Renoir exhibits a *Box at the Opera* that would not too greatly displease the philistines. The sweet little faces of the two young girls, their attire, and the color of the ensemble have bourgeois qualities that Impressionism execrates. He should not continue along this path. He would soon quietly start showing signs of common sense, which would be devastating for the official critics of the sect."[8]

PROVENANCE

[Probably Dubourg, Paris; sold to Durand-Ruel, 30 Nov. 1880]; [Durand-Ruel, Paris, from 1880]; [Durand-Ruel, New York, until 1928; on consignment to Holston]; [William H. Holston Galleries, New York; sold to Clark, 28 May 1928]; Robert Sterling Clark (1928–55); Sterling and Francine Clark Art Institute, 1955.

REFERENCES

Vollard 1918, vol. 1, no. 333; Daulte 1970, no. 329; London 1985, no. 51; Williamstown 1996, pp. 11–12, 14, 23, 30, 32, ill. p. 31, and ill. on cover; Ottawa 1997, pp. 18, 186, 309n12; Dauberville 2007, no. 252; London 2008, pp. 21, 28–29, 36–40, no. 11; Distel 2009, pp. 186, 190, fig. 173.

NOTES

1 On *La Loge* and the position of this sequence in Renoir's career, see London 2008.

2 Gimpel 1963, p. 181, recording a conversation with Paul Durand-Ruel in 1920; according to François Daulte, the two figures represent Turquet's wife and daughter, rather than, as Durand-Ruel stated, his two daughters (Daulte 1971, no. 329). Turquet's role in commissioning the painting has been disputed by Colin Bailey (Bailey 2008, p. 342), who questions whether he and Renoir ever met.

3 See Duret 1924, pp. 70–71; London 1985, p. 238.

4 On these reviews, see London 2008, p. 31.

5 Armand Sallanches, *Le Journal des arts*, 3 Mar. 1882, reprinted in Berson 1996, vol. 1, p. 412: "crânement dessinées"; "ou deux élégantes . . . causent de tout autre chose que de ce qui se passé sur la scène."

6 Émile Hennequin, *La Revue littéraire et artistique*, 11 Mar. 1882, reprinted in Berson 1996, vol. 1, p. 393: "Il est le seul [impressionniste] qui me paraisse peindre sans inexactitude les couleurs qu'il voit. Sa *Loge à l'Opéra* contient une jeune fille en noir, dont les yeux et le sourire sont délicieusement vivants."

7 Paul Leroi, *L'Art* 29 (1882): p. 92, reprinted in Berson 1996, vol. 1, p. 401: "Les bonnes gens qui, après avoir vu *Une Loge à l'Opéra*, croyaient à une commencement d'évolution sensée, désespèrent définitivement [on seeing his views of Venice]."

8 Louis Leroy, *Le Charivari*, 17 Mar. 1882, reprinted in Berson 1996, vol. 1, p. 402: "Chose singulière, le même Renoir expose une *Loge à l'Opéra* qui ne déplaît trop aux philistins. Les frimousses des deux jeunes filles, leurs ajustements, la couleur de l'ensemble ont des qualités bourgeoises que l'impressionnisme exècre. Il ne faudrait pas s'attarder dans cette voie. On arriverait tout doucement a avoir le sens commun, ce qui serait désolant pour les critiques autorisés de la secte."

Sleeping Girl
1880

Oil on canvas
120.3 x 91.9 cm
Signed and dated lower
right: *Renoir. 80.*
1955.598

Sleeping Girl was exhibited at the Paris Salon in 1880 with the title *Jeune fille endormie*, together with the still larger canvas *Mussel Fishers at Berneval* (Barnes Foundation, Merion, Pennsylvania). Renoir had returned to the Salon in 1878 and had won considerable attention and success there in 1879 with *Portrait of Madame Georges Charpentier and Her Children* (Metropolitan Museum of Art, New York). His two exhibits in 1880 attracted little attention, however. Émile Zola in his review of the exhibition praised Renoir's decision to exhibit once again at the Salon, but he noted that Renoir's paintings were hung in very unfavorable positions: "His two canvases have been hung in the circular gallery that runs around the garden, and the harsh daylight, the reflected sunlight, do great harm to the pictures, still more so because the painter's palette already deliberately fuses all the colors of the prism into a range of hues that is sometimes very delicate."[1] Zola's true praise, though, was reserved for artists such as Jules Bastien-Lepage rather than Renoir and Monet, who had, he felt, failed to live up to their promise. In the only other traced review that discussed Renoir's canvases, Maurice du Seigneur described them as "the last word in grotesque" and "so bad that to be silent about them would have seemed like cowardice."[2]

Zola only agreed to review the show at the request of Paul Cézanne, who forwarded to him a letter that Renoir and Monet had written to the Minister of Fine Arts, protesting at the hanging conditions at the Salon.[3] In addition, Renoir drew up a set of recommendations for a total reform of the Salon, which were published during the exhibition in an article by their friend Eugène Murer; the key point of Renoir's proposals was that Salon submissions should be subdivided according to their style and subject matter, and that each group should be judged by a separate jury sympathetic to that type of painting.[4]

Sleeping Girl was seen to better advantage two years later, in 1882, in the seventh Impressionist group exhibition, mounted by the dealer Durand-Ruel; Renoir's work was included in this show against his wishes,[5] and all the paintings shown seem to have come from Durand-Ruel's stock.[6] Even here, though, the press took little notice of it; beyond some critics' general praise for Renoir's work, the only specific verbal response to this canvas was in a review by Henry Robert, who described it as "a very beautiful study of flesh."[7]

An account of the genesis of the canvas was recorded by Renoir's friend Georges Rivière. The model was Angèle, a young girl from Montmartre noted for her irregular lifestyle and her many lovers, who fascinated Renoir with her colorful slang and her implausible storytelling; often she arrived to model after an exhausting night, and Renoir's painting, we are told, depicts one of these occasions.[8]

However, this story obscures the fact that the painting treats a well-established theme in genre painting: the female model caught at a moment when she is no longer posing. In paintings of the period we may see the model before she begins to pose or as she relaxes between poses, often naked or partly naked, or at a moment when she has ceased to pose, whether through becoming distracted or, as here, falling asleep. In all these scenarios, by ceasing to pose, the model has moved from the artistic to the human sphere, and the position of the artist and viewer has shifted from the aesthetic to the voyeuristic. This is accentuated in Renoir's canvas by the fact that the implied original pose (of which no representation exists) would have depicted her shift correctly adjusted, rather than slipped from her shoulder to reveal part of her breast. Her whole pose, like that of the cat on her lap, has become relaxed and passive. We must assume that Renoir originally conceived the canvas in terms of the subject as we now see it. The story of its genesis is made

still more questionable because of the existence of a smaller canvas of the same model, similarly dressed and in a comparable pose but placed in an outdoor setting (private collection).

The erotic suggestiveness of the painting is heightened by her clothing and by the presence of the cat. Her striped stockings and plain blue skirt are working-class apparel, while her white shift is an undergarment that would only have been exposed in an intimate, private situation. She is dressed very similarly to the figure in *Girl Crocheting* (cat. 6). In this context, the feathered hat here seems something of an anomaly.

Renoir cannot have been unaware of the erotic suggestiveness of depicting the cat, with its thick fur, lying on the model's lap between her hands. The associations are made crudely and misogynistically explicit in the entry on *chat* in Alfred Delvau's *Dictionnaire érotique moderne*, published in the mid-nineteenth century: "*Chat*: Name that women give to the divine scar that they have at the base of their belly, because of its thick fur, and also sometimes because of the claws with which it scratches the penis of the honest men who rub against it."[9] One response to the picture in 1882 makes it clear that it was indeed

viewed in sexualized terms: a cartoon by an artist named only as "Draner" of the image that was included in a page of cartoons entitled "Une Visite aux Impressionnistes," published in *Le Charivari*. Here the cat is awake, its tail massively and phallically erect, and the model, too, is awake and smiling as she scratches the cat's hind quarters. The caption reads: " . . . Mademoiselle, hide that immediately."[10] There is also a contrast between her class, as implied by her clothing, and the bourgeois chair on which she sits;[11] however, X-ray photography of the canvas (fig. 15.1) suggests that originally she was seated on a quite different chair—larger and perhaps wicker—whose nearest leg extended almost to the bottom of the canvas, close to the present location of the figure's left foot. Originally, her feet seem to have been placed somewhat further to the left.

In the canvas as we see it now, the figure and chair are placed alone in a somewhat indeterminate space; they are presented in clear light against what can best be read as a background wall, deep blue above the dado and a dull orange-red below it; there is some indication that the bottom of the wall falls approximately on the same line as the front of the chair seat. A more emphatic vertical form in the left background—perhaps a door—can now be seen through the final paint layer; the X ray shows further verticals somewhat closer to the model, but the original layout of the background cannot be clearly determined. There is some uncertainty, too, about the placement of the figure; her head does not seem to rest securely on the chair back, and her thighs seem somewhat elongated. These again may have resulted from adjustments that Renoir had to make after the radical changes to the chair. There was also originally a cursive form on the floor at bottom left, now replaced by bare floorboards, and a deleted shape to the

FIG. 15.1

An X ray of *Sleeping Girl* reveals that the figure was once seated on a larger chair

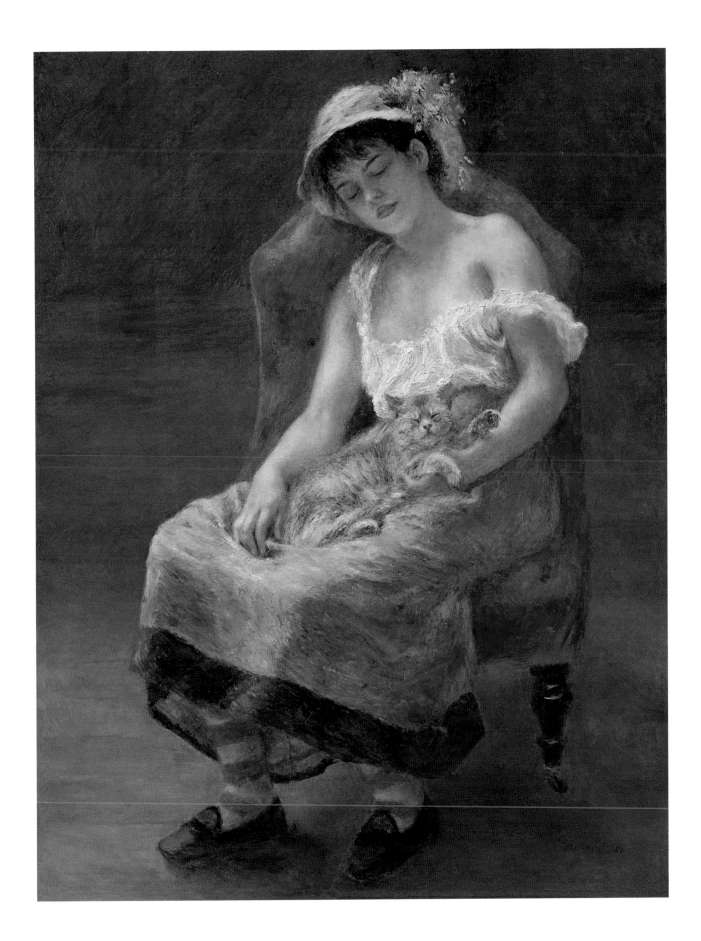

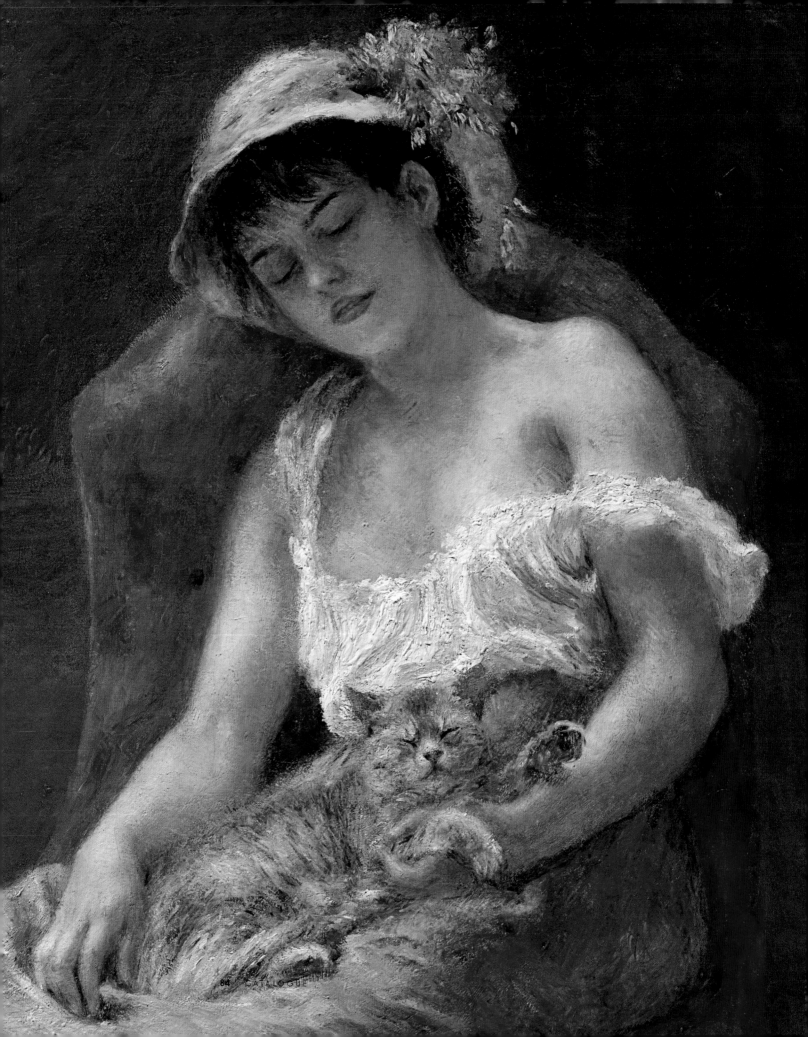

lower right, which may perhaps be interpreted as representing a wine bottle; Renoir may have removed this marker of the model's habits to make the canvas more palatable to the Salon jury.

The resulting image, though, has a clear and vivid presence, achieved by the rich contrasts of color and tone and the lavish brushwork on the lit parts of the figure. The composition is dominated by contrasts between blues and reds, bold in the foreground, muted in the background. In almost every zone of the canvas one or the other color predominates, though subtle nuances of other colors appear throughout; only in the flowers on her hat do we find the complex mixture of colors so characteristic of Renoir's work in the mid 1870s. Tonal contrasts also heighten the impact of the image, with sharp highlights on her hat, the flesh of her chest and arms, and especially on the loose folds of her shift; it is here, too, that Renoir deployed the most extravagant brushwork in the canvas, using the freely brushed impasto to heighten the effect of the model's exposed flesh above it. The cat's fur is densely brushed as well, but is treated with a finer texture that suggests its distinctive qualities.

The painting was bought by Durand-Ruel in January 1881 and was included in the one-artist show that he mounted of Renoir's work in April 1883—one of a sequence of shows that the dealer organized in that year on Boudin, Monet, Pissarro, and Sisley, as well as Renoir, which seem to have been the first sustained attempt by a dealer to propagate individual artists through single-artist exhibitions. Soon after this show, Durand-Ruel sold the canvas to a collector listed only as Kuyper, of whom nothing is known; he bought it back from him in 1890 or 1891, and thereafter it became one of the highlights of his collection of Renoir's work until his firm sold it to Sterling Clark in 1926. In 1892,

it was the centerpiece of the *petit salon* in Durand-Ruel's private residence,[12] and an etching after the picture appeared as the frontispiece of the catalogue of the major retrospective that Durand-Ruel organized in May 1892.

PROVENANCE

[Durand-Ruel, Paris, bought from the artist, 6 Jan. 1881; sold to Kuyper, 29 May 1883]; Kuyper, returned to Durand-Ruel, 23 May 1891; [Durand-Ruel, Paris, 1891–1926; sold to Clark, 3 May 1926]; Robert Sterling Clark (1926–55); Sterling and Francine Clark Art Institute, 1955.

REFERENCES

Vollard 1918, vol. 1, no. 342; Meier-Graefe 1929, p. 135, fig. 101; Daulte 1971, no. 330; London 1985, no. 50; Williamstown 1996, pp. 11–12, 14, 23, 25, 44, ill. p. 45; Ottawa 1997, pp. 18–19, 186, 304n2, 305n23; fig. 23; Dauberville 2007, no. 487; Distel 2009, pp. 172–74, fig. 159.

NOTES

1 Émile Zola, "Le Naturalisme au Salon," *Le Voltaire*, 18–22 June 1880, reprinted in Zola 1970, p. 341: 'Ses deux toiles . . . ont été accrochées dans la galerie circulaire qui règne autour du jardin; et la lumière crue du grand jour, les reflets du soleil, leur font le plus grand tort, d'autant plus que la palette du peintre fond déjà volontiers les couleurs du prisme dans une gamme de tons, parfois très délicate.'
2 Seigneur 1880, pp. 100–101: "sont du dernier grotesque;" "c'est tellement mauvais que garder le silence à leur sujet nous aurait semblé une lâcheté."
3 See letter from Cézanne to Zola, 10 May 1880, in Rewald 1976, p. 187.
4 "Affaire du Salon: Protestation des artistes," *Chronique des tribunaux*, 23 May 1880, reprinted in Gachet 1956, pp. 165–67.
5 See letters from Renior to Durand-Ruel, 24, 26 Feb. 1882 and undated, in Godfroy 1995, pp. 24–30.
6 See Berson 1996, vol. 2, pp. 201–13.
7 Henry Robert, "Chronique parisienne: Le Salon des impressionnistes," *La Petite Presse*, 5 Mar. 1882, reprinted in Berson 1996, vol. 1, p. 411: "une fort belle étude de chair."
8 Rivière 1921, pp. 137–38.
9 Delvau 1867, p. 92.
10 Draner 1882.
11 See London 1985, p. 218.
12 See Lecomte 1892, pp. 134–36, for an extended and eloquent description of the canvas and its setting.

16 Peonies

c. 1880

Oil on canvas
55.3 x 65.7 cm
Signed lower right: *Renoir.*
1955.585

Renoir's friend Georges Rivière recorded the artist's view of the role of flower painting in his oeuvre: "Painting flowers rests my brain. I don't feel the same tension as when I am face-to-face with a model. When I paint flowers, I place my colors and experiment with values boldly, without worrying about spoiling a canvas."[1] Although this comment may relate more specifically to the many informal flower studies of Renoir's later years, it seems that throughout his career it was in flower paintings that he produced many of his most ebullient effects of color and brushwork.

Peonies is one of Renoir's most sumptuous still-life compositions. The bouquet virtually fills the canvas, with the flowers just cut by left, right, and top margins. This sense of immediacy is unobtrusively enhanced by the way in which the flowers are set against the background and the table. The deep blues of the background thrust the bouquet forward, while the intense blue shadows across the white tablecloth and the deep blue vase create a luminous cool base to offset the play of vibrant reds and greens above. Overall, the canvas is a vivid example of the way in which Renoir liked to fill his canvases to their margins and to avoid any open or empty spaces in them.

The light source in the canvas is implicitly from the left, since the vase casts a shadow to the right, but it is hard to read the shadows in literal terms, as there is no indication of what is casting them. The vase is not crisply defined; like the tabletop, it is softly brushed, acting as a foil to the thickly impastoed and dynamic handling of the bouquet. Within the bouquet itself, the contrast between the flowers and the leaves is established by both color and touch—between the lavish, fleshy forms and rich red hues of the flowers and the incisive, more linear strokes that describe the crisp green leaves that punctuate them.

In *Peonies*, Renoir did not resort to an underlying armature within the picture, as he sometimes did in earlier flower pieces; the complex interplay between flowers and leaves creates a coherent overall structure for the picture in relation to the rectangle of the canvas itself. A comparable fluency of execution combined with lavish color can be seen in Claude Monet's flower pieces painted in 1880;[2] Renoir's canvas, however, with its horizontal format filled to the margins with richly colored impasto, creates an overall effect even more fluid and ebullient than Monet's.

The rich color and blue shadows show how, by around 1880, Renoir was introducing into subjects set in interiors the high-key colored palette that he had evolved in the mid 1870s to treat effects of outdoor sunlight. There are no sharp contours in the canvas; the various objects—flowers, leaves, vase, and table—are differentiated solely by contrasts of color and texture. The variety and confidence of his informal, seemingly improvised brushwork was soon afterward to give way to a renewed concern for more traditional notions of form and drawing.

PROVENANCE
[Durand-Ruel, Paris, bought from the artist, 6 Jan. 1881]; Potter Palmer, Chicago (by 1892, d. 1902); Bertha Honoré Palmer, Chicago, his wife, by inheritance (from 1902); [Howard Young Galleries, New York, c. 1922]; Annie Swan Coburn, Chicago (by 1932); Art Institute of Chicago, Mr. and Mrs. Lewis Larned Coburn Memorial Collection (1933–42); [Knoedler, New York; sold to Clark, 31 Jan. 1942]; Robert Sterling Clark (1942–55); Sterling and Francine Clark Art Institute, 1955.

REFERENCES
Meier-Graefe 1929, p. 145, fig. 124; Williamstown 1996, pp. 15, 88, 93, ill. p. 90; Dauberville 2007, no. 36.

NOTES
1 Rivière 1921, p. 81: "Cela me repose la cervelle de peindre des fleurs. Je n'y apporte pas la même tension d'esprit que lorsque je suis en face d'un modele. Quand je peins des fleurs, je pose de tons, j'essaye des valeurs hardiment, sans souci de perdre une toile."
2 See *Dahlias* and *Asters* in Wildenstein 1974–91, vol. 1, nos. 625, 627.

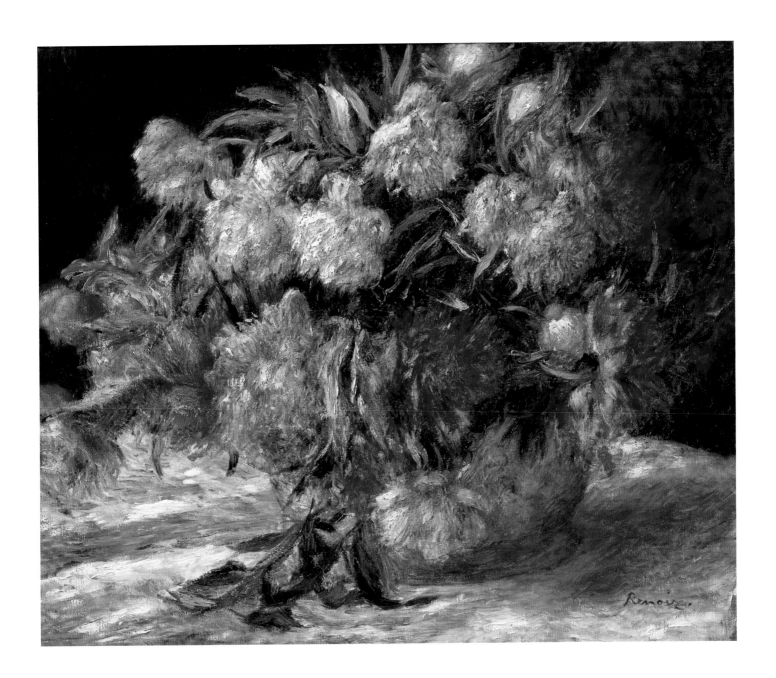

Sketches of Heads (The Berard Children)
1881

Oil on canvas
62.6 x 81.9 cm
Signed and dated lower
right: *Renoir. 81.*
1955.590

Between 1879 and 1884, Renoir painted a long sequence of canvases for Paul Berard, a diplomat and banker, and brother of Édouard Berard, whose daughter Thérèse he had painted in 1879 (cat. 10). For his first commission for Paul, a portrait of his eldest daughter, Marthe (Museu de Arte de São Paulo), Renoir chose a relatively restrained palette, just as he did in the portrait of Thérèse, painted the same year.[1] Paul and his family liked the painting, and Renoir quickly became a close family friend and a regular guest at their country home, the Château de Wargemont, outside Dieppe. At Wargemont, Renoir entered enthusiastically into the life of the household, establishing cordial relationships with the chief servants and joining their Saturday trip to market day in Dieppe, where he appeared in a canoeist's hat.[2]

Sketches of Heads (The Berard Children) is one of the liveliest and most unusual of Renoir's child portraits. It shows all four of Berard's children: André (born 1868) at bottom left; Marthe (born 1870) at bottom center and in profile at bottom right; Marguérite (born 1874) at top right and in profile at top center; and Lucie (born 1880) twice at upper left, and probably again as the third head along the top row. This was not the first occasion on which Renoir had juxtaposed multiple heads in a single painting. In 1876 he had painted a canvas for his patron Victor Chocquet with multiple small images based on photographs of Chocquet's daughter Marie-Sophie, who had died in 1865.[3] Nor was an image of this

sort unprecedented; as Colin Bailey has shown, one of Jean-Antoine Watteau's most celebrated drawings of multiple heads (fig. 17.1) had been included in the exhibition *Les Dessins des maîtres anciens* at the École des Beaux-Arts in 1879; since this show was organized by Renoir's friend and patron Charles Ephrussi, it seems very likely that Renoir would have seen it.[4] The arrangement of heads in Renoir's *Sketches of Heads (The Berard Children)* is closely comparable to Watteau's drawing.

This format allowed Renoir to view the children informally from many angles, instead of building a composition from a single pose. The contrast between the highly finished faces and the sketchy background ensures that the figures are seen as separate vignettes and cannot be read as existing in a single, coherent space. Perhaps, too, the lively informality of the composition gave some idea of the experience of the Berard household; as Jacques-Émile Blanche remembered, "the Berard girls, unruly savages who refused to learn to write or spell, their hair wind-tossed, slipped away into the fields to milk the cows."[5] Indeed, the picture sets up a contrast between the animation of the heads of the three girls in the right half of the picture and the studied detachment of their older brother at lower left.

For all its apparent informality, the picture is carefully organized. The pivotal red book and frontal figure at bottom center are flanked by two figures in profile looking inward, with faces looking outward at the two top corners. Color, too, is used to structure the image, with the dominant blue tones set off against smaller accents of red, particularly in the flesh and hair, that link up with the foreground red book, as well as the yellow and orange tones in the children's hair. Seen from

FIG. 17.1
Jean-Antoine Watteau (French, 1648–1721)
Nine Studies of Heads, 1717–18
Black and red chalk with white highlights, 26.1 x 40.6 cm
Musée du Petit Palais, Paris

up close, the color is constantly varied, with blues, yellows, and even reds used to model the shaded areas of their skin; their hair is treated in a wide range of colors—blues and purples as well as reds and yellows—that give the viewer no clear sense of the actual color of their hair. The faces are treated with great finesse, and those seen in profile are crisply set off against the background. Some of the features, particularly the eyes, are picked out with the skill of a miniaturist. Yet there is no sign of the preoccupation with line and contour that overtook Renoir's art within the next year.

In later years, Renoir frequently juxtaposed sequences of heads on a single canvas or sheet of paper, but these were generally studies that were not intended for public display; in 1892 he showed an interviewer some of these, pointing out the freedom that such sketches allowed him but insisting that he did not exhibit them because he did not regard them as "complete pieces."[6] As an exception, however, he did regard the present picture as complete in its own terms, ex-

hibiting it in 1883 with the title *Croquis de têtes*; the heads in it are far more highly finished than in most of his pictures containing multiple images.

PROVENANCE

Paul Berard, father of the sitters, Wargemont and Paris (1881–1905; his sale, Georges Petit, Paris, 8 May 1905, no. 16 sold to Pra); Albert Pra, Paris (1905–38; his sale, Galerie Charpentier, Paris, 17 June 1938, no. 52, sold to Knoedler); [Knoedler, New York; sold to Clark, 30 June 1938]; Robert Sterling Clark (1938–55); Sterling and Francine Clark Art Institute, 1955.

REFERENCES

Daulte 1971, p. 46, no. 365; Williamstown 1996, pp. 61–62, ill. p. 64; London 1985, no. 60; Ottawa 1997, no. 39; Dauberville 2007, no. 282; Distel 2009, pp. 176–77, fig. 163.

NOTES

1 Duret 1924, p. 63.
2 Blanche 1937, pp. 55–58.
3 See Ottawa 1997, pp. 22, 25.
4 Ibid., pp. 184 and 308.
5 Blanche 1937, pp. 37–38.
6 *L'Eclair* 1892: "des morceaux complets."

18

Venice, the Doge's Palace
1881

Oil on canvas
54.5 x 65.7 cm
Signed and dated lower
right: *Renoir. 81.*
1955.596

Renoir's primary motive in traveling to Italy in 1881–82 was to study the work of the Old Masters, and notably to see the work of Raphael[1]—an unexpected interest for an Impressionist painter, and one that stands as a clear marker of his dissatisfaction with the informality and lack of draftsmanship in his own recent work. His first major stop in Italy was in Venice, in late October and early November 1881. The fluent painterly qualities of Venetian sixteenth-century painting, notably of Titian and Veronese, would have been far closer than Raphael to Renoir's own previous interests, but neither his letters from Venice nor his later reminiscences suggest that his experience of their paintings in Venice was a revelation to him, for he had studied their work closely in

the Louvre. Instead, in Venice it was the art of Tiepolo and Carpaccio that aroused his interest.[2]

Nonetheless, the paintings that he executed in Venice show little sign of any engagement with the art of the past. His main focus was the place itself, and he painted a sequence of canvases of the standard tourist sites—the Grand Canal, the Lagoon, the gondolas. *Venice, the Doge's Palace* is one of the two most highly finished of these canvases; the other represents the Grand Canal (Museum of Fine Arts, Boston). Together, these two canvases present the most stereotypical view of Venice, sites that had been represented by the city's most celebrated painters such as Canaletto, Turner, and many others. As Renoir wrote

to Charles Deudon, "I have painted the Doge's Palace seen from San Giorgio; that has never been done before, I think. There were at least six of us queuing up to paint it."[3]

Venice, the Doge's Palace is a fascinating attempt to combine topographical specificity with Impressionist facture. The brushwork is busy and variegated throughout, and the forms of the buildings are suggested by colored touches rather than linear contours. Their shadowed sides are richly colored, predominantly in a full blue, picking up the color of the sky, and set off against the dominant cream, yellow, and soft orange hues that define their sunlit façades. The same colors are repeated in the water, with the addition of rich green strokes. At the center of the composition, the green, white, and red flag acts as a pivot around which the predominant blue-orange contrast of the rest of the composition revolves (the house in *Bridge at Chatou* [cat. 4] fulfils a very similar function). The darker tones of the shadowed sides of the buildings also help to structure the composition. As in other works by Renoir, the reflections in the water are only approximately indicated — the reflection of the Campanile, for instance, is wider than the tower itself; unlike Claude Monet, Renoir never notated such effects precisely.

Within this array of colored touches, a remarkable amount of information is conveyed about the details of the buildings. Though not precisely defined, the superimposed arcading of the Doge's Palace and the fenestration of the Zecca to the left are indicated in considerable detail; the upper level of arcading on the palace façade appears even to have the correct number of arches (thirty-four), and the orb and cross that top the principal dome of San Marco can be clearly seen above the palace roof.

It seems very likely that this and *Grand Canal, Venice* were the two Venetian views that Durand-Ruel included in the seventh Impressionist group exhibition in March 1882. Durand-Ruel registered two Venetian views, one of them subtitled "G. Canal," in his stock book on 30 November 1881; this entry was erased and the pictures re-entered in the stock book on 12 May 1882, presumably when the purchase was completed.[4] These must have been the two Venice views included in the seventh group exhibition, since all the Renoirs exhibited came from the dealer's stock, and these two were the only Venice views in his hands by this date. The "G. Canal" can be securely identified as the painting now in Boston. For many reasons, it is highly probable that the other canvas was *The Doge's Palace*: the two are the same size; they are very similar in execution and markedly different from Renoir's other Venice views; the reviewers consistently discussed them as a pair; and in a letter to Deudon from Venice Renoir mentioned that he had sent two canvases to Durand-Ruel, immediately following this by describing the view of the Doge's Palace, suggesting that it was one of the two.[5]

Critical response to the Venice canvases at the 1882 exhibition was largely negative. Several reviewers compared them to the work of Félix Ziem, renowned for his endlessly repeated, hot-toned Venetian views; Jacques de Biez described them as "the ugliest fireworks,"[6] while Paul Leroi saw them as "the most outrageous series of ferocious daubs that a calumniator of Venice could possibly imagine."[7] Louis Leroy was particularly critical of the treatment of the water: "The painter has posed himself this problem: to create water that is . . . solid, on which gondolas on wheels can roll, without it being possible to interpret this hatched, striped, spotty surface as any sort of dry land. He has admirably mastered this difficulty. It resembles nothing in the known world."[8]

PROVENANCE

Possibly E. Oppenheim (until 1897; sale, Hôtel Drouot, Paris, 11 May 1897, no. 21; possibly Dr. Hirschmann, Amsterdam (sometime between 1897–1933); [Durand-Ruel, Paris and New York, possibly by 1897, definitely by 1905, until 1933; sold to Clark, 3 March 1933]; Robert Sterling Clark (1933–55); Sterling and Francine Clark Art Institute, 1955.

REFERENCES

Meier-Graefe 1929, p. 156, fig. 141.; Williamstown 1996, pp. 77, 80, 83, ill. p. 78; London 2007, no. 62; Dauberville 2007, no. 161; Distel 2009, p. 202–3, fig. 187.

NOTES

1 See letter from Renoir to Madame Charpentier, n.d., from Venice, in Florisoone 1938, p. 36.

2 For mention of his discovery of Tiepolo, see ibid. For his discovery of Carpaccio, see Vollard 1938, p. 201. See also the letter from Renoir to Charles Deudon, n.d., from Venice, in Schneider 1945, pp. 96–97.
3 Letter from Renoir to Charles Deudon, n.d., from Venice, in Schneider 1945, pp. 96–97.
4 Durand-Ruel stock books, Durand-Ruel Archives, Paris.
5 Renoir to Deudon, n.d., in Schneider 1945.
6 Jacques de Biez, "Les Petits Salons: les Indépendants," *Paris*, 8 Mar. 1882, reprinted in Berson 1996, vol. 1, p. 381: "le plus laid des feux d'artifice."

7 Paul Leroi, "Salon de 1882," *L'Art* 29 (1882): p. 98, reprinted in Berson 1996, vol. 1, p. 401: "la série la plus inouïe de barbouillages féroces que puisse imaginer un calomniateur de Venise."
8 Louis Leroy, "Exposition des impressionnistes," *Le Charivari*, 17 Mar. 1882, reprinted in Berson 1996, vol. 1, p. 402: "Le peintre s'est posé ce problème: faire de l'eau . . . solide, sur laquelle des gondoles à roulettes pourraient évoluer, sans que cependant cette surface hachée, zébrée, tachée, puisse être prise pour un terrain quelconque. Il a admirablement vaincu la difficulté. Cela ne ressemble à rien de connu."

19 Bay of Naples, Evening
1881

Oil on canvas
57.9 x 80.8 cm
Signed and dated lower
left: *Renoir. 81.*
1955.587

Bay of Naples, Evening was painted in late November 1881, about a month after *Venice, the Doge's Palace* (cat. 18), but the two canvases are markedly different in treatment and effect. Whereas the Venice scene is loosely brushed and variegated in touch, *Bay of Naples, Evening* is more thinly painted, and its brushwork is more regular and less emphatic. This change may be seen as the result of Renoir's experiences of seeing the paintings by Raphael in Rome and the murals from Pompeii and Herculaneum in the museum in Naples (see *Blonde Bather*; cat. 21), but such contrasts between works that are close in date recur throughout his career, as in his views of Yport and Guernsey of 1883 (see cats. 24 and 25), where the more systematic canvas preceded the freely brushed one.

Renoir adopted a viewpoint looking eastward across the bay of Naples toward Mount Vesuvius, viewing the scene from an upstairs window near the northeast corner of the Piazza Municipio, overlooking the Strada del Piliero and Porto Grande. This was not, as has been suggested, the location of the hotel in which he was staying, the Albergo della Trinacria, which was in the Piazza Principessa Margherita, near the church of San Pietro Martire, about a quarter of a mile away and a little inland from the port.[1]

There is a marked contrast between the busy foreground and the sunlit expanses beyond. The roadway is busy with passing traffic, reminiscent of Renoir's street scenes of the quais and boulevards of Paris, apart from certain small details that are distinctively Neapolitan, such as the woman carrying a burden on her head at bottom right and the little figure running down the roadway to the left of center with a burden on poles across the shoulders. Out on the bay, we see a range of different local boats set against the sunlit shoreline. Beyond the imagery of city and port, we see the silhouette of Mount Vesuvius, familiar from many images over the previous century; but Renoir virtually ignored the customary associations of views of the bay of Naples, with the twin peaks of the mountain. A small and seemingly benign puff of smoke on the right peak is the only hint of its volcanic power, which had formed such a potent image through the eighteenth and early nineteenth centuries.[2] Despite the volcano's looming presence and memories of its most recent eruption in 1872, the whole scene seems serene and untroubled.

The overall tonality of the canvas is warm, and Renoir used recurrent soft accents throughout to create a highly integrated atmospheric effect. Streaks of red and orange recur in the sky and water and on the mountain, picked up by sequences of accents

on the figures and road in the foreground and by a sequence of small, crisp red verticals on the far side of the bay, immediately to the left of the central sailing boat, whose representational function is unclear.

The foreground figures are sketched with a delicate painterly shorthand that suggests both gestures and costumes without any distracting detail. Beyond this, the sea, mountain, and sky are primarily treated in sequences of soft parallel strokes running from lower right to upper left, apart from the zone in the sky to the left and right of the mountain. At no point do these strokes seem to be used to characterize the forms or textures represented; indeed, in the sea, they seem to work against any sense of the flatness of the water surface. Rather, they function as a way of ordering the canvas; similar parallel strokes can be seen in parts of *Onions* (cat. 20), also painted during Renoir's stay in Naples. Superficially, they resemble the sequences of parallel strokes that Paul Cézanne was using in these years, though they are not used as Cézanne employed them, to build up a sense of form and space through modulations of color.

The painting is executed on an off-white priming, but there are signs of dark paint beneath the surface in the area of water around the kiosk at lower center. These may be traces of a failed start on the canvas, rather than an earlier version of the present image. It seems, too, that the left peak of the mountain was slightly lowered during the execution of the present view.

Although in recent years the picture has been identified as *Bay of Naples, Morning*, the angle of the sunlight, coming into the scene from low in the southwest and casting long shadows up the roadway, makes it clear that this is the evening canvas of the pair; in the Metropolitan's *Bay of Naples* (fig. 19.1), which is the morning painting, the sun shines from ahead of the viewer and to the right, casting shadows across the road, and a little more of the city can be seen on the left, including the steeple of the church of Santa Maria del Carmine. The hazy blue tonality of the morning canvas contrasts with the warm golden evening light of the present picture. Such pairs of canvases of the same scene at different times of day were already, by this date, frequent in the work of Claude Monet, but they are most unusual in Renoir's work. We must assume that in this instance he was consciously following his friend's example.

REFERENCES
Vollard 1918, vol. 1, no. 349; Meier-Graefe 1929, p. 158, fig. 143; Williamstown 1996, pp. 23, 28, 80, ill. p. 79; Dauberville 2007, no. 166; London 2007, pp. 249–50, fig. 112.

NOTES
1 The name and address of the inn are given in Renoir's letter from Naples to Charles Deudon, Dec. 1881, in Schneider 1945, p. 97.
2 See Boston 1978.

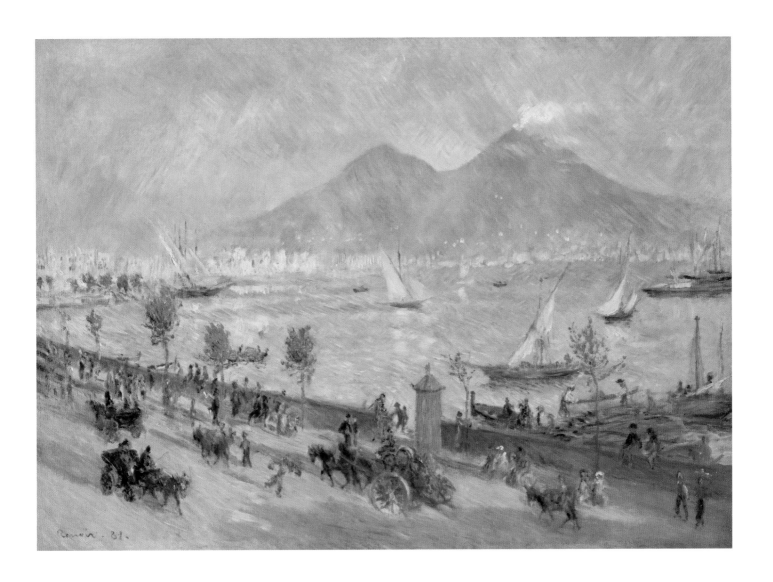

Onions

1881

Oil on canvas
39.1 x 60.6 cm
Signed, dated, and
inscribed lower left:
Renoir. Naples. 81.
1955.588

In contrast to the elaboration of flower pieces such as *Peonies* (cat. 16), *Onions* presents a deliberately relaxed and informal image. It was painted during Renoir's stay in Naples late in 1881; by inscribing it "Naples," he highlighted the link between the location and the picture's form and imagery, implicitly contrasting its informality with the artifice of Parisian culture, since it was in Paris that the painting was intended to be seen.

Onions and heads of garlic are loosely arranged across a tabletop, placed on and off a crumpled white cloth with a red and blue border. Their seemingly casual placing and simple setting heighten the sense that they belong to a modest, relaxed southern way of life. The picture's treatment may also reflect a personal sense of relief; for the past three years Renoir had been dependent on the patronage of wealthy collectors, but early in 1881 the dealer Paul Durand-Ruel had begun to buy his paintings on a regular basis, enabling the artist to travel as his own master on an extended Italian tour.

The rhythms of the whole composition are dynamic and animated. The rhyming shapes of the onions and garlic, set at different angles, create an ebullient effect, complemented by the brushwork and the overall tonality of the canvas. The warm reds, yellows, and pinks on the onions offset the softer, cooler hues in the background; fluent, cursive brushstrokes give a vivid sense of their three-dimensional form while at the same time contributing to the overall liveliness of the paint surface. Despite its informality, the composition is carefully structured, with the sharp band of the cloth border on the left acting as a counterpoise to the weight of the principal group of onions.

The brushstrokes run in varied directions on the tabletop and cloth, but on the background wall they follow a roughly diagonal direction, from upper left to lower right; their comparative regularity acts to set off and emphasize the rounded forms of the onions.

It was around this date that Renoir began regularly to use sequences of parallel brushstrokes such as this to structure his canvases, particularly, as here, in the background. Comparable strokes appear in *The Bay of Naples, Evening* (cat. 19) painted at much the same time, but there is no trace of such regularity in *Venice, the Doge's Palace* (cat. 18), painted earlier in his Italian trip. In some ways this handling is comparable to the more systematic parallel strokes that Cézanne was using in these years, but Renoir seems to have used them more to create pattern and texture in his backgrounds, rather than as a means of modeling form with color, as Cézanne did.

Onions bears a close resemblance to Renoir's *Fruits of the Midi* (Art Institute of Chicago), also dated "81," a canvas that is larger and somewhat more formally arranged but very similar in its handling. It seems very likely that these were the two still life paintings that Renoir mentioned in a letter from Naples to Charles Deudon in December 1881: "In a few days, I am going to send [to Durand-Ruel] one or two still-lifes; one of them is good."[1] We have no way of knowing whether it was *Onions* that he favored.

The composition of these two canvases may be compared to Claude Monet's recent still-life paintings, such as *Still Life with Apples and Grapes* of 1880 (Art Institute of Chicago), in which the fruit is spread across a wide table in a seemingly casual disorder. The deliberate informality of Renoir's and Monet's paintings of fruit is quite unlike the far more tautly structured still lifes that Cézanne was executing in these years; two years later, in Renoir's *Apples in a Dish* (cat. 26), it was Cézanne's example that was paramount.

It seems most likely that this was the canvas titled *Onions* that Durand-Ruel bought from Renoir in May 1882, and was in turn included in his one-artist show mounted by the dealer in April 1883. After Sterling

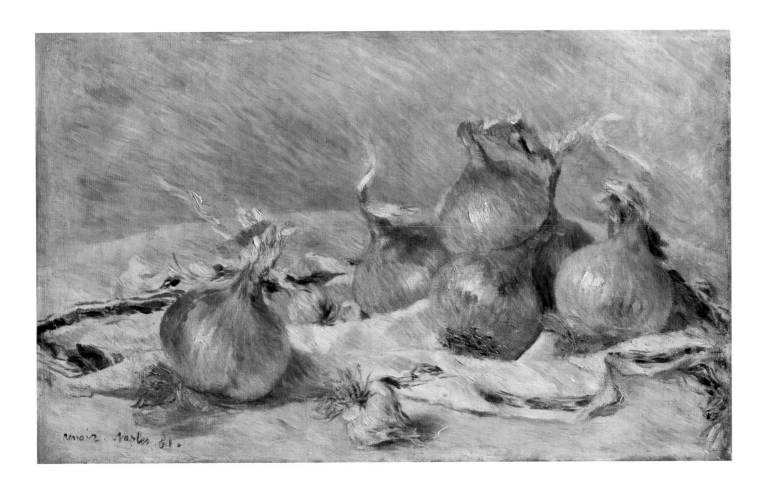

Clark bought the canvas from Durand-Ruel in 1922, he reiterated on many occasions that it was his favorite among his collection of Renoir's works, and used it as a yardstick for judging other pictures.[2]

PROVENANCE

[Durand-Ruel, Paris, probably bought from the artist, May 1882]; Possibly Madeleine and Charles Haviland, Limoges; Dr. Jacques Soubies, sold to Durand-Ruel, 29 Dec. 1921; [Durand-Ruel, Paris, sold to Clark, 6 Apr. 1922]; Robert Sterling Clark (1922–55); Sterling and Francine Clark Art Institute, 1955.

REFERENCES

Meier-Graefe 1929, p. 152, fig. 132; London 1985, no. 62; Williamstown 1996, pp. 13, 28, 80, 93, ill. p. 91; Dauberville 2007, no. 58; Distel 2009, p. 205, fig. 189.

NOTES

1 The name and address of the inn are given in Renoir's letter from Naples to Charles Deudon, Dec. 1881, in Schneider 1945, p. 97.
2 See, for example, RSC Diary, 14 Mar. 1941.

21

Blonde Bather

1881

Oil on canvas
81.6 x 65.4 cm
Signed, dated, and inscribed upper right:
*à Monsieur H. Vever/
Renoir 81* [partially overpainted]/*Renoir. 81.*
1955.609

Blonde Bather was painted during Renoir's Italian trip in the autumn and winter of 1881. It seems certain that the model was Aline Charigot (1859–1915), who accompanied Renoir on at least part of the trip;[1] she had probably begun to model for Renoir in 1880. In later years, both Renoir and Aline maintained that they were husband and wife during this visit to Italy,[2] concealing from their family the fact that they were not married until 1890, five years after the birth of their first child, Pierre. The figure here wears a wedding ring, but it would be unwise to read any particular personal significance into this, since similar rings appear on the fingers of several of his earlier nudes. It has been suggested that they were added for reasons of propriety,[3] but this does not seem to have been a recurrent convention in the depiction of the modern-life nude.

On his return from Italy, Renoir proudly told his friends that he had painted the canvas on a boat in full sunlight in the Bay of Naples.[4] As the picture now stands, however, its background clearly does not represent the view from a boat. The figure seems to be seated by the shore, and the set of crisp green strokes behind her back suggest that she is seated on a grassy outcropping. In any case, the spatial relationship between the model and the sea and cliffs beyond is unclear, and these cliffs are sketchy and imprecise in their forms, in marked contrast to the figure. There are clear signs of dense, dried paintwork describing quite different forms beneath the present painting of the cliffs, and some color that is unrelated to the present image can be seen through the top paint layers; evidently the background was much altered, perhaps after Renoir's return from Italy.

The painting marks a turning point in Renoir's art. When he first showed it to his friends in France, they immediately recognized that its subject and its technique were a departure for the artist. Renoir himself recalled their response, many years later: "Do you remember Paul Berard, Deudon, and Charles Ephrussi when I brought back to Wargemont my Bather from Capri? And how afraid they were that I would not do any more Ninis?"[5]

The painting is markedly different from Renoir's open-air nude of 1875–76, *Study: Sunlight Effect* (fig. 21.1). In place of the variegated color patches of the earlier picture, which blend the figure into the loosely sketched surrounding foliage, the figure in *Blonde Bather* stands out boldly from the background. The contours are relatively soft, but the dazzling lu-

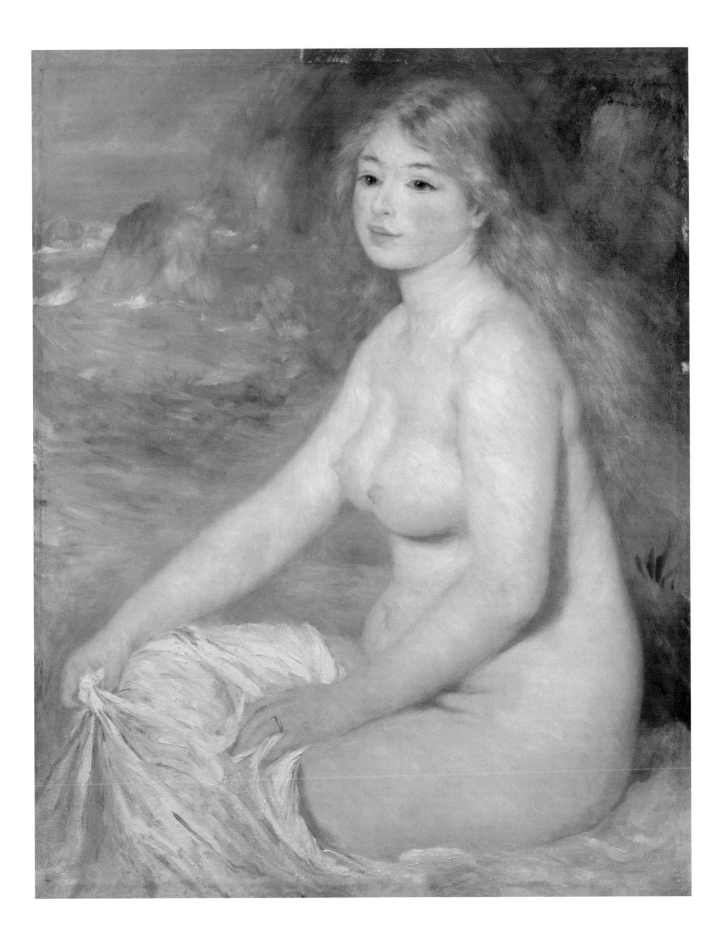

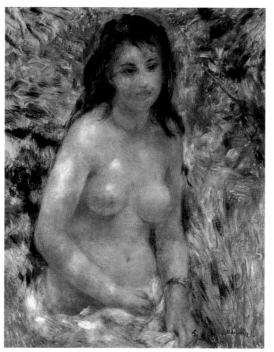

FIG. 21.1

Pierre-Auguste Renoir
Study: Sunlight Effect, 1875–76
Oil on canvas, 81 x 65 cm
Musée d'Orsay, Paris (RF 2740)

minosity of the sunlit nude is clearly demarcated from the darker, cooler colors beyond her. Moreover, in contrast to the garden setting of *Study*, the open, coastal background of *Blonde Bather* detaches the figure comprehensively from any associations with the city or any explicit sense of modernity.

Likewise, apart from the wedding ring, there is no sign of modernity in the figure. Its pose marks a change from Renoir's previous work. In contrast to a painting such as *Sleeping Girl* (cat. 15), the figure is turned to the side and looks out beyond us, creating a distance from the viewer, whereas in *Sleeping Girl* she faces us, relaxed and turned toward our gaze. The simple, pyramidal shape of *Blonde Bather* gives her a more monumental, seemingly timeless air; the figure is presented without reference to any specific time or place, as an iconic image of womanhood.

The form that the figure assumed was a direct result of Renoir's artistic experiences on his Italian trip. In conversation with Jacques-Émile Blanche, Renoir pinpointed Raphael's frescoes in the Villa Farnesina in Rome as the paintings that had made the most significant impact on him: "Raphael broke with the schools of his time, dedicated himself to the antique, to grandeur and eternal beauty."[6] He wrote from

Naples in November 1881 about the "simplicity and grandeur" that he found in the frescoes[7] and enlarged on this in a letter to Madame Charpentier early in 1882, shortly after his return to France, explaining what he had learned: "Raphael, who did not work out of doors, had still studied sunlight, for his frescoes are full of it. So, by studying out of doors I have ended up only seeing the broad harmonies without preoccupying myself any longer with the small details that dim the sunlight rather than illuminate it."[8] In addition, he expressed his admiration for the "simplicity" that he found in the wall paintings from Pompeii and Herculaneum that he saw in the Naples Archaeological Museum.[9]

The simplification of form and effect in *Blonde Bather* was a direct result of these artistic experiences. Indeed, Renoir's discovery of the Villa Farnesina frescoes was particularly topical, since in 1879 William-Adolphe Bouguereau had exhibited a *Birth of Venus* (Musée d'Orsay, Paris) at the Salon that was widely recognized as a reworking of Raphael's Farnesina *Triumph of Galatea*; after Bouguereau's slick academicism, Renoir's experience of "simplicity and grandeur" may have been particularly surprising. More specifically, the modeling of *Blonde Bather* owes something to the robust forms that he admired in the female deities in Raphael's spandrel decorations in the Villa Farnesina.[10] At the same time, *Blonde Bather* invites comparison with a wider range of artistic precedents. Both the pose and the ample female form carry echoes of Rembrandt's *Bathsheba*, which Renoir would have known well in the Louvre, and, in more generic terms, Titian's *Venus at Her Toilet* (several versions). Taken together, these affinities mark Renoir's canvas as the starting point of his project over the remainder of his career to harness his art to what he saw as the great tradition of European figure painting.

The painting may also be viewed as a response to Edgar Degas's vision of modern womanhood, as displayed in the wax sculpture *Little Dancer Aged Fourteen* (National Gallery of Art, Washington, D.C.), which was exhibited at the sixth Impressionist group exhibition in spring 1881 and thus was fresh in Renoir's memory. Renoir's wholesome, ample young woman, presented as if in harmony with her natural surroundings, stands in stark contrast to Degas's emaciated adolescent, the "little flower of the gutter" with her "vicious muzzle" that so disturbed the critics.[11]

Later in her life, Aline recalled how, on their trip to Italy when she was twenty-two, she had still been very slender, though in 1895 Julie Manet, daughter of Berthe Morisot, found this hard to believe;[12] the form of the figure in *Blonde Bather* might confirm Manet's doubts, but at the same time the canvas may mark the beginnings of Renoir's tendency, especially marked after 1900, to enlarge his female figures as he sought to create an ideal of female beauty as a vision of physical amplitude.

Blonde Bather, however, does not represent a wholesale rejection of Impressionism. The contours of the figure are relatively soft, in contrast to *Bather Arranging Her Hair* (cat. 27), painted four years later. The figure in *Blonde Bather* is still modeled in color, with soft blues and reds used to suggest the shadows on her flesh; fuller blues indicate the folds on her towel, which are treated with a breadth and imprecision somewhat at odds with the strongly volumetric figure. The rich and varied warm hues of the hair—primarily reds, oranges, and yellows, modeled by soft, muted blue touches—are set off against the rich blues immediately behind her head, but they also establish a link between the figure and the sunlit zones of the background. The freely brushed background itself is unequivocally Impressionist in its treatment. As a whole, the picture is a remarkable marriage of form and color.

On his return from Italy, Renoir either sold the picture or gave it to Henri Vever, the jeweler, Japonist, and collector of contemporary art.[13] It was pre-sumably at this point that Renoir erased its original signature, now partly visible, to leave room for the addition of the presentation inscription to Vever. It was, it seems, after his return to France in spring 1882 that Renoir executed a second version of the canvas at the request of the dealer Durand-Ruel (private collection).[14] In this, the figure is still more sharply set off against its setting, while the background depicts a wide bay with a distant line of cliffs, very similar to that in *Bather Arranging Her Hair* of 1885.

Before buying the present canvas in 1926, Sterling Clark recorded his uncertainties about the purchase in terms that reveal how competitively he viewed the formation of his collection: "The Nude, Naples 1881 she [Francine] thought a marvel . . . To Voisins for lunch. We talked over the Renoir Nude, & agreed that it would probably be tiresome to live with. True it is marvelous paint, never saw finer, but it lacks line and is only 3/4 length & all the great nudes have line & all are full length Titian, Giorgione, Velasquez. The price is very high at $100,000. In comparison with the "Dancing Girl" sold Widener for $120,000 which had line it is worth $60,000 under the hammer. In comparison with the "Loge" and the "Girl with the Cat" the same holds true. I am not going to take Widener's and the rest's leavings at the same price. I shall leave that for others."[15]

PROVENANCE
Henri Vever, Paris (purchase from the artist–until 1897); his sale, Galerie Georges Petit, Paris, 1–2 Feb. 1897, no. 96, sold to Durand-Ruel; [Durand-Ruel, Paris and New York, 1897–1926; sold to Clark, 2 July 1926]; Robert Sterling Clark (1926–55); Sterling and Francine Clark Art Institute, 1955.

REFERENCES
Meier-Graefe 1929, pp. 164–68, fig. 138; Daulte 1971, p. 46, no. 387; London 1985, no. 63; Williamstown 1996, pp. 11–12, 14, 23, 49–50, 54, 66, 93, ill. p. 51; Ottawa 1997, pp. 212, 321, fig. 254; Dauberville 2007, no. 583; London 2007, p. 68, fig. 48; Distel 2009, p. 205, fig. 194; Paris 2009, p. 29, fig. 6.

NOTES
1 See diary entry for 19 Sept. 1895 in Manet 1979, p. 66.
2 Renoir 1962, p. 232; Manet 1979, p. 66.
3 White 1969, p. 340; Callen 1978, p. 74.

4 Blanche 1921, p. 37; cf. Blanche 1931, p. 73; Vollard 1938, p. 203.
5 Blanche 1949, p. 43.
6 Ibid., p. 435.
7 Pierre-August Renoir to Paul Durand-Ruel, 21 Nov. 1881, in Venturi 1939, vol. 1, pp. 116–17: "simplicité et de grandeur."
8 Florisoone 1938, p. 36: "Raphael qui ne travaillait pas dehors avait cependant étudié le soleil car ses fresques en sont pleines. Ainsi à force de voir le dehors j'ai fini par ne plus voir que les grandes harmonies sans plus me préoccuper des petits détails qui éteignent le soleil au lieu de l'enflammer."

9 Vollard 1938, p. 203.
10 Ibid., p. 140.
11 Jules Claretie, "La Vie à Paris: Les Artistes indépendants," *Le Temps*, 5 Apr. 1881, p. 3, in Berson 1996, vol. 1, p. 335: "fleurette de ruisseau," "museau vicieux."
12 Manet 1979, p. 66.
13 Vollard 1939, p. 203, said he sold it; Meier-Graefe 1912, p. 108, said he gave it as a gift.
14 For details, see London 1985, p. 234.
15 RSC Diary, 29 Mar. 1926.

22 Child with a Bird (Mademoiselle Fleury in Algerian Costume)
1882

Oil on canvas
126.4 x 78.1 cm
Signed and dated lower
right: *Renoir. 82.*
1955.586

Speaking to Ambroise Vollard late in his life, Renoir commented about his second trip to Algeria in the early spring of 1882: "There I made a life-sized portrait of a young girl named Mlle. Fleury, dressed in Algerian costume, in the setting of an Arab house, holding a bird."[1] Sterling Clark, viewing the painting in Durand-Ruel's gallery in New York in 1929, noted that the model was the "little daughter of the Governor General of Algeria";[2] when he bought the canvas from Durand-Ruel in 1937, the invoice identified her as "daughter of the governor general of Algiers." No general named Fleury was ever governor general in Algiers, but two French generals with that name seem to have been serving in Algeria when Renoir was there, Émile-Félix Fleury (1815–1884), and Paul-Louis-Félix

Fleury (1831–1915), of whom the latter had two daughters.[3] Nevertheless, the precise identity of Mademoiselle Fleury cannot be determined.

The status of the picture is also ambiguous. Its scale and elaboration might suggest that it was a commissioned portrait. Yet there is no evidence that this was so. Renoir brought it back from Algiers to Paris and sold it to the dealer Paul Durand-Ruel in May 1882; it was exhibited with the title *L'Enfant à l'oiseau* in the one-artist show that the dealer mounted of Renoir's work in April 1883, indicating that it should be viewed as a genre painting, not as a portrait. One possibility is that it was originally commissioned as a portrait but was rejected by Mademoiselle Fleury's father.

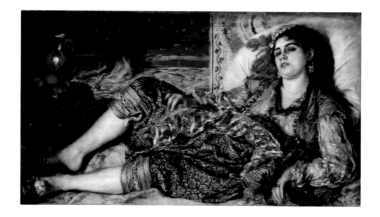

FIG. 22.1
Pierre-Auguste Renoir
Odalisque, 1870
Oil on canvas, 39 x 60.5 cm
National Gallery of Art, Washington, D.C.
Chester Dale Collection (1963.10.207)

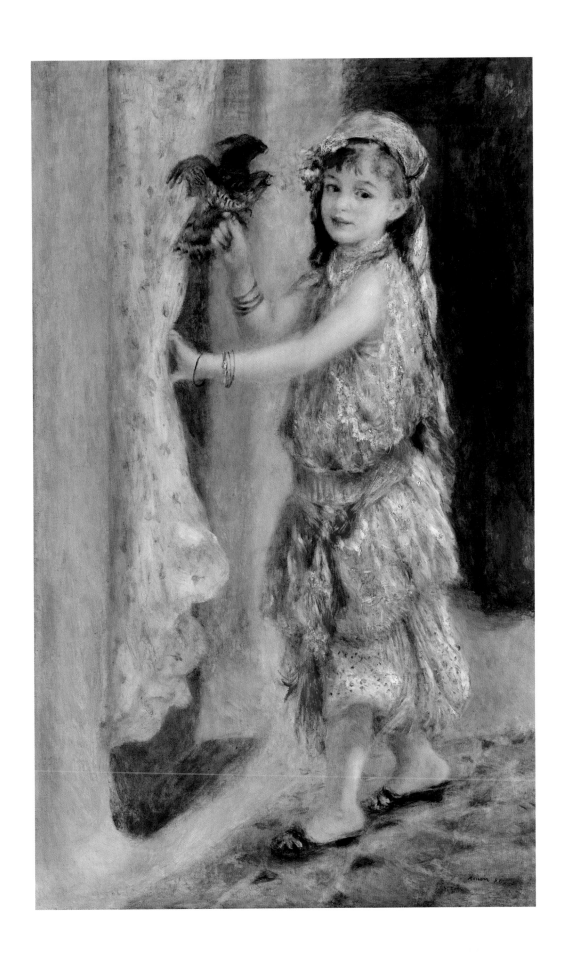

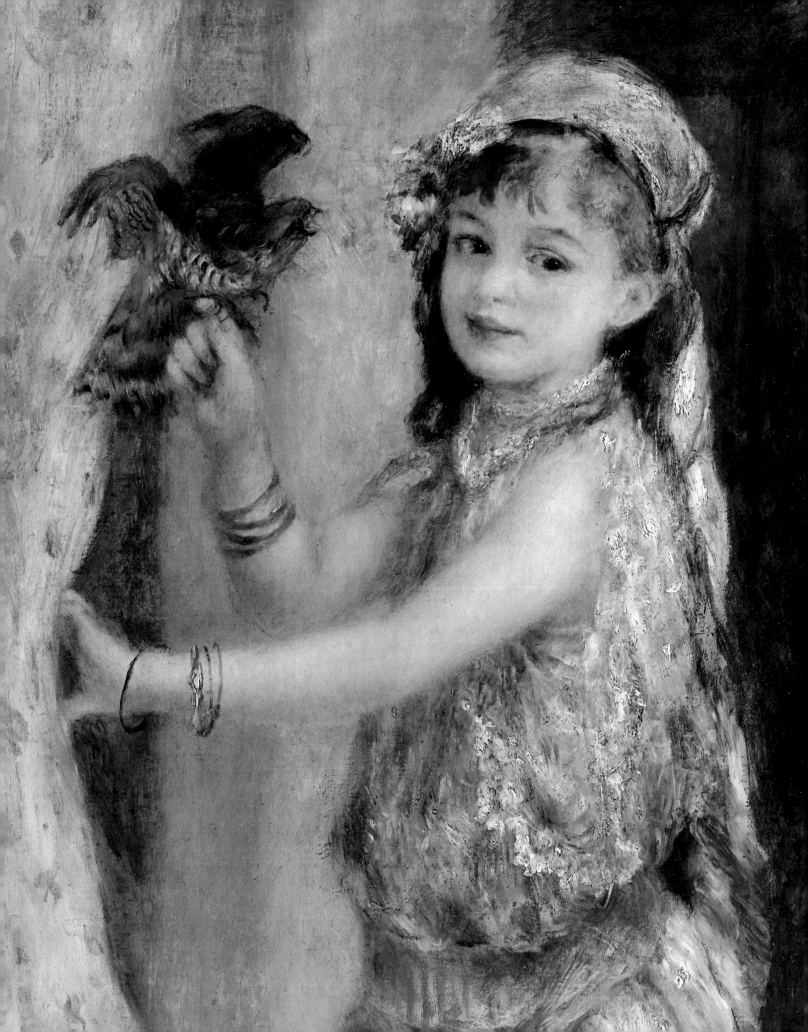

Viewed as a genre painting, it falls into the category of pictures of models who are evidently European wearing "Oriental" or North African costumes, and can be compared with Renoir's own *Odalisque* (fig. 22.1), a canvas depicting his mistress Lise Tréhot in Algerian costume, exhibited at the 1870 Salon. The Clark's picture is different in two crucial respects: it was painted in North Africa, and it presents the model in an "Arab house"—an explicitly local building. Only the girl's fair hair and skin prevent it from being viewed as a straightforward representation of an "exotic" type. The bird, traditionally described as a falcon, has been identified as a European kestrel; it seems most unlikely that it was painted from a living bird.[4]

Despite the exoticism of the figure's dress and setting, the picture's imagery belongs firmly within a European context, as one among many canvases depicting women with pet birds. At times frivolous and flirtatious, at times ambiguous and inscrutable, as in Édouard Manet's *Woman with a Parrot* of 1866 (Metropolitan Museum of Art, New York), these pictures play in various ways on the associations between the positions and status of the women depicted and the kept birds. Renoir himself had treated the theme in his *Woman with a Parrot* of 1871 (Solomon R. Guggenheim Museum, New York), a canvas showing Lise Tréhot in fashionable dress attending to a caged bird.

Most of the canvas is thinly painted, using the white of the canvas priming to lend luminosity to the scene. By contrast, the figure's clothing and headscarf are executed with a full impasto, with loose, improvised brushstrokes that give a sense of the volume and folds of the costume without depicting its intricacies illusionistically. The use of color further enhances the focus on the figure. Throughout the canvas, there is a play on contrasts between warm and cool, orange and blue, with the floor and curtain set off against the door and walls. The same contrasts are repeated in the figure, with orange and blue tones closely juxtaposed on the girl's upper garment, interspersed with white highlights.

The orange and intense reds of the sash that falls from her waist act as a focal point around which the play of colors in the rest of the canvas revolves. The smaller red accents of the model's lips and the rose in her hair echo the color of the sash, which in turn contrasts with the intense green of her scarf.

At first sight the date on the canvas appears to read "80." However, another, largely overpainted signature and date at lower left may perhaps read "82." In its handling and treatment, the painting closely resembles *Old Arab Woman*, painted in Algiers in 1882 (Worcester Art Museum, Worcester, Massachusetts); taken together with Renoir's reminiscences recorded by Vollard, there seems no reason to doubt that it was painted during Renoir's visit to Algiers in 1882.

Sterling Clark viewed the painting on a number of occasions in Durand-Ruel's New York gallery before buying it in 1937. In 1929 he noted that he and his wife considered the figure of the girl to be "dwarfish," but shortly before buying it he wrote that "it looked fine and the child less dwarfish than I remembered it."[5]

PROVENANCE

[Durand-Ruel, Paris, bought from the artist, 22 May 1882–84; sold to David, 30 Dec. 1884]; Charles Leroux, Paris (1884–88; his sale, Drouot, Paris, 27–28 Feb. 1888, no. 72, sold to Durand-Ruel); [Durand-Ruel, Paris and New York, 1888–1909; sold to Thompson, 17 Apr. 1909]; Anna Thompson, New York (1909–28; sold to Durand-Ruel, 23 Apr. 1928); [Durand-Ruel, New York, 1928–37; sold to Clark, 6 May 1937]; Robert Sterling Clark (1937–55); Sterling and Francine Clark Art Institute, 1955.

REFERENCES

Vollard 1918, vol.1, no. 345; Daulte 1971, no. 349; Williamstown 1996, pp. 61, 65–66, ill. p. 67; Ottawa 1997, pp. 18, 49n165; Distel 2009, p. 217, fig. 199.

NOTES

1 Vollard 1938, p. 207: "Je fis là un portrait, grandeur nature, d'une jeune fille, Mademoiselle Fleury, habillée en Algérienne, dans un décor de maison Arabe, et tenant un oiseau."
2 RSC Diary, 19 Feb. 1929.
3 See Williamstown 2003, pp. 88, 153nn15&16.
4 Ibid., p. 90.
5 RSC Diary, 8 Apr. 1929, 19 Jan. 1937.

Marie-Thérèse Durand-Ruel Sewing

1882

Oil on canvas
64.9 x 54 cm
Signed and dated lower
left: *Renoir. 82.*
1955.613

The dealer Paul Durand-Ruel had made extensive purchases from Renoir's colleagues Claude Monet, Alfred Sisley, and Camille Pissarro in 1872–73, but he bought only a few canvases from Renoir during the 1870s, among them a commissioned portrait of his youngest daughter, Jeanne, in 1876 (Barnes Foundation, Merion, Pennsylvania). In 1880, however, a fresh injection of capital allowed him to begin to purchase Renoir's work, together with that of his friends, in substantial quantities. With a few intermissions, he was to remain Renoir's principal dealer until the end of the artist's life; Sterling Clark purchased many of his works by Renoir from the Durand-Ruel company.

In 1882, Durand-Ruel commissioned Renoir to paint portraits of all five of his children. In June, Renoir reported to his friend Paul Berard: "Durand wants to get me to paint his whole family, and has engaged me for the month of August."[1] The four portraits were all, it seems, executed at the house that Durand-Ruel rented in Dieppe for that month. *Marie-Thérèse*

Durand-Ruel Sewing shows Durand-Ruel's elder daughter, Marie-Thérèse (1868–1937), around the time of her fourteenth birthday. Together with two other portraits of the Durand-Ruel children, it was executed in the garden of the house; Jacques-Émile Blanche described the scene: "The Durand-Ruel children posed for him in a garden on the *côte de Rouen*, beneath the moving leaves of the chestnut trees; the sun dappled their cheeks with reflections incompatible with the beautiful 'flat modeling' of studio lighting."[2]

It seems that Durand-Ruel was not entirely happy with the results of this outdoor portraiture. In autumn 1882, Renoir wryly reported to Berard: "I think that Durand is not very pleased with his portraits . . . I'm delighted by what is happening to me now. I'm going to return to the true path and I'm going to enter the studio of Bonnat [a leading academic portraitist]. In a year or two I'll be able to earn 3000000000000000 francs a year. Don't talk to me any more about portraits in sunlight. A nice dark background, that's the right thing."[3]

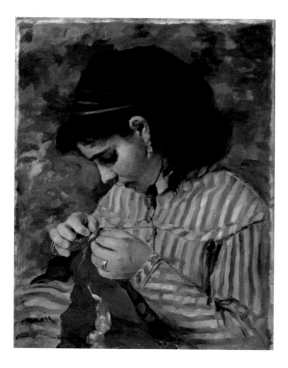

FIG. 23.1
Pierre-Auguste Renoir
Lise Sewing, c. 1866
Oil on canvas, 55.9 x 45.7 cm
Dallas Museum of Art, Dallas.
The Wendy and Emery Reves Collection (1985.R.59)

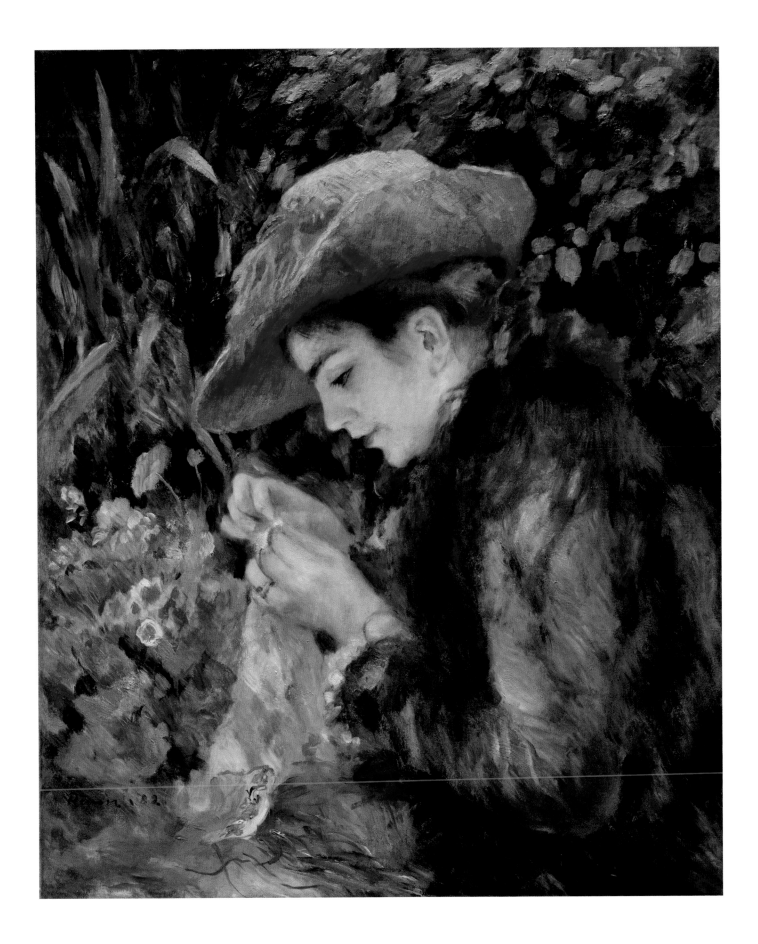

The matching portrait of Marie-Thérèse's brothers Charles and George (private collection) carries generic associations with a tradition of Baroque court portraiture, as seen, for instance in Anthony van Dyck's half-length *Portrait of Prince Charles Louis and Prince Rupert* of 1637, which Renoir would have known in the Louvre, or, as suggested by Colin Bailey, with a double portrait from Pompeii that he would have seen in the Naples Archaeological Museum in 1881.[4] By contrast, the generic prototypes for the portrait of Marie-Thérèse are Dutch, in paintings such as Jan Vermeer's *Lace Maker*, acquired by the Louvre in 1870. Bailey has proposed a source for the picture in an antique relief of a girl sewing that Renoir would have seen in the Naples Museum,[5] but this overlooks the fact that Renoir himself had used virtually the identical composition in about 1866, in one of his first depictions of his mistress Lise Tréhot, *Lise Sewing* (fig. 23.1). It seems impossible that this reprise was not deliberate on Renoir's part; we must assume, however, that Durand-Ruel was unaware that Renoir was superimposing memories of his youthful mistress onto the image of his patron's teenage daughter.

The project of outdoor portraiture clearly links *Marie-Thérèse Durand-Ruel Sewing* to Renoir's painting of the 1870s, and parts of the picture are treated in a broadly Impressionist manner—notably the girl's hair and dress, both loosely modeled in variegated color, her sewing, and the flowers (nasturtiums?) at lower left. However, in other ways it bears the imprint of the recent changes in his art, specifically of the lessons that he had learned from his visit to Italy (see *Blonde Bather*, cat. 18). Marie-Thérèse's profile is very precise and is sharply set off against the dark background; a harsh contrast is set up between her hat and the leaves behind it; and the foliage in the background is defined more crisply and tightly than in his previous work. Though a relatively wide range of colors—yellows, blues, and pinks—is used to model her face, these are blended into a smoother overall effect than in his earlier work. Overall, it is the sharp contrasts of color and tone that make the effect of the canvas so unlike his outdoor figure subjects of the 1870s.

Writing in his diary in 1937, Sterling Clark noted, "What 'un effet boeuf' the Mdlle Durand-Ruel with the red hat by Renoir 1882 makes!!!!"[6] This colloquial phrase may be translated "makes a strong impression."

PROVENANCE

Commissioned by Paul Durand-Ruel, Paris, father of the sitter (from 1882–d. 1922); Mme. Félix André Aude (Marie-Therèse Durand-Ruel), Paris (by 1925); [Knoedler, New York; sold to Clark, 23 July 1935]; Robert Sterling Clark (1935–55); Sterling and Francine Clark Art Institute, 1955.

REFERENCES

Daulte 1971, no. 409; Williamstown 1996, pp. 13, 15, 41, ill. p. 39; Ottawa 1997, no. 43; Distel 2009, p. 182, fig. 169.

NOTES

1 Letter from Renoir to Paul Berard, 22 June 1882, quoted in Ottawa 1997, p. 311, n. 7.
2 Blanche 1927, p. 64: "Les enfants Durand-Ruel posaient pour lui dans un jardin de la côte de Rouen, sous des marronniers aux feuilles mouvantes; le soleil tachetait leurs joues de reflets incompatibles avec le beau 'modelé plat' des éclairages d'atelier."
3 Letter from Renoir to Paul Berard, autumn 1882, Archives Durand-Ruel, part quoted in Ottawa 1997, p. 311, n. 15, part in London 1985, p. 231: "Durand n'est pas je crois très content des siens . . . ne me parlez plus de portraits au soleil. Le joli fond noir, voilà le vrai."
4 Ottawa 1997, pp. 196, 313.
5 Ibid.
6 RSC Diary, 17 Oct. 1937.

24 Low Tide, Yport
1883

Oil on canvas
54 x 65 cm
Signed and dated lower
right: *Renoir. 83.*
1955.607

Renoir traveled to Yport, a small town just to the west of Fécamp, on the northern coast of Normandy between Dieppe and Le Havre, during August 1883, to visit Alfred Nunès, a relative of Camille Pissarro, who was mayor of the town. There, Renoir painted portraits of Nunès's two children; in a letter to a friend he complained that he was "busy with two brats who make me furious" and that there were "a few too many parties, that's the weak point. . . . For at their place you spend the whole day at the table."[1] *Low Tide, Yport* served as the basis for the view in the background of the portrait of Alfred Nunès's son Robert in sailor-boy costume on the beach (fig. 24.1). The scene depicted can be firmly identified as the view looking eastward from Yport towards Fécamp. For many

years, however, it was misidentified as a view of Guernsey. In fact, Sterling Clark bought the painting in the belief that it represented Guernsey.[2]

In the late nineteenth century, the coast of Normandy had become highly developed as a destination for vacationers, and Yport had a casino; a number of Parisians, particularly artists and writers, also owned villas in Yport,[3] but the town had not lost its original natural charm. Although the guidebooks of the period regularly denigrated the place for its rocky and unpleasant beach,[4] seen in the foreground of Renoir's canvas, its cliffs were highly praised; in 1866, Eugène d'Auriac described the view that Renoir chose as follows: " . . . to the right the cliffs and waves extend as far as the eye can see; . . . the whole scene forms a picture that is gracious, imposing and full of poetry."[5] As late as 1887, the place could still be recommended to painters: "The outsiders who live in Yport, the painters who like to paint the many varied aspects of the bay of Fécamp, who find so many interesting motifs in the comings and goings of the fishermen and their boats . . . praise the solitude of their retreat, and the beautiful appearance of the sea and the cliffs."[6]

FIG. 24.1
Pierre-Auguste Renoir,
Sailor Boy (Robert Nunès), 1883
Oil on canvas, 130.2 x 80 cm
Barnes Foundation, Merion,
Pennsylvania

Renoir's canvas gives no indication of the status of the place as a resort. It does, though, take some note of the activities of the local fishermen, with the small boat and the summary indications of figures out on the rocks. Its primary focus is the rocks themselves, together with the sunlit panorama of the bay beyond. The motif is comparable to Claude Monet's *Rocks at Low Tide* of 1882 (Memorial Art Gallery, University of Rochester, Rochester, New York), but Renoir was far less concerned than Monet with finding distinctive types of brushmark to suggest the varied textures of the scene in front of him. Instead, the rocks and foreground sea alike are treated in relatively homogeneous, loosely parallel strokes running from upper left to lower right; the rocks are indicated by tone and color, rather than by texture, and enlivened by dappled patches of sunlight. Although the tonal contrasts in the foreground differentiate it clearly from the uniformly high-key tonality of the background, the continuation of the parallel brushstrokes through most of the sky lends an overall unity to the whole image.

This means of unifying a canvas through the direction of the brushstrokes can be compared with the system of parallel hatching (generally from lower left to upper right) that Paul Cézanne was evolving in these years; over the next couple of years, Renoir's treatment of his landscape subjects became tighter and dryer, and seemingly more closely indebted to Cézanne's example.

Although Renoir used the present canvas as the basis for the landscape in the background of the portrait of Robert Nunès, it is a fully finished picture in its own right, signed and dated. It is very possibly the painting that Renoir sold to the dealer Paul Durand-Ruel in December 1883 with the title *Low Tide, Yport*;[7] however, this could also have been another canvas, also dated 1883, that shows the rocks at Yport at low tide looking directly out to sea (State Hermitage Museum, St. Petersburg).

PROVENANCE

[Durand-Ruel, Paris; bought from the artist, probably in Dec. 1883]; [Durand-Ruel, New York; sold to Clark, 5 Nov. 1941]; Robert Sterling Clark (1941–55); Sterling and Francine Clark Art Institute, 1955.

REFERENCES

Williamstown 1996, pp. 80–81, 83, 87, ill. p. 85; London 2007, p. 73, fig. 52; Distel 2009, p. 225, fig. 209.

NOTES

1 Letter from Renoir to Paul Berard, 21 Aug. 1883, quoted in White 1984, p.133.
2 RSC Diary, 6 June 1934.
3 See the lists in Joanne 1866, p. 132; Joanne 1887, p. 144; and Conty 1896, p. 186.
4 Joanne 1866, p. 133; Conty 1876, p. 103.
5 Auriac 1866, p. 165: "à droite [les falaises] déroulent à perte de vue, aussi loin que vont les flots . . . tout . . . se réunit pour former un tableau à la fois gracieux, imposant, et plein de poésie."
6 Joanne 1887, p. 144: "Les étrangers qui habitent Yport, les peintres qui aiment à reproduire les sapects si variés de la baie de Fécamp, qui trouvent tant de motifs intéressants dans les va-et-vient des pêcheurs, de leurs bateaux . . . vantent la solitude de leur retraite, les beaux aspects de la mer et de ses faiaises. . . ."
7 Archives Durand-Ruel, Paris.

View at Guernsey

1883

Oil on canvas
46 x 55.7 cm
Signed and dated lower
right: *Renoir. 83.*
1955.601

Renoir spent a little over a month on Guernsey, one of the Channel Islands off the west coast of Normandy, from the beginning of September to early October 1883. All of the canvases that he executed there represent Moulin Huet Bay, on the southeastern tip of the island and an easy walk from the principal town St. Peter Port, where he was lodging. He made a number of studies of figures on the beach, seemingly in preparation for ambitious figure subjects that he planned to execute in the studio on his return to Paris, but none of these was brought to completion at the time of his visit. By contrast, he completed four landscapes of views over the bay, which he signed and dated, then sold to the dealer Paul Durand-Ruel in December 1883.[1]

Guernsey was well known in France as the scene of Victor Hugo's exile between 1855 and 1870 and as the setting for his novel *Les Travailleurs de la mer* (1866), but it seems not to have been a regular port of call for French visitors. Moulin Huet Bay was admired as the island's finest scenic attraction. *Black's Guide to the Channel Islands*, a guidebook frequently reprinted in the period of Renoir's visit, described its attractions in terms that would have appealed to an Impressionist landscapist: "The real source of the beauty of this spot lies, no doubt, in the ever-changing effects at all times and seasons; the freshness and life derived from the running stream; and the exquisite and sudden shifting of the scene, by the occasional introduction of the sea, with its numerous rocks and islets and the enclosing cliff."[2]

Renoir's four landscapes all depict the bay from viewpoints on or very near the main path that leads down to the bay; characteristically, and quite unlike Monet, Renoir did not leave the beaten track in his search for landscape motifs. *View at Guernsey* shows the panorama of the bay from a spot about halfway down the path, near the present tearoom, and includes the Cradle Rock, one of the distinctive features of the bay, and, beyond it, the Pea Stacks, the set of rocks at the end of the far promontory. Apart from the loosely brushed suggestion of the track entering the picture at lower right, there is no sign of human presence; the focus is on the play of light and color across foliage, rocks, sea, and sky.

There is a distinct contrast between the formal organization of the picture and its execution. Renoir's chosen viewpoint generated a composition that is relatively conventional in terms of academic landscape practice. The eye is led down the path and then out to the headland, with the darker forms of the bush on the left and the shadowed cliff face on the right framing the scene, and a tree punctuating the vista in approximately the same position as the trees in the idealized landscapes of Claude Lorrain. The orderliness of this composition contrasts with the informal arrangement of many of Renoir's landscapes of the 1870s.

At the same time, the painting is executed with a variegated and lively touch throughout. The brushwork is informal and seemingly impromptu, seeking appropriate marks to convey the diverse texture of the scene, with an emphasis that suggests the effect of a windy day. Much of the canvas was executed rapidly, wet-on-wet and presumably on site. There is absolutely no trace here of the greater systematization, with sequences of parallel strokes, that Renoir had begun to introduce into his landscapes over the previous two years, as seen in *Bay of Naples, Evening* of 1881 (cat. 19) and *Low Tide, Yport* (cat. 24), painted very shortly before his visit to Guernsey. The shadows throughout the present picture are modeled in clear blue—light and high key on the far cliffs but somewhat darker in the foreground, where they add a tonal structure to the scene without detracting from the richly colored overall effect of the canvas. Deeper crimson tones also enrich some of the darker areas of the canvas, picking up the hot salmon and orange hues in the foreground, emphasizing Renoir's determination that the

whole image should be viewed in terms of harmonies and contrasts of color.

Unlike many of Renoir's landscapes, *View at Guernsey* reveals clear traces in the sky that some of the white clouds were painted with a palette knife; this is especially evident in the larger white cloud half way up the sky area near the right margin, where the edges of the knife-stroke have been delicately worked over with a brush.

PROVENANCE

[Durand-Ruel, Paris; bought from the artist, 15 Dec. 1883]; [Durand-Ruel, Paris; sold to Clark, 3 Mar. 1933]; Robert Sterling Clark (1933–55); Sterling and Francine Clark Art Institute, 1955.

REFERENCES

Williamstown 1996, pp. 80–81, 83, 87, ill. p. 84; London 2007, pp. 73–4, fig. 53.

NOTES

1 For more extended discussion of the Guernsey trip and its place in Renoir's career, see Guernsey 1988.
2 Anstead 1868, p. 129.

26 Apples in a Dish
1883

Oil on canvas
54.1 x 65.3 cm
Signed and dated lower
left: *Renoir. 83.*
1955.599

Apples in a Dish contrasts markedly with *Onions* (cat. 20), painted in Italy only two years earlier. In contrast to the animated, informal arrangement of the onions, the apples are presented on a table viewed frontally, with the majority of the fruit carefully stacked in a large blue bowl. This arrangement bears a clear resemblance to the fruit still-life paintings that Paul Cézanne had been executing in the years around 1880 — canvases that Renoir would have had a chance to see when he visited Cézanne early in 1882, on his return journey from Italy. It can be compared to canvases such as Cézanne's *Fruit Bowl, Apples and Loaf of Bread* (Sammlung Oskar Reinhart, am Römerholz, Winterthur).

In certain canvases in these years, Renoir's paint-handling also bears comparison to Cézanne's brushwork, in his use of sequences of parallel strokes. Despite the Cézanne-like arrangement of forms, however, the touch is more flexible and supple. On the background wall the strokes eddy in various directions, and on the fruit they generally serve to model their forms by following their contours, though on a few of the apples in the bowl they run in slightly more insistent parallel sequences than the shape of the fruit would seem to demand.

Contrasting warm and cool colors run throughout the canvas. The intense deep blue of the fruit bowl with its white edges and feet acts as pivot to the composition, set off against the rich red-orange tones of the ripe apples, and the same contrast is picked up in the soft pastel-like hues of the background wall. Alongside this, greens and yellows contribute to a constantly variegated surface; unusual for Renoir, the overall effect is one of insistent diversity rather than revolving around one dominant color relationship.

There is something of a contrast between the seemingly rough homespun surface of the background wall and the formality of the arrangement, with the elaborate fruit bowl and the complex patterned drapery on the table. A set of near-vertical blue strokes can be see through the present paint layer down the right margin, suggesting that the background may originally have been framed by a curtain—another device that is found in many of Cézanne's still-life arrangements. However, the formality of the image is countered, again, by the evident signs of rotting in the foremost apple — a specific sign of the passing of time that appears in some of Gustave Courbet's still-life paintings executed in 1871–72 but otherwise most infrequent in nineteenth-century still life paintings; this seems at odds with Renoir's general avoidance of signs of decay and ageing in his art.

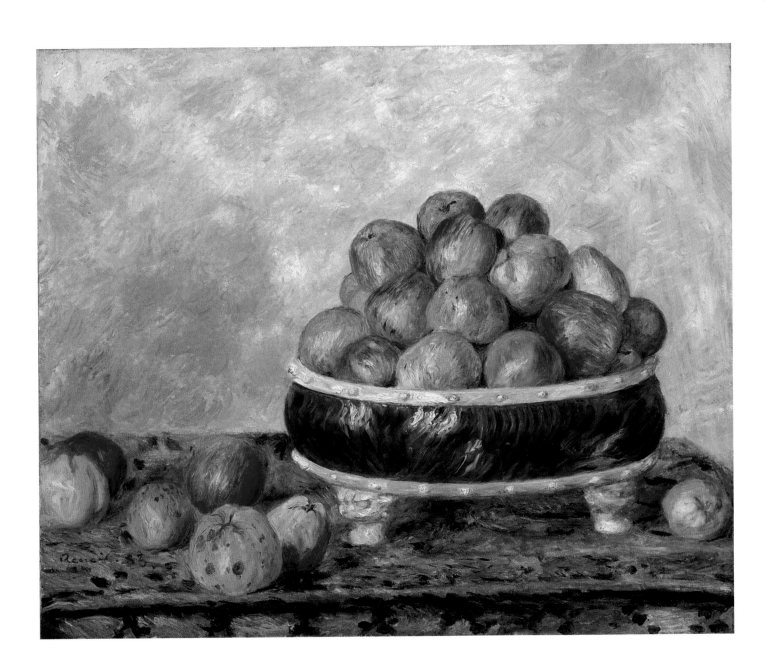

PROVENANCE

[Durand-Ruel, Paris; bought from the artist, 25 Aug. 1891]; Annie Swan Coburn, Chicago (1926–32); Fogg Art Museum, Harvard University Art Museums, Cambridge, Mass., by bequest (1934–51); [John Levy Galleries, New York; in 1951]; [Knoedler, New York; sold to Clark, 19 May 1951]; Robert Sterling Clark (1951–55); Sterling and Francine Clark Art Institute.

REFERENCES

Williamstown 1996, pp. 27, 93, ill. p. 92.

27

Bather Arranging Her Hair
1885

Oil on canvas
91.9 x 73 cm
Signed and dated lower
left: *Renoir. 85.*
1955.589

Bather Arranging Her Hair is one of the most crisply defined and harshly contoured of all Renoir's figures painted during his period of technical experimentation in the mid-1880s. Along with *Bathers* (Philadelphia Museum of Art), completed in 1887, it makes the extreme point of his rejection of the Impressionist technique of absorbing figures into their surroundings and into the ambient atmosphere.

The figure is sharply differentiated from the background, an effect achieved by contrasts of color and paint texture; only around the model's buttocks, belly, and thigh is a soft blue line used to demarcate it. Strongly lit from the front, the model's skin is treated in simple, relatively flatly painted planes of dense impasto, mostly in soft pinks and creams, with only slight color modulations suggesting the play of light across her form. The simplicity of her coloring, with dark hair against light skin, sets the figure decisively apart from the background.

The model is shown seated on a grassy area amid an irregular and partly rocky terrain, with some hint of waves on a shoreline at lower left; but the space in the right foreground is quite unclear, and the figure is not depicted in a credible three-dimensional relationship to her immediate surroundings. Beyond, we see distant cliffs across a wide bay, but these, too, seem to be generic; they cannot be identified as representing any specific site, and they closely resemble the background in the second version of *Blonde Bather* painted in 1882 (private collection). The entire setting is treated in clear and variegated, light-toned color, with the addition of much white,

forming a kaleidoscopic backdrop beyond the figure. In contrast to the softly brushed background of the 1881 *Blonde Bather* (cat. 21), the handling here is crisper and stiffer, with areas where sequences of parallel brushstrokes are reminiscent of the recent work of Paul Cézanne. They are less rigorously parallel, however, than Cézanne's, and Renoir, unlike Cézanne, did not use these strokes to evoke colored modeling but instead to create a set of textures that act as a foil to the figure.

The fabric around the figure's legs appears to represent an item of clothing rather than a towel or generic drapery, since what seems to be an elastic waistband can be seen running beneath her thigh. This garment may be compared with the far less clearly defined material across the legs of the 1881 *Blonde Bather*; together with the hint of underarm hair, it gives the present canvas a degree of specificity that contrasts with the wholly inexplicit context and setting in which the figure is placed. Moreover, the figure's gesture, as she tends her hair, and the tiny detail of her eyelashes, indicated with almost a miniaturist's precision, suggest a trace of coquettishness absent from the 1881 *Blonde Bather*.

Bather Arranging Her Hair belongs to a lineage of images of seated naked women seen from behind. It carries echoes of both Jean-Auguste-Dominique Ingres's "Valpinçon" *Bather* of 1808 (Musée du Louvre, Paris), placed in an "Oriental" interior, and Gustave Courbet's *La Source* of 1868 (Musée d'Orsay, Paris), which shows a precisely modeled, full-bodied figure beside a stream in deep woodland. Renoir noted his

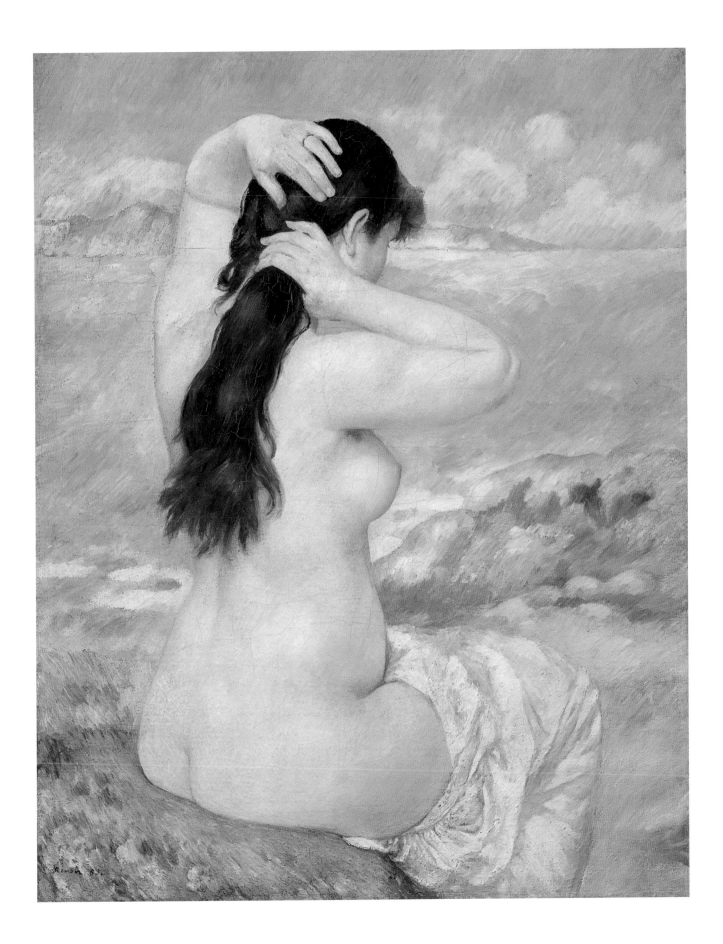

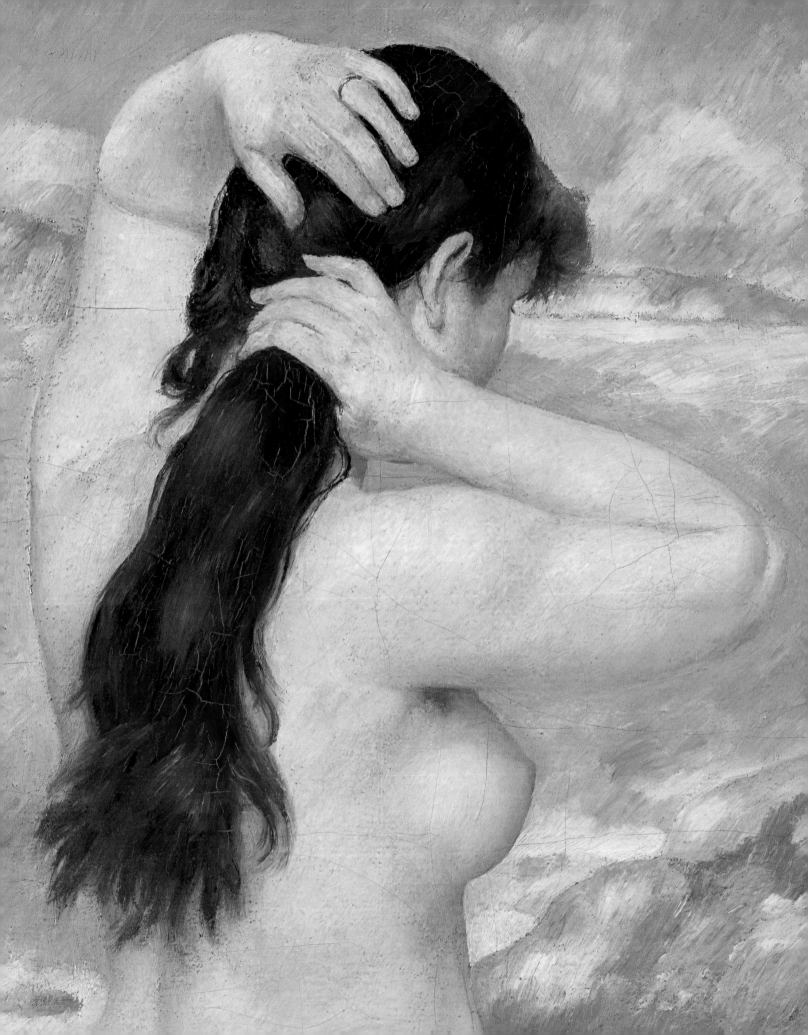

admiration for Ingres's oil paintings in a letter from Italy in 1881, and Ingres was clearly an example that he had in mind as he sought to reintroduce draftsmanship into his art.[1] He would have renewed his knowledge of Courbet's art at the retrospective held at the École des Beaux-Arts in May 1882, in which *La Source* was included under the title *Baigneuse vue de dos*. In some ways Renoir's canvas is also comparable to Pierre Puvis de Chavannes's *Young Girls by the Sea*, shown at the 1879 Salon (Musée d'Orsay, Paris), in which no extraneous details detract from the semi-clad female figures beside the sea; Renoir and Puvis shared a model in these years—the future painter Suzanne Valadon.

Nevertheless, Renoir's canvas is quite unlike these precedents in its synthesis—which is in some ways disconcerting—of a tautly contoured figure and a seemingly timeless setting with luminous, high-key color. This was analyzed with great sympathy by Julius Meier-Graefe in 1911, in the first monograph published on Renoir; a drawing after this picture even appeared on the cover of the book. Meier-Graefe characterized the figure as a modern Venus: "This Venus Anadyomene does not borrow her charms from any antique sculpture. She testifies to her origins in a way more credible to our modern ideas; she is truly woman born from the waves. Renoir draws her brilliant enamel out from the colored beauty of the atmosphere that surrounds her, and thus avoids the immobile isolation of painted modeling."[2]

The visible cracking in the paint surface of the figure, and particularly in her hair, suggests that this was one of the canvases in which Renoir tried to reduce the quantity of medium that he added to his color;[3] certainly the dense superimposed paint layers here did not fully bond together. The somewhat chalky tonality of the canvas also suggests his interest in the visual qualities of fresco painting, something that Puvis de Chavannes was exploring in his use of oil paint in these years. However, the sleekness and fullness of finish on Renoir's figure creates an effect quite unlike the dryness of painting on plaster; comparisons with painting on enamel or porcelain (Renoir's trade in his youth) may be more relevant. Soon afterward, as Renoir told Vollard, he realized that "oil painting must be done with oil";[4] from around 1888, he never had similar problems with the bonding of his materials.

PROVENANCE

[Durand-Ruel, Paris, on deposit from the artist, Apr. 1885; bought from the artist, 3 Feb. 1892; sold to Clark, 4 Oct. 1937]; Robert Sterling Clark (1937–55); Sterling and Francine Clark Art Institute, 1955.

REFERENCES

Meier-Graefe, 1929, pp. 186–87, fig. 172; Daulte 1971, pp. 28, 50, no. 492; London 1985, no. 75; Williamstown 1996, pp. 15, 17, 50, 54, ill. p. 52; Ottawa 1997, pp. 214, 216, 321n9; Distel 2009, p. 243, fig. 223.

NOTES

1 Renoir to Paul Durand-Ruel, 21 Nov. 1881, in Venturi 1939, vol. 1, pp. 116–17.
2 Meier-Graefe 1912, p. 114: "Cette Vénus Anadyomène n'emprunte ses charmes à aucune sculpture antique. Elle prouve son origine d'une manière plus croyable à nos idées modernes. Elle est vraiment la femme née de l'écume. Renoir fait sortir son émail brillant du charme coloré de l'atmosphère qui l'entoure, et évite ainsi l'isolement immobile de la plastique peinte."
3 Vollard 1938, pp. 216–17.
4 Ibid.: "la peinture à l'huile doit être faite avec de l'huile."

Standing Bather

c. 1885

Oil on canvas
43.2 x 27.3 cm
Signed lower left: *Renoir.*
1955.605

In theme and treatment, *Standing Bather* clearly belongs with *Bather Arranging Her Hair* (cat. 27), as one of the outdoor nudes that Renoir executed during the period in the mid-1880s when he was reassessing his painting technique, in the aftermath of his visit to Italy. Indeed, in its subject it can be seen as a pair to *Bather Arranging Her Hair*, which has a very similar setting, with distant mountains across a wide bay, and shows a similar model, now standing.

The small scale of the canvas, however, makes it clear that it cannot be viewed as a painting of similar status and ambition to *Bather Arranging Her Hair*. It seems possible that it was originally meant to serve as a study or preparation for a larger and more ambitious picture, and a drawing of a figure similarly posed suggests that it was a project to which Renoir devoted some attention;[1] but there is no evidence that he ever undertook a larger canvas, and the present picture was signed and sold soon after its execution.

The pose of the figure can be seen as a fusion between the theme of the Venus Pudica, shielding herself from the viewer's gaze, and the surprised nymph, whose gesture suggests that she has been caught unawares; quite unlike the static and detached poses of the 1881 *Blonde Bather* (cat. 21) and *Bather Arranging Her Hair*, the model here makes direct eye contact with the viewer, placing us in the role of the intruder who

has disturbed her in her nakedness. Moreover, as in *Bather Arranging Her Hair*, her garment appears to be contemporary—something like a shift—rather than a non-specific towel or drapery, though there are no signs of contemporaneity in her surroundings.[2]

The figure stands out sharply from the background, her pink flesh contrasting with the rich blues beyond, the edges of her body crisply demarcated from the background; though there are no actual outlines, fine blue contours are used to separate her arm from her torso. The brushwork is less ordered than in *Bather Arranging Her Hair* and runs in varied directions, but throughout the canvas it is relatively stiff, with none of the supple fluency that characterized Renoir's earlier work.

PROVENANCE
Boskowitz, Paris (sold to Durand-Ruel, Paris, 4 May 1892); [Durand-Ruel, Paris and New York, 1892–1919; sold to Henderson, 15 Dec. 1919]; Hunt Henderson, New Orleans (from 1919); [Jacques Seligmann, New York; sold to Durand-Ruel, New York, 3 Mar. 1937]; [Durand-Ruel, New York; sold to Clark, 10 Nov. 1938]; Robert Sterling Clark (1938–55); Sterling and Francine Clark Art Institute, 1955.

REFERENCES
Daulte 1971, no. 520; Williamstown 1996, pp. 50, 54, ill. p. 53.

NOTES
1 See Rewald 1958, pl. 31.
2 See Williamstown 1996, p. 50.

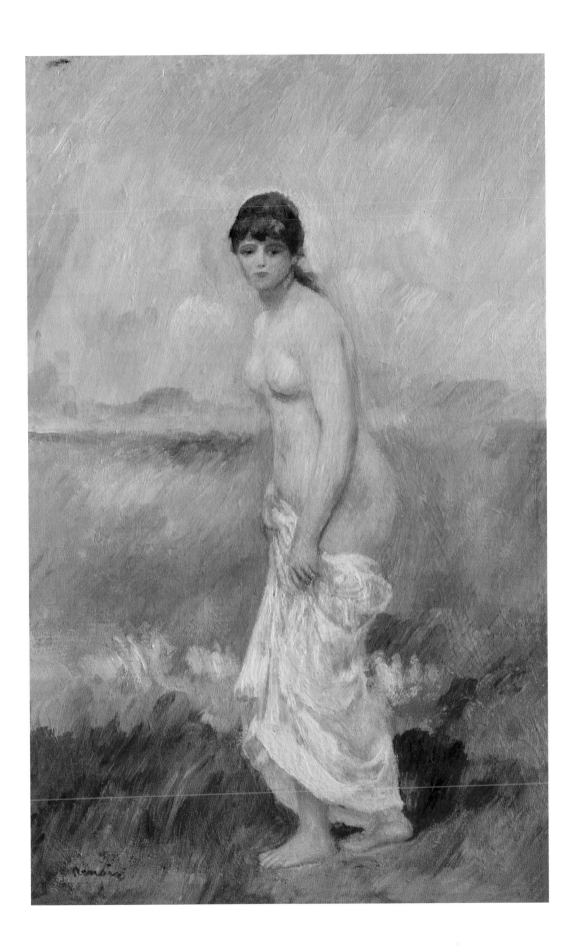

The Letter

c. 1895–1900

Oil on canvas
64.9 x 81.1 cm
Signed lower right: *Renoir.*
1955.583

The Letter is one of many genre paintings by Renoir in which two female figures are depicted without any clear indications of the relationship between them or any clues that might lead the viewer to read the canvas in narrative terms. In the genre painting of the nineteenth century, the theme of writing and receiving letters was commonly used as a means of suggesting a sentimental story and extending the inbuilt limitations of the art of painting by hinting at time before or after the moment depicted. In *The Letter*, however, Renoir deployed none of the techniques generally used to achieve this. Neither gestures, nor facial expressions, nor any details hint at the addressee or the content of the letter; all we see is one young woman writing a letter as the other watches.

Their clothing indicates that we are meant to see them as young bourgeois women, and the lightly brushed panel decoration on the left suggests a bourgeois interior; indeed, the ability to write itself suggested a degree of education and status. The model for the figure on the left, however, was not a *bourgeoise*; she can be recognized as Gabrielle Renard (1878–1959), a distant cousin of Renoir's wife, Aline, who joined the family in 1894 to help in the household and became perhaps Renoir's most frequent model over the next twenty years, initially in clothed genre scenes such as this, and after 1900 in many nudes. The many diverse ways in which Renoir represented Gabrielle remind us that the roles and identities that he created for his models cannot be viewed as evidence of the character or class of the women who posed for him.

In the 1890s, Renoir painted many canvases that included figures wearing lavish hats like the one adorned with a ring of poppies worn by the second woman in *The Letter*. The painter Suzanne Valadon, who modeled for Renoir in the 1880s, remembered his love of hats and how many he bought for his models to wear.[1] In the later 1890s, Paul Durand-Ruel seems

to have tried to persuade Renoir to stop painting girls with elaborate hats, since these had gone out of fashion; Jeanne Baudot witnessed his indignant response to the dealer's request, and his insistence that commercial concerns should not interfere with his artistic imagination.[2] *The Letter* and many other canvases testify to the failure of the dealer's appeal.

The Letter is a prime example of Renoir's abandonment during the 1890s of the characteristic "Impressionist" palette, with its use of blue to model forms and suggest shadow. The modeling here is essentially tonal, lightening and darkening the local colors to suggest the three-dimensionality of the figures and their clothing. He organized the composition around contrasts of both color and tone. The reds are set against the blue-green wallpaper, which itself is enlivened by small red accents, presumably flowers; but tonal contrasts are equally important, with, it seems, pure black used in the foreground figure's hair, for the ribbons on her sleeves, and for the inkwell. It was in the late 1890s that Renoir repeatedly emphasized the vital role that black should play in the painter's palette, repudiating the principles that he and his colleagues had followed by abandoning black in the later 1870s, now citing the examples of Titian and Velázquez to justify his new position.[3]

PROVENANCE
[Durand-Ruel, Paris; from the artist]; [Durand-Ruel, New York, probably by 1935–37; sold to Clark, 4 Oct. 1937]; Robert Sterling Clark (1937–55); Sterling and Francine Clark Art Institute, 1955.

REFERENCES
Williamstown 1996, pp. 15, 41, ill. p. 40.

NOTES
1 Coquiot 1925, pp. 96–97, 199–200.
2 Baudot 1949, p. 15.
3 See e.g., Manet 1979, pp. 191–92, 248 (diary entries for 2 Oct. 1898 and 7 Aug. 1899); Baudot 1949, p. 90.

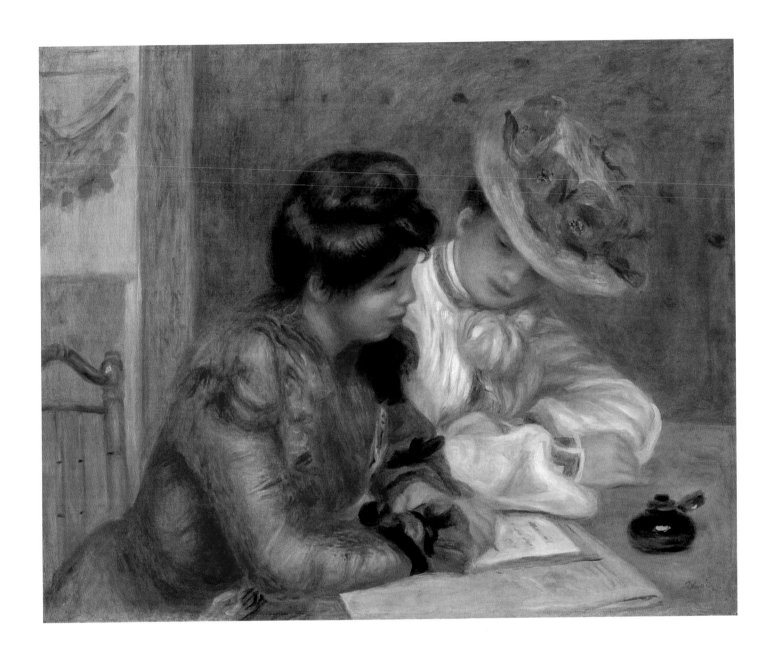

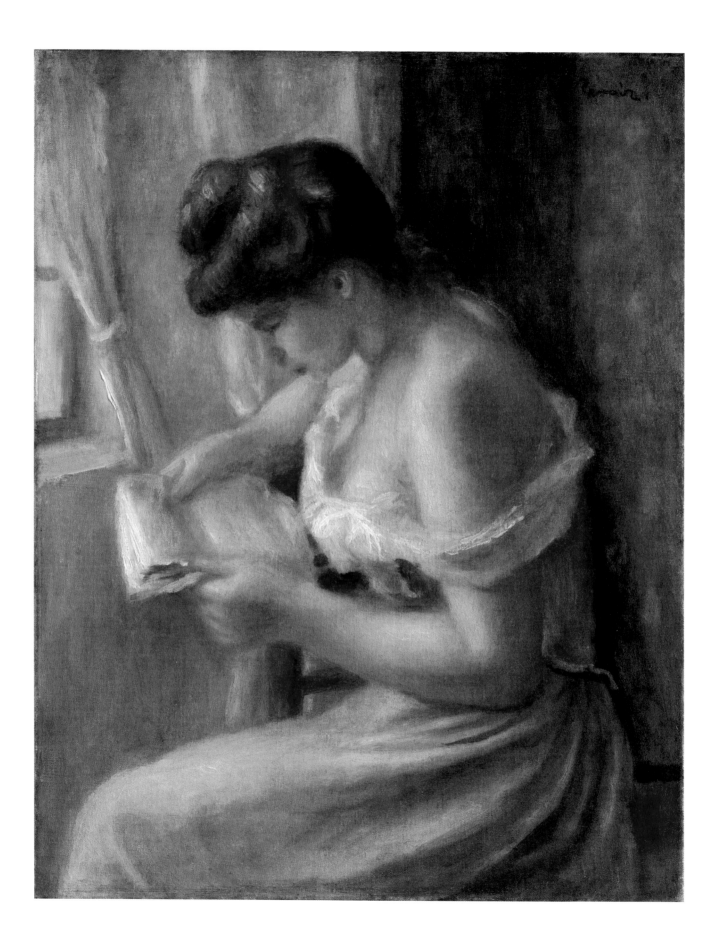

Woman Reading

c. 1895

Oil on canvas
41.6 x 32.7 cm
Signed upper right:
Renoir.
1955.908

Woman Reading takes up the theme of *Girl Crocheting* (cat. 6), depicting a model who is not formally posed but is seated, absorbed in her own activity, seemingly unaware that she is being painted, though of course this arrangement is just as carefully planned as the most conventionally configured composition. As in the earlier picture, too, she is informally dressed and the strap of her shift has slipped from her shoulder; the viewpoint here offers the viewer a particularly voyeuristic glimpse of her breasts. Indeed, it is clear that her shoulder strap was originally placed somewhat further up her arm. The papers that she is reading are not bound together like a book; the suggestion is that this is a long letter, written on multiple sheets, which adds a further dimension to the voyeurism implied by the picture as the viewer imagines who might have written to her at such length.

The execution of the canvas heightens this sense of voyeurism. Its central focus is the cascade of rich, fluid white brushstrokes that represent the loosened top of her shift, framing our view of her breasts. In comparison, the brushwork in the remainder of the canvas is less assertive, and even the figure's head is paid no special attention; the brush loosely follows the forms of head, hair, body, clothing, and curtains without creating any distinctive points of emphasis. The color scheme of the canvas is dominated by soft pinks, browns, and warm grays set off by the muted blue-greens of the wall in the right background. In sharp contrast to Renoir's work of the 1870s, blue is not used to model the figure or to suggest the play of shadow. Although the canvas has normally been dated to c. 1891, it seems more likely that it was painted in the mid-1890s, during the phase

when he was using blue so sparingly. *Woman Reading* has clear affinities with the genre painting of the French eighteenth century. In both subject and technique it is reminiscent of the work of Jean-Honoré Fragonard; the erotic suggestiveness of the figure's half-revealed breasts, too, has its precedents in the eighteenth century, in the work of Fragonard and especially Jean-Baptiste Greuze. Renoir painted many canvases of this type during the 1890s—not ambitious, but readily saleable. He joked to his dealer Paul Durand-Ruel in 1891 about painting a "tableau de genre—genre vente";[1] *Woman Reading* would doubtless have come into this category. However, despite its apparent lack of pretensions, Durand-Ruel thought highly enough of the canvas to include it in the major exhibition of Impressionist paintings that he mounted at the Grafton Galleries in London in 1905. In the context of Sterling Clark's collection, it is striking that Clark—in contrast to a contemporary collector such as Albert C. Barnes—should have taken so little interest in this phase of Renoir's career.

PROVENANCE
[Durand-Ruel, Paris, bought from the artist, 3 Aug. 1900]; Paul Durand-Ruel, Paris (by 1901–d. 1922); Durand-Ruel family, Paris (1922–39; sold to Durand-Ruel, New York, by 26 June 1939); [Durand-Ruel, New York; sold to Clark, 26 June 1939]; Robert Sterling Clark (1939–55); Sterling and Francine Clark Art Institute, 1955.

REFERENCES
Williamstown 1996, p. 48, ill. p. 46.

NOTES
1 Letter from Renoir to Berthe Morisot, 1891, in Rouart 1950, p. 163.

Jacques Fray

1904

Oil on canvas
42.2 x 33.8 cm
Signed and dated upper
right: *Renoir. 04.*
1955.600

In the late summer of 1901, Renoir visited Fontaine-bleau to fulfill a commission to paint the portraits of Suzanne and Mathilde Adler, fiancées of Gaston and Joseph (Josse) Bernheim, the proprietors of the Bernheim-Jeune Gallery in Paris.[1] There he met a young painter, Valentine Fray, a distant relative of the Adlers, whose portrait he painted the same year, presumably during his stay at Fontainebleau; she is wearing an elaborate dress and is posing against a loosely brushed green background that suggests an open-air setting (Kelvingrove Art Gallery and Museum, Glasgow).[2] Two years later, he painted the present portrait of her young son Jacques, for a commission of only three hundred francs, a very low sum for Renoir's work at this date. The portrait can be seen on the wall in a photograph of Valentine and her children taken around 1909.[3] Fray, seen at the piano in this photograph, later became a concert pianist; he worked with George Gershwin and in 1947 became the presenter of one of the first classical music series on radio.[4]

The portrait of Jacques Fray, seemingly around one year old at the time it was painted, closely resembles the type of picture that Renoir had recently executed of his own third son Claude (Coco), born in August 1901. The young Jacques is shown playing with toy birds, clasping one in his hand while another stands on the table in front of him with a third lying overturned beside it—a witty detail that hints at the characteristically limited attention span of a child of this age.

The baby's dress is handled in a fluent impasto, while the remainder of the canvas is freely but more thinly brushed. The warm hues of his face and hair are set off against the soft green background, but, as in other works from the later 1890s, blue is not used to model the figure. At the same time, the black ribbons on the child's sleeves, set boldly against the whites of the garment, highlight Renoir's return to the use of black as a key element in his palette.

PROVENANCE
Valentine Fray, Paris (d. 1939); Jacques Fray, Paris, by inheritance, 1939; [Carroll Carstairs, New York; sold to Durand-Ruel, 1 May 1940]; [Durand-Ruel, Paris and New York; sold to Clark, 28 May 1940]; Robert Sterling Clark (1940–55); Sterling and Francine Clark Art Institute, 1955.

REFERENCES
Williamstown 1996, pp. 61, 69, ill. p. 68.

NOTES
1 Distel 1993, pp. 45–48; Dauberville 2007, p. 30.
2 Donald 1966, pp. 22–23.
3 Reproduced in Distel 1993, p. 22.
4 Obituary notes from WQXR News, 1963, Sterling and Francine Clark Art Institute Archives, Williamstown, Massachusetts.

Self-Portrait
1899

Oil on canvas
41.4 x 33.7 cm
Signed upper left: *Renoir*
1955.611

Although this self-portrait has generally been dated to 1897–98, it is the only painting that can plausibly be identified with the self-portrait that Julie Manet described Renoir painting at Saint-Cloud in the summer of 1899: "He is finishing a self-portrait that is very nice, but he had made himself look rather harsh and wrinkled, we insisted that he suppress some wrinkles, and now it's more like him. 'I think it more or less catches those calf's eyes,' he says."[1] Colin Bailey has argued that the photographs taken of Renoir in the later 1890s show that he has "constructed the geography of his face with detachment and honesty" in the present painting;[2] however, these photographs show his face already deeply creased and furrowed, suggesting that the picture's original appearance may have been closer to reality.[3] Moreover, in the winter of 1898–99 he had suffered an acute rheumatic attack, a prelude to the arthritis that crippled him in his last years. Immediately after completing this canvas, he left for Aix-les-Bains, where he was treated for his condition.[4]

In the present painting, the creases on the face are somewhat softened and are woven into the network of cursive patterns that runs through the whole canvas — through his beard, collar, and tie, and through the arabesques — seemingly stylized flowers or leaves — of the wall decoration behind him. The color-range is quite restricted; the canvas is dominated by gradations of beiges, browns, and grays with occasional warmer touches in the modeling. The jacket and necktie are deep blue, but, in sharp contrast to his work of twenty years earlier, blue is not used to model the forms or to suggest shadow. Throughout the canvas, the colors used are essentially the local colors of the objects depicted, lightened and darkened to suggest the play of light.

As in his earlier self-portrait (cat. 5), Renoir depicts himself here in respectable bourgeois clothing, with no hint of his profession. The facial expression and tone of the two canvases are, by contrast, very different. Whereas in the earlier one the face conveys a sense of alertness and energy, here his expression is stiller and more passive, perhaps pensive and world-weary; the deep shadow on the right-hand side of the face gives it an elegiac, even melancholy, tone, perhaps hinting at his sense of his own physical frailty.

PROVENANCE
Collection of the artist (d. 1919); Pierre Renoir, the artist's son, Paris (1919–35; consigned to Durand-Ruel, Paris); [Durand-Ruel, Paris, 1935–36; transferred to New York]; [Durand-Ruel, New York, 1936–37; sold to Clark, 10 Apr. 1937]; Robert Sterling Clark (1937–55); Sterling and Francine Clark Art Institute, 1955.

REFERENCES
London 1985, no. 97; Williamstown 1996, pp. 55, 58, ill. p. 57; Ottawa 1997, no. 56; Distel 2009, p, 298, fig. 271; Paris 2009, no. 19.

NOTES
1 Manet 1979, p. 249, diary entry for 9 August 1899: "Il termine un portrait de lui qui est très joli, il s'était d'abord fait un peu dur et trop ridé; nous avons exigé qu'il supprimât quelque rides et maintenant c'est plus lui. 'Il me semble que c'est assez ces yeux de veau,' dit-il."
2 Ottawa 1997, p. 230.
3 See photographs reproduced in White 1984, pp. 298, 213, and Ottawa 1997, p. 329.
4 For discussion of the circumstances of this self-portrait, see also Ottawa 1997, p. 230.

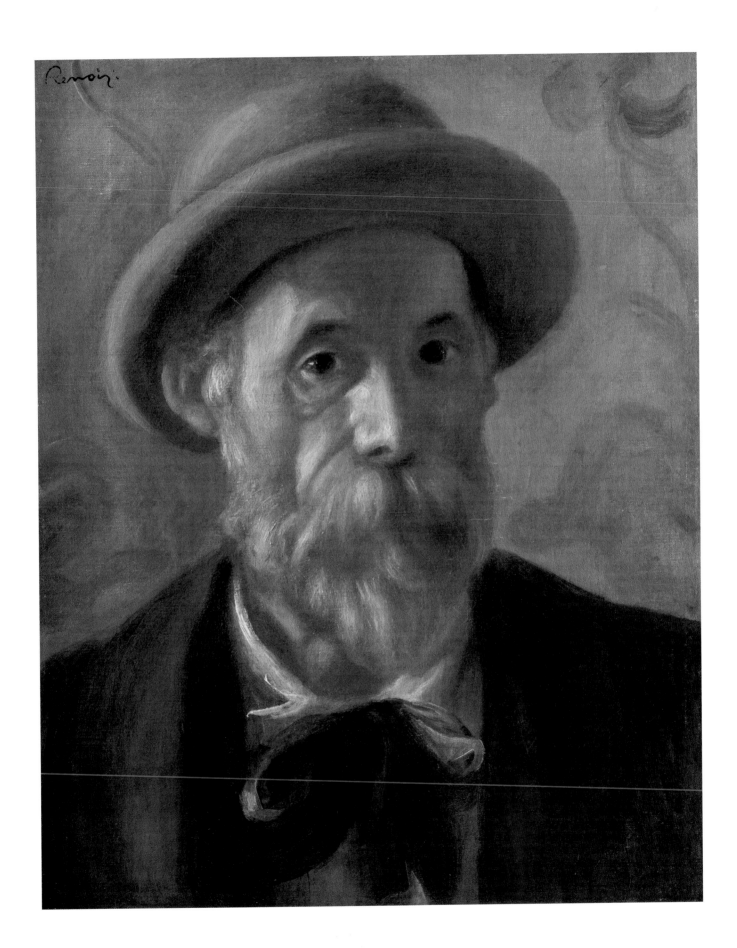

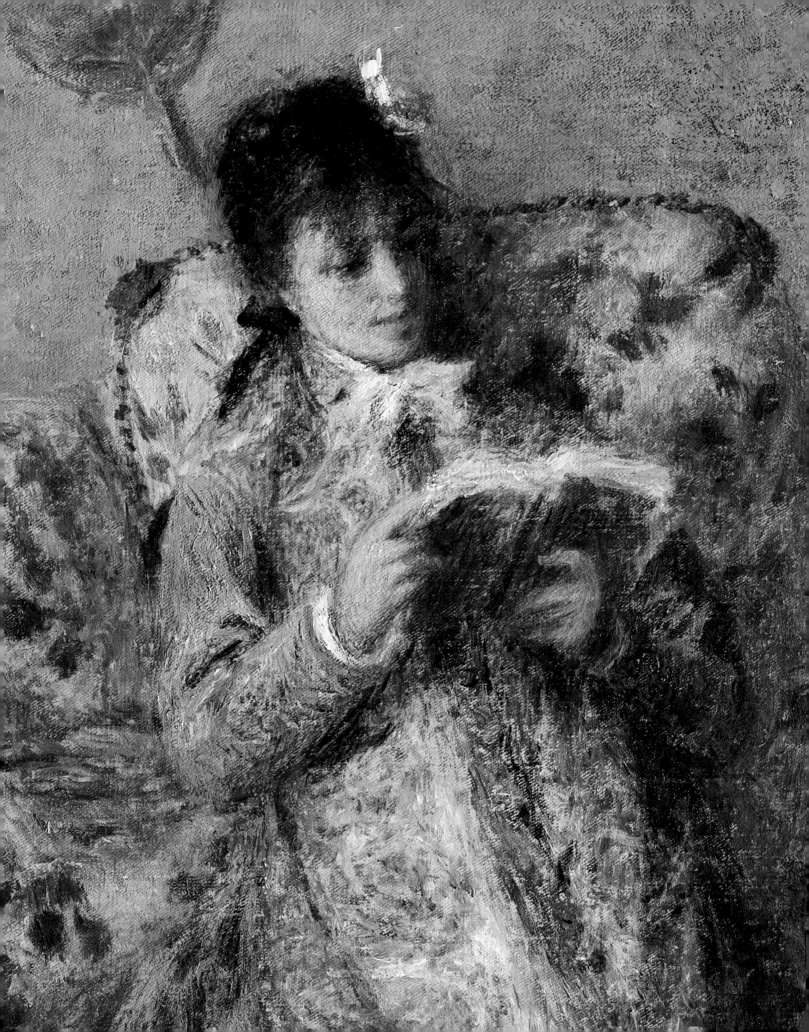

Artist Biography / Works Cited / Index

Pierre-Auguste Renoir (1841–1919)

Pierre-Auguste Renoir was born on 25 February 1841 in Limoges, France. His father was a tailor who moved the family to Paris when the artist was an infant. Renoir began his professional career in 1854 as an apprentice in a porcelain manufactory. During these early years he also began taking drawing lessons, working as a fan painter, and making copies of pictures in the Musée du Louvre. In 1861 he entered the studio of Charles Gleyre, an established painter, where he met Claude Monet, Frédéric Bazille, and Alfred Sisley; over the next several years he studied at the École des Beaux-Arts. In the mid-1860s he exhibited several paintings at the Paris Salon, but met with modest success; in 1867 his large *Diana the Huntress*, a monumental nude influenced by the art of Gustave Courbet, was rejected by the Salon jury.

In 1870, Renoir served in the Franco-Prussian War, stationed mostly in Libourne, in southwestern France. After the war, he returned to Paris, where he continued working in tandem with avant-garde artists, whose bond grew in their disenchantment with the dominant academic manner of painting. He exhibited two paintings at the 1873 *Salon des Réfusés*; the following year Renoir and his colleagues joined forces to organize the first exhibition of "independent artists," a group that soon came to be known as the Impressionists. Renoir would remain a central figure of the Impressionist movement for the rest of his career, showing at four of the group's eight exhibitions. While he is best known for his depictions of young fashionable ladies and bathers, he also painted landscapes, portraits, and still lifes. These themes recurred throughout the stylistic evolutions his art would undergo over a forty-year career.

While Renoir had modest success as a portrait painter early in his career, he attracted an increasingly wealthy clientele in the later 1870s. Through commissions and through developing relationships with art dealers, particularly Paul Durand-Ruel, Renoir finally achieved a degree of financial stability. In 1881 he traveled to Algeria and Italy with his partner Aline Charigot, visiting Venice, Rome, and Naples; he returned to Algeria in 1882. His study of Renaissance painting, particularly of Raphael's frescoes, introduced a solidity and sense of line to his Impressionist technique. In 1883, just two years after this trip, he had his first one-man show at the Durand-Ruel gallery in Paris, where seventy of his paintings were exhibited.

The first of his three sons was born in 1885, and he married Aline in 1890. In 1888, he was diagnosed with rheumatoid arthritis, and the condition would have a profound impact on his later painting style. He continued creating a prolific output of paintings throughout the 1890s, his bright palette becoming even more daring. By 1900, Renoir's reputation as a great painter was becoming solidified, and in that same year he was appointed Chevalier (eventually promoted to Commandeur) of the French Legion of Honor.

Renoir did not stop working in his old age. In 1907, at the age of sixty-six, he had a new house and studio built in Cagnes, near Nice. He suffered an attack of paralysis in 1912 that further disabled his already weak body. Even so, though often wheelchair-bound and with gnarled fingers that had to be tied together with cloth so that he could hold a brush, he continued to paint almost daily until his death on 3 December 1919. ∎

Works Cited

Adriani 1999
Adriani, Götz. *Renoir.* Cologne: Dumont, 1999. First published in German in 1996.

Alcock 1863
Alcock, Sir Rutherford, *The Capital of the Tycoon: A Narrative of a Three Years' Residence in Japan.* London: Harper & Brothers, 1863.

André 1928
André, Albert. *Renoir.* Paris: G. Crès, 1928.

Anstead 1868
Anstead, D. T., ed. *Black's Guide to the Channel Islands.* Edinburgh: R. Clark, 1868.

Atlanta 2000
Dumas, Ann, and David Brenneman. *Degas and America, The Early Collectors.* Exh. cat. Atlanta: The High Museum of Art, 2000.

Auriac 1866
Auriac, Eugène, d'. *Guide pratique, historique et descriptif aux bains de mer de la Manche et de l'Océan.* Paris: Garnier frères, 1866.

Baedeker 1874
Baedeker, Karl (firm). *Paris and Its Environs, With Routes from London to Paris, Paris to the Rhine and Switzerland Handbook for Travellers.* Leipsic: K. Baedeker, 1874.

Bailey 2008
Bailey, Colin. "Renoir's 'La Loge.'" *Burlington Magazine* 150, no. 1262 (May 2008): pp. 341–43.

Barnes 1993
Barnes Foundation. *Great French Paintings from the Barnes Foundation.* Exh. cat. New York: Knopf, 1993.

Barron 1886
Barron, Louis. *Les environs de Paris.* Paris: Maison Quantin, 1886.

Baudot 1949
Baudot, Jeanne. *Renoir, ses amis, ses modèles.* Paris: Éditions littéraires de France, 1949.

Berard 1939
Berard, Maurice. *Renoir à Wargemont.* Paris: Larose, 1939.

Berard 1956
Berard, Maurice. "Un Diplomate ami de Renoir." *Revue d'Histoire diplomatique* 3 (July–Sept. 1956): pp. 239–46.

Berson 1996
Berson, Ruth, ed. *The New Painting: Impressionism, 1874–1886: Documentation.* 2 vols. San Francisco: Fine Arts Museums of San Francisco, 1996.

Blanche 1921
Blanche, Jacques-Émile. "La technique de Renoir." *L'Amour de l'art* 2 (Feb. 1921): pp. 38–40.

Blanche 1927
Blanche, Jacques-Émile. *Dieppe.* Paris: Émile-Paul frères, 1927.

Blanche 1931
Blanche, Jacques-Émile. *Les Arts plastiques: La troisième république, 1870 à nos jours.* Paris: Les Éditions de France, 1931.

Blanche 1933
Blanche, Jacques Émile. "Renoir portraitiste." *L'Art vivant,* July 1933.

Blanche 1937
Blanche, Jacques-Émile. *Portraits of a Lifetime.* London: J. M. Dent & Sons ltd., 1937.

Blanche 1949
Blanche, Jacques-Émile. *La Pêche aux souvenirs.* Paris: Flammarion, 1949.

Bodelsen 1968
Bodelsen, Merete. "Early Impressionist Sales 1874–94 in the Light of Some Unpublished *procès-verbaux.*" *Burlington Magazine* 110, no. 783 (June 1968): pp. 339–40.

Boston 1978
Murphy, Alexandra R. *Visions of Vesuvius.* Exh. cat. Boston: Museum of Fine Arts, 1978.

Callen 1978
Callen, Anthea. *Renoir.* London: Oresko Books, 1978.

Cambridge 1965
Mongan, Agnes. *Memorial Exhibition, Works of Art from the Collection of Paul J. Sachs Given and Bequeathed to the Fogg Art Museum, Harvard University.* Exh. cat. Cambridge, Mass.: Fogg Art Museum, 1965.

Canberra 2001
National Gallery of Australia. *Monet & Japan.* Exh cat. Canberra: National Gallery of Australia, 2001.

Comstock 1940
Comstock, Helen. "Silver in a Benefit Exhibition." *The Connoisseur* 106, no. 468 (Sept. 1940): p. 72.

Conforti 2001
Conforti, Michael. "The Mind and the Eye." *CAI: Journal of the Clark Art Institute* 2 (2001): pp. 13–26.

Conty 1876
Conty, Henry-Alexis de. *Guides Conty. Les Côtes de Normandie.* Paris, 1876.

Conty 1896
Conty, Henry-Alexis de. *Guides Conty. Les Côtes de Normandie.* Paris, 1896.

Coquiot 1925
Coquiot, Gustave. *Renoir.* Paris: Albin Michel, 1925.

Dauberville 2007
Dauberville, Guy-Patrice, and Michel Dauberville. *Renoir: Catalogue raisonné des tabealux, pastels, dessins et*

aquarelles. Vol. 1. Paris: Bernheim-Jeune, 2007.

Daulte 1971
Daulte, François. *Auguste Renoir: catalogue raisonne de l'loeuvre peint.* Lausanne: Durand-Ruel, 1971.

Delvau 1867
Delvau, Alfred. *Dictionnaire érotique moderne.* Bale: Imprimerie de K. Schmidt, 1867.

Distel 1990
Distel, Anne. *Impressionism: The First Collectors.* Translated by Barbara Perroud-Benson. New York: H. N. Abrams, 1990.

Distel 1993
Distel, Anne. *Renoir: "Il faut embellir."* Paris: Gallimard: Réunion des musées nationaux, 1993.

Distel 2009
Distel, Anne. *Renoir.* Paris: Citadelles Mazenod, 2009.

Donald 1966
Donald, Anne. "Renoir's *Madame X* in Glasgow." *Scottish Art Review* 10, no. 41966 (1966): pp. 22–23.

Draner 1882
Draner. "Une Visite aux impressionnistes." *Le Charivari,* 9 Mar. 1882.

Durand-Ruel 1907
Galeries Durand-Ruel, Paris. *Tableaux modernes, pastels et aquarelles. Collection de M. George Viau.* Auction catalogue. Paris: Durand-Ruel, 4 Mar. 1907.

Duret 1906
Duret, Théodore. *Histoire des peintres impressionnistes: Pissarro, Claude Monet, Sisley, Renoir, Berthe Morisot, Cézanne, Guillaumin.* Paris: H. Floury, 1906.

Duret 1924
Duret, Théodore. *Renoir.* Paris: Bernheim-Jeune, 1924.

Florisoone 1938
Florisoone, Michel. "Renoir et la Famille Charpentier." *L'Amour de l'Art* 19, no. 1 (Feb. 1938): pp. 31–40.

Gachet 1956
Gachet, Paul. *Deux amis des impressionistes: le docteur Gachet et Murer.* Paris: Editions des Musées Nationaux, 1956.

Gimpel 1963
Gimpel, René. *Journal d'un collectionneur, marchand de tableaux.* Paris: Calmann-Lévy, 1963.

Godfroy 1995
Godfroy, Caroline Durand-Ruel, ed. *Correspondance de Renoir et Durand-Ruel.* Lausanne: Bibliothèque des arts, 1995.

Guernsey 1988
House, John. *Renoir 1841–1919: Artists in Guernsey.* Exh. cat. Guernsey: Guernsey Museum & Art Gallery, 1988.

Hôtel Drouot 1903
Hôtel Drouot, Paris. *Tableaux modernes par Bastien Lepage, Dumont, Humbert, Pierre Lagarde, Le Basque.* Auction catalogue. Paris: Hôtel Drouot, 25–27 Mar. 1903.

House 1986
House, John. *Monet, Nature into Art.* New Haven: Yale University Press, 1986.

Joanne 1866
Joanne, Adolphe. *Itinéraire général de la France: Normandie.* Paris: L. Hachette, 1866.

Joanne 1872
Joanne, Adolphe. *Les Environs de Paris illustrés.* Paris: Hachette, 1872.

Joanne 1887
Joanne, Paul. *Itinéraire général de la France: Normandie.* Paris: Hachette, 1887.

Laffon 1981
Laffon, Juliette. *Catalogue sommaire illustré des peintures.* Vol. 1. Paris: Palais des Beaux-Arts de la Ville de Paris, 1981.

Lapauze 1910
Lapauze, Henry. *Le Palais des Beaux-Arts de la Ville de Paris (Petit Palais).* Paris: Lucien Laveur, 1910.

Larousse 1866–90
Larousse, Pierre. *Grand dictionnaire universel du XIXe siècle: français, historique, géographique, mythologique, bibliographique, littéraire, artistique, scientifique, etc.* Paris: Administration du Grand dictionnaire universel, 1866–90.

L'Éclair 1892
"Nos artistes: Le Peintre P.-A. Renoir chez lui." *L'Éclair,* 9 Aug. 1892.

Lecomte 1892
Lecomte, Georges. *L'Art impressioniste d'après la collection privée de M. Durand-Ruel.* Paris: Chamerot et Renouard, 1892.

London 1985
Hayward Gallery. *Renoir.* Exh. cat. London: Arts Council of Great Britain, 1985.

London 2007
Bailey, Colin B. *Renoir Landscapes, 1865–1883.* Exh. cat. London: National Gallery, 2007.

London 2008
Vegelin van Claerbergen, Ernst, Barnaby Wright, and John House. *Renoir at the Theatre: Looking at "La Loge."* Exh. cat. London: Courtauld Gallery, 2008.

Los Angeles 1990
Freeman, Judi. *The Fauve Landscape.* Exh. cat. Los Angeles: Los Angeles County Museum of Art, 1990.

Manet 1979
Manet, Julie. *Journal (1893–1899).* Paris: C. Klincksieck, 1979.

McBride 1937
McBride, Henry. "The Renoirs in America: In Appreciation of the Metropolitan Museum's Exhibition." *Art News* 35 (1 May 1937): p. 60.

Meier-Graefe 1912
Meier-Graefe, Julius. *Auguste Renoir.* Translated by A. S. Maillet. Paris: H. Floury, 1912.

Meier-Graefe 1929
Meier-Graefe, Julius. *Renoir.* Leipzig: Klinkhardt-Biermann, 1929.

New York Times 1950
"Buyer Takes Title in Park Ave. Deal." *New York Times,* 14 June 1950.

Ottawa 1983
Druick, Douglas, and Michel Hoog. *Fantin-Latour.* Exh. cat. Ottawa: National Gallery of Canada, 1983.

Ottawa 1997
Bailey, Colin B., et al. *Renoir's Portraits: Impressions of an Age.* Exh cat. New Haven: Yale University Press in association with National Gallery of Canada, Ottawa, 1997.

Paris 1988
Galeries nationales du Grand-Palais. *Degas.* Exh. cat. Paris: Éditions Adam Biro, 1988.

Paris 2009
Galeries nationales du Grand-Palais. *Renoir au XXe siècle.* Exh. cat. Paris: Réunion des musées nationaux, 2009.

Reff 1976
Reff, Theodore. *Manet, Olympia.* London: Allen Lane, 1976.

Renoir 1962
Renoir, Jean. *Renoir, My Father.* London: Collins, 1962.

Rewald 1958
Rewald, John, ed. *Renoir Drawings.* New York: T. Yoseloff, 1958.

Rewald 1976
Rewald, John, ed. *Paul Cézanne Letters.* New York: Hacker Art Books, 1976.

Rivière 1921
Rivière, Georges. *Renoir et ses amis.* Paris: H. Floury, 1921.

Rouart 1950
Denis Rouart, ed. *Correspondance de Berthe Morisot.* Paris: Quatre Chemins-Éditart, 1950.

RSC Diary
Robert Sterling Clark Diary. Sterling and Francine Clark Art Institute Archives, Williamstown, Massachusetts.

Schneider 1945
Schneider, Marcel. "Lettres de Renoir sur l'Italie." *L'Âge d'Or—Études* 1 (1945): pp. 95–99.

Seigneur 1880
Seigneur, Maurice du. *L'Art et les Artistes au Salon de 1880.* Paris: Ollendorff, 1880.

Venturi 1939
Venturi, Lionello. *Les archives de l'impressionnisme.* 2 vols. Paris: Durand-Ruel, 1939.

Vollard 1918
Vollard, Ambroise. *Tableaux, pastels et dessins de Pierre-Auguste Renoir.* 2 vols. Paris: Vollard, 1918. Reprinted in 1954.

Vollard 1938
Vollard, Ambroise. *En écoutant Cézanne, Degas, Renoir.* Paris: B. Grasset, 1938.

Wagner 1861
Wagner, Richard. *Quatre poèms d'opéras.* Paris: Librairie nouvelle, 1861.

Washington 1996
Rathbone, Eliza E., et al. *Impressionists on the Seine: A Celebration of Renoir's "Luncheon of the Boating Party."* Exh. cat. Washington, D.C.: The Phillips Collection, 1996.

White 1969
White, Barbara Ehrlich. "Renoir's Trip to Italy." *Art Bulletin* 51 (Dec. 1969): pp. 333–51.

White 1984
White, Barbara Ehrlich. *Renoir: His Life, Art and Letters.* New York: Abrams, 1984.

Wildenstein 1974–91
Wildenstein, Daniel. *Claude Monet: Biographie et catalogue raisonné.* 5 vols. Lausanne and Paris: La Bibliothèque des Arts, 1974–91.

Williamstown 1996
Kern, Steven, et al. *A Passion for Renoir: Sterling and Francine Clark Collect 1916–1952.* Exh. cat. Williamstown, Mass.: Sterling and Francine Clark Art Institute, 1996.

Williamstown 2003
Benjamin, Roger. *Renoir and Algeria.* Exh. cat. New Haven: Yale University Press; Williamstown, Mass.: Sterling and Francine Clark Art Institute, 2003.

Williamstown 2006
Conforti, Michael, et al. *The Clark Brothers Collect: Impressionist and Early Modern Paintings.* Exh. cat. Williamstown, Mass.: Sterling and Francine Clark Art Institute, 2006.

Zola 1970
Zola, Émile. *Mon Salon, Manet, Ecrits sur l'art.* Edited by A. Ahrard. Paris: Garnier-Flammarion, 1970.

Index

PHOTOGRAPHY CREDITS

Permission to reproduce images is provided by courtesy of the owners listed in the captions. Additional photography credits are as follows: